GW00579493

INSIDE

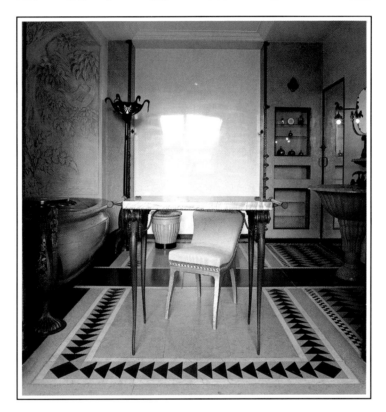

PARIS

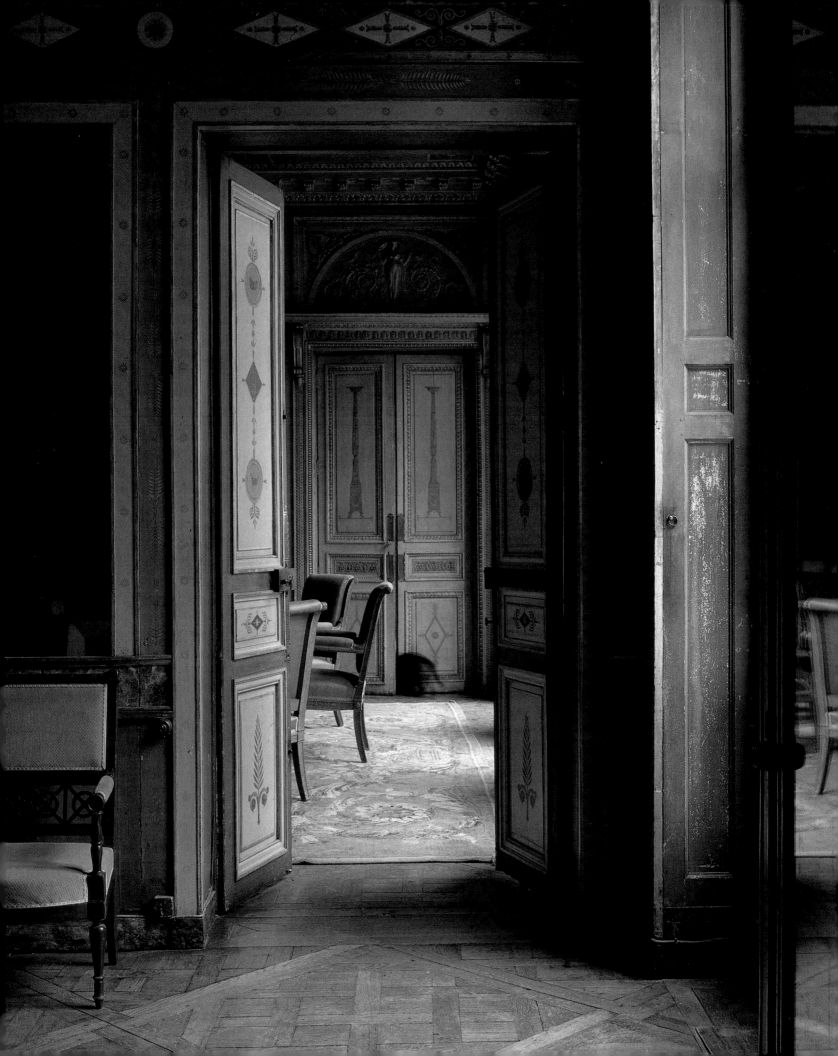

INSIDE

Discovering the Period Interiors of Paris

JOE FRIEDMAN

PHOTOGRAPHS BY JEROME DARBLAY

PHAIDON · OXFORD

PARIS

FOR MY MOTHER

WHOSE LOVE OF PARIS I HAVE INHERITED

Phaidon Press Limited, Musterlin House, Jordan Hill Road,
Oxford OX2 8DP

First published 1989

© Phaidon Press Limited 1989
Text © Joe Friedman 1989
Photographs © Jérôme Darblay 1989

A CIP record for this book is available from the British Library.

ISBN 0-7148-2603-0

All rights reserved. No part of this publication may be
reproduced, stored in a retrieval system or transmitted in
any form or by any means, electronic, mechanical, photocopying,
recording or otherwise, without the prior permission of
Phaidon Press.

Design by James Campus
Typeset by Tradespools Ltd, Frome, Somerset
Printed in Great Britain by
Ebenezer Baylis & Son Ltd, Worcester

page 1:
MUSÉE DES ARTS DÉCORATIFS
This striking bathroom is one of a suite of interiors designed by
Armand Rateau for the celebrated *couturière* Jeanne Lanvin in the
1920s. Dismantled in 1965, the suite was presented to the Musée des
Arts Décoratifs by Lanvin's son-in-law, the Prince de Polignac.

frontispiece:
HÔTEL DE BOURRIENNE
The neo-classical interiors of the Hôtel de Bourrienne are virtually
untouched since the turn of the nineteenth century and resemble ever
more closly the Pompeian ruins which inspired their decoration.
(see pages 50–51)

title page:
CARREFOUR BOUCHEZ
Carousing putti play ring-a-ring-a-wine-bottle on the ceiling over the bar
of the Carrefour Bouchez, an Art Nouveau brasserie built around 1900.
The artist is unknown, but the style is clearly inspired by the work
of Boucher and other French painters of the eighteenth century.

front jacket picture:
Magnificent bronze doors lead through to the austere neo-Classical
entrance hall of the Château de Bagatelle, a late eighteenth century
villa built by the architect François-Joseph Bélanger for the Comte
d'Artois, later Charles X.

endpapers:
Detail of the ceiling of La Pagode
(see page 43)

Contents

Introduction

When a publisher asks you to travel out to Paris to write a book on the city's most outstanding historic interiors you say yes; later you wake up in the middle of the night shouting no. Paradoxically the hard part is how easy it is, how easy to find suitable locations. The real difficulty is choosing.

Paris is a centre of fashion, and fashion means change, yet when it comes to architecture few cities have shown greater respect for the past. Statistics can be boring, so I will use just one: Paris has no fewer than 112 listed shops. This is an indication of how seriously the French take the question of architectural conservation, but it also shows how rich the capital is in historic buildings of every sort. When I explained to colleagues in Paris that I was writing a book on the city's period interiors they generally replied 'But which period? Which type of interior?' When I answered that I was looking for interiors of every type and period they shrugged their shoulders or laughed into their handkerchiefs, wishing me the best of luck but putting me down, no doubt, as an eccentric Englishman embarked on a hopeless and endless task.

Now, as then, I offer no apologies. *Inside Paris* is not an exhaustive survey of the city's historic interiors, still less an illustrated survey of French interior decoration. Like its forerunner, *Inside London*, it is the portrait of a city from a new and I hope unfamiliar angle. I have tried to be representative. I have made a careful choice. For every interior in this book I have visited four and probably five; but in the end this is a portrait like any other, partial, personal, selective.

The choice was made easier by the fact that I began with certain rules or criteria, the same by and large as those which guided me through *Inside London*, although sticking to them was another matter. In the first place I eliminated places of worship, Religious architecture is too weighty a subject to be treated lightly, and for reasons I understand only dimly myself, I felt uneasy about mixing the sacred with the profane. It is a pity to have missed out on Notre Dame and the Sainte Chapelle, not to mention the Paris mosque and the remarkable Art Nouveau synagogue in the Marais. But in another sense I am relieved, since it has left me with more space for other types of location. I have slipped up only twice, first in the case of the Neo-Romanesque crypt in the basement of the Pasteur Institute (page 66), and again in the case of the miniature Neo-Gothic chapel at the Palais Royal, built in the mid nineteenth century for Prince Napoleon and his bride Marie-Clotilde of Savoy (page 111). However, since the first is more a monument to science than to God, and the second serves today as a broom cupboard, I can perhaps be forgiven.

So many books have been published on Paris that the only excuse for another is that it offers something new. I have tried therefore to illustrate interiors which are little known. Some are published here for the very first time. But if I had limited myself only to the obscure and the unpublished the reader would have missed out on some of the most outstanding interiors in Paris. I could hardly have included a section on banks and offices and left out the sumptuous Galerie Dorée at the Banque de France (page 89), and in a section on government and civic buildings it would have been perverse to omit the Hôtel de Ville (page 113). Sometimes I have taken a familiar location and illustrated an unfamiliar prospect or angle. At the Elysée Palace, for instance, I foresook the splendours of the principal reception rooms, and chose instead to photograph two interiors not usually shown to guests, the former bathroom of the

Empress Eugénie and an intimate silver-gilt boudoir designed for Napoleon's sister, Caroline Murat (page 114). At the Paris Opera I decided to illustrate the famous foyer not from the entrance or the galleries but from the foot of the staircase leading down to the basement, a part of the building rarely visited by the public. One of the in-house firemen described it as his favourite vantage point. I had to agree.

Inside Paris is designed to be useful as well as entertaining, not just a picture book but a guide. I have set out to include as many locations as possible which are open to the public; which explains why I have devoted as much space as I have to restaurants and cafés, theatres and cinemas, shops and museums. Some locations are strictly out of bounds of course, especially private houses, but it is surprising how even the most forbidding doors occasionally give way, even if it is on only one or two days in the year. It is a matter of being in the right place at the right time. Opening times, transport facilities, and other details can be found in the gazetteer at the back of the book.

I made it a point not to fall prey to snobbish ideas about what is, and what is not, deserving of serious attention in architecture. We already have a gross imbalance in our architectural heritage, a great many historic churches, palaces, and country houses, but only the tiniest number of shops, offices, restaurants and cafés. Anyone would think we were descended from a society of priests and patricians, rather than ordinary people who shopped, went to work, dined out and stood one another drinks. In the opening line of his introduction to *An Outline of European Architecture* the late Professor Pevsner makes the memorable remark 'A bicycle shed is a building; Lincoln Cathedral is a piece of architecture'. No one could argue with the second statement, but it is surely as futile to try to separate building from architecture as it is to divide body and mind or content and style. It is ironic also that Professor Pevsner, a champion of functionalism, should have dismissed a building type whose form is so

strictly governed by its function. *Inside Paris* contains no photographs of bicycle heds, but the range is fairly broad and I have tried to cover as many different types of interior as possible, modest as well as grand. A personal favourite is the public lavatory in the Place de La Madeleine, a shabby yet distinguished Art Nouveau interior dating from the turn of the century. It may not be Lincoln Cathedral, but it is architecture.

When we think of French interiors we tend to think of interiors of the Louis XV period, of elegant salons with white and gilt panelling and plasterwork. Why we should think this way is a mystery. In the first place Louis XV interiors were not always white and gold but very often bright blue or yellow. Secondly only a fraction of interiors in the Louis XV style are genuine, the vast majority dating from the second half of the nineteenth century when the Louis XV style was revived. And finally, as I hope this book will show, French interior decoration is remarkable not for its conformity to any one particular style but for its boundless variety.

The interiors I feature range in date from the third century A.D. to the mid 1950s, from the Gallo-Roman baths at the Hôtel de Cluny to the proto-psychedelic bar room at the Brasserie Pigalle. I could not have begun any earlier – the baths are the oldest surviving interior in Paris – but I did think long and hard about including the interiors of more recent buildings, the Pompidou Centre, for instance, and the pyramid at the Louvre. In the end I rejected the idea, not because I do not admire these buildings, but because this is a book of period interiors, interiors with the power to evoke the past, and however dated they may seem to future generations, the Pompidou Centre and the pyramid at the Louvre belong unequivocally to the present.

Ideally I would have liked to include interiors from every period so as to illustrate the development of French interior decoration from the earliest times; but history

was against me. This book is published at a time when the French are celebrating the French Revolution. However, for architectural historians there is little to celebrate. Whatever good the Revolution may have done in political terms, from the architectural point of view it was one of the most disastrous events in French history. It interrupted and in some cases ended the careers of several brilliant designers; it hampered construction at a time when French architecture was reaching a new high point of sophistication and experimentation; and it led to the destruction of countless historic interiors. Royal palaces and the houses of the nobility were generally left standing. They were useful to the Revolutionary government, which in any case could not afford to replace them. But the treasures they contained were generally confiscated and dispersed at public auction. To my knowledge, there is not a single pre-Revolutionary interior in Paris which retains its original contents. Those I have illustrated are either empty or decorated with furniture and ornaments added at a later date. The earliest interiors in Paris retaining most, if not all, of their original contents are those at the Hôtel de Beauharnais, to which I have devoted no fewer than four photographs. Interiors before *c*.1600 survive in only fragmentary form, and aside from the Gallo-Roman baths I have included only one, the staircase of the Tour de Jean sans Peur, a fortified tower built in the early fifteenth century, which rises to a dramatic vaulted ceiling carved in stone with radiating oak branches (page 91). My chief concern was authenticity, or completeness, and so inevitably I have ended up with a majority of interiors dating from the second half of the nineteenth century and after.

History was not the only obstacle. It is not everyone who relishes the idea of admitting to their home or place of work two perfect strangers, the first asking a lot of difficult and sometimes personal questions about the past, the second trailing

cameras, umbrellas, flash-lights, and yards of electric cable. Nor is it everyone's dream to have their private world exposed to public scrutiny.

In the red light district of Pigalle I came across an astonishing late nineteenth-century billiard hall, a cavernous top-lit interior with exuberant plasterwork and classical pilasters, the whole shrouded in cigarette smoke and tarred a dirty yellow. I strode across the room, trying hard to adopt a tough-looking swagger, but when I approached the manager and asked permission to photograph the interior he flatly refused, explaining to me in the most colourful language that he could live without the publicity. The last thing he wanted was for the billiard hall to come to the attention of the historic buildings authorities since it would then be declared a national monument and neither he nor his successors could put a nail in the wall without express permission from the Minister of Culture. The hammering motion he made convinced me that it was useless, and probably dangerous, to persist.

In a street off the Avenue des Ternes I came across a neo-Gothic apartment undisturbed since the late nineteenth century, complete with stencilled wall paper, carved oak furniture, and monumental stone chimney pieces surmounted by medieval figures. Again the answer was no; not because the owner was on the run from the historic buildings authorities, but because he was afraid that the apartment would become a target for film companies and that location scouts would be ringing his doorbell day and night.

Sometimes it was a question of security. Books of this sort are a favourite with burglars (honest people read them too), and it often happens that when a house or apartment is published it is instantly robbed. Another problem was availability. Historic interiors require constant maintenance, and several I had hoped to feature were under restoration and in no state to be photographed. At the Hôtel Lambert, for

instance, a seventeenth-century town house on the Ile Saint Louis, electricians were rewiring the magnificent Galerie d'Hercule, while at the former residence of the Duke and Duchess of Windsor, which I myself was helping to restore, there were not only electricians, but plasterers and painters, carpenters and plumbers, heating and telephone engineers, and a whole battalion of conservators, not to mention ladders, scaffolding, paint pots and building materials. The wonder is that we were able to photograph as many interiors as we did. This is due to the kindness and co-operation of literally hundreds of people, to whom I offer the most sincere and grateful thanks.

One of the main incentives for writing this book was curiosity. For me a facade is a question mark, and I do not feel I know a building until I have been inside. I had visited Paris many times before and was familiar with its principal architectural landmarks, but I had rarely got beyond the exterior and longed to explore behind the scenes. As my work progressed I felt that I was penetrating to the heart of the city, coming to a more intimate understanding of its architecture and character. It was thrilling, enlightening, sometimes astonishing. But the book has a more serious purpose.

One of the first addresses I visited in Paris was Maxim's, the legendary Belle Epoque restaurant in the rue Royale. The interior is listed and is reputed to be among the finest of its kind anywhere in the world. I do not mean to be unkind. I am sure the management had the best intentions, but the interior has been spoilt by poor restoration and vulgar redecoration and is now virtually indistinguishable from the kitsch Belle Epoque revival restaurants which have sprung up all over Paris in recent years. Another restaurant, Prunier, recently changed hands and is currently closed for refurbishment. The interior dates from 1925 and is an outstanding example of the Modern Style, with black marble walls inlaid in onyx and gilt, a geometric mosaic floor, and a sweeping counter in carved and gilded wood. I could not get access and so am

unable to comment on the refurbishment programme, but for their own sake, as well as the restaurant's, I hope the management have done nothing to spoil this rare masterpiece of 1920s design. The interior is protected by law and so in theory nothing can be altered or removed.

Shops too are in danger. The traditional boulangerie, which we all take for granted, is fast becoming extinct. I visited more than fifty, many of them listed. The street fronts were generally well preserved, retaining their original painted signs, but virtually every interior had been spoilt by inappropriate modern fittings and garish merchandising. I could find only one that was still intact, the Boulangerie Azrak, a bakery built around 1910, which has somehow held on to its original counters and bread-racks, as well as a painted ceiling and marble-panelled walls.

When it came to hotels it was like Sodom and Gomorrah; impossible to find ten good representatives. In the nineteenth century Paris became an important centre of international tourism and trade. Magnificent hotels were built to cope with the influx of foreign visitors, hotels designed to reinforce the idea of French supremacy in architecture and the decorative arts. Many are still standing, but there are few surviving interiors. Most have succumbed to that insidious wasting disease, international hotel syndrome, the symptoms of which are acres of fitted carpet (usually on a trellis pattern and with a pile so deep you could lose your doorkey in it), pastel-coloured paintwork and fabrics, and the ostentatious use of marble, gilding, mirrors, and trimmings, the whole governed by a total disregard for scale and proportion. At one hotel I visited a listed nineteenth-century interior had been painted tangerine orange and electric blue. The ceiling and walls of another had been decorated with giant panels of smoked and speckled glass.

An exciting discovery was the Salle Joffre, an evocative late nineteenth-century

classroom at the Lycée Charlemagne which takes its name from the French war hero, the Maréchal Joffre, who attended lessons here as a boy. The interior is virtually undisturbed, a unique example of its kind, but it is unprotected, and by the time this book is published it will almost certainly have been demolished to make way for a fire exit.

The laws governing historic buildings are multiplying and becoming more stringent. The number of listed buildings is increasing, and in recent years there has been a movement to protect a broader range of buildings. We have not yet reached the stage we have reached in painting, where contemporary works go straight into the museum, but we are at last getting round to listing the masterpieces of the 1950s and '60s. The sad thing is that in many cases it is already too late, and that listing a building seems to be no guarantee against the vandalism which so often passes for restoration. As I have argued elsewhere, interiors are especially vulnerable since they are generally invisible from the street and so are difficult to monitor. They are made up of sensitive materials which in the wrong conditions can quickly perish, and the consensus seems to be that they are somehow less important than facades. In Paris, as in London, the number of unspoilt historic interiors is dwindling, especially in the commercial sector. In the process the city is losing a vital part of its architectural heritage. I have written this book partly because I believe it may help to stem the tide. Some of the interiors I feature are not yet listed and will I hope receive immediate protection. As for the rest, we must be vigilant.

Finally, and on a gentler note, I should like to end with a special word of thanks to my partner in this venture, Jérôme Darblay, whose keen eye, high spirits, and absolute commitment were a constant inspiration, and whose photographs are simply outstanding, the book's main strength.

CHRONOLOGY

In the course of this book reference is made to various periods in
French history, a long and sometimes bewildering succession of reigns,
empires, and republics interspersed with revolutions and *coups d'état*.
The following chronology may help to situate these various periods and
interstices. Since only two of the interiors in the book predate the
seventeenth century the chronology begins with the reign of Henri IV.

Reign of Henri IV	1589–1610
Reign of Louis XIII	1610–1643
Reign of Louis XIV	1643–1715
Reign of Louis XV	1715–1774
incorporating Régence (minority of Louis XV)	1715–1723
Reign of Louis XVI	1774–1792
French Revolution	1789–1799
First Republic	1792–1804
Directoire	1795–1799
Consulate	1799–1804
First Empire	1804–1814
First Bourbon Restoration	May 1814–March 1815
Hundred days/Restoration of First Empire	March–June 1815
Second Bourbon Restoration	July 1815–July 1830
Reign of Louis XVIII	1814–1815 & 1815–1824
Reign of Charles X	1824–1830
Revolution ending Bourbon Restoration	July 1830
Reign of Louis-Philippe Iᵉʳ, duc d'Orléans	July 1830–February 1848
Revolution ending reign of Louis-Philippe	February 1848
Second Republic	1848–1852
Second Empire	1852–1870
Third Republic	1870–1940
Paris Commune	March–May 1871
Fourth Republic	1944–1958
Fifth Republic	1958 to present day

SELECT BIBLIOGRAPHY

ACCOLTI GIL, Biagio, *Paris Vestibules de l'Eclectisme*, Paris, 1982

CHRIST, Yvan (ed.), *Le Faubourg Saint Germain*, Paris, 1987

Champs-Elysées, Faubourg Saint Honoré, Paris, 1982

CONTET-VACQUIER, *Les Vieux Hôtels de Paris*, Paris, 1921

Du Faubourg Saint Antoine au Bois de Vincennes, cat. of exhibition at
Musée Carnavalet, Paris, 1983

ETIENNE, Pascal (ed.), *Le Faubourg Poissonnière*, Paris, 1986

FREGNAC, Claude, & ANDREWS, Wayne, *The Great Houses of
Paris*, London, 1979

GOMEZ Y CACERES, Georges & DE PIERREDON, Marie-Ange,
Les Décors de Boutiqués parisiennes, Paris

HILLAIRET, Jacques, *Dictionnaire Historique des Rues de Paris*, 2
vols, 7th ed., Paris, 1963

Ile Saint Louis, cat. of exhibition at Musée Carnavalet, Paris, 1980

La Nouvelles Athènes, cat. of exhibition at Musée Renan-Scheffer,
Paris, 1983

La rue de Lille/Hôtel de Salm, cat. of exhibition at Institut
Néerlandais, Paris, 1983

La rue Saint Dominique, cat. of exhibition at Musée Rodin, 1984

La rue de Varenne, cat. of exhibition at Musée Rodin, Paris, 1981

LEMOINE, Bertrand, *Les Passages Couverts*, Paris, 1989

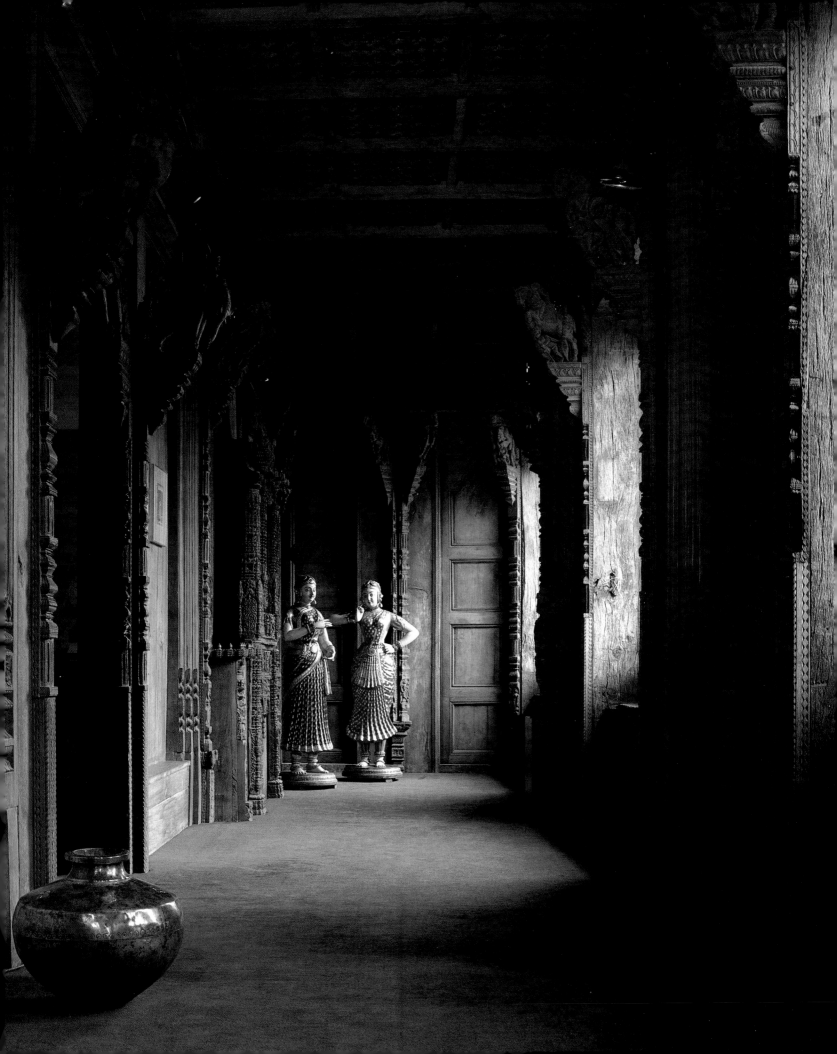

Shops

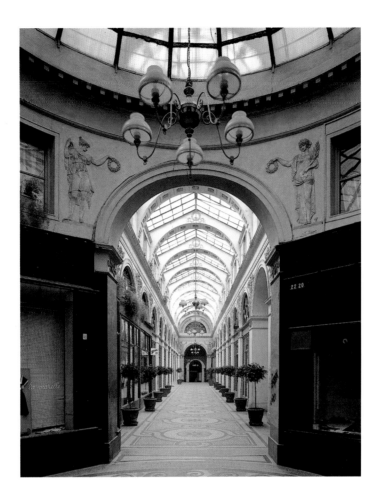

C. T. LOO & CIE

WHAT was once a conventional Second Empire town house with demure rococo revival interiors is today a four-storey art gallery in the form of a bright red pagoda with interiors decorated in the oriental and Indian styles. The gallery takes its name from its founder, Ching Tsai Loo, who arrived in Paris from China in 1900, quickly building up a flourishing business which is still in family ownership. The pagoda was erected in the late 1920s and must have raised a few eyebrows in what has always been a highly conservative and prosperous middle-class neighbourhood. The Indian Gallery is decorated with ninteenth-century panelling salvaged from a Hindu temple.

GALERIE VIVIENNE

THE Galerie Vivienne (*above*) has been described as the queen of Parisian shopping arcades. Built in 1823, it is an outstanding example of neo-classical design in the years following the First Empire. The arcade was designed by Delannoy, architect of the Théâtre du Conservatoire (page 45), but the project was conceived and financed by a local notary and entrepreneur, Marchoux. Particularly striking are the allegorical female figures in the Rotunda symbolizing Plenty and the anchors and cornucopia representing prosperity through overseas trade.

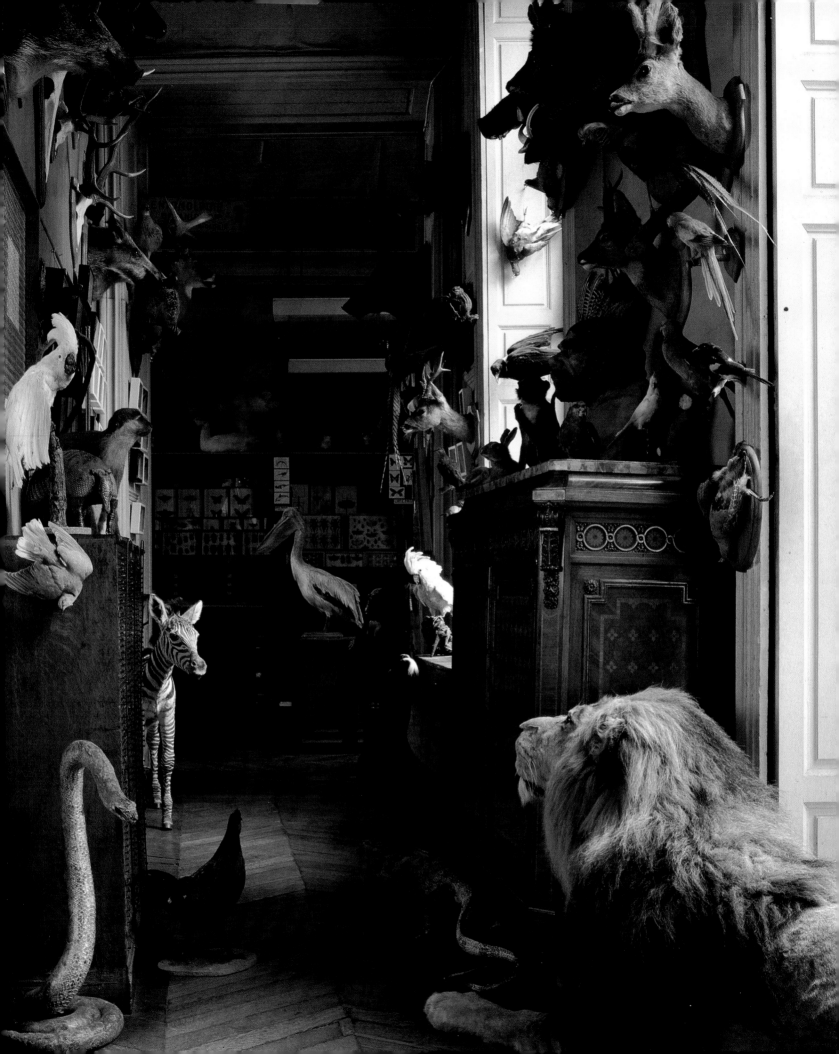

DEYROLLE

\mathcal{D}EYROLLE takes its name from its founder, taxidermist Emile Deyrolle, who started up in business in 1831. Since 1850 or so the shop has occupied the ground and first floors of a once-magnificent town house built in the 1740s by architect Germain Boffrand for Jacques-Samuel Bernard, financier, art collector, and treasurer of the Queen's Household. Vestiges of original eighteenth-century panelling provide the background to an extraordinary display of stuffed animals and insects. One wonders what the original owner would have made of it.

STERN

\mathcal{F}OUNDED in the first half of the nineteenth century by a medal-engraver from Alsace, Stern was at one time the largest printing and stationery concern in France, supplying headed paper, visiting cards, stock certificates, and even banknotes to an international clientele which included several heads of state, among them Napoleon III and the Emperor Maximilian of Mexico. Since 1840 the business has occupied a prominent position in the Passage des Panoramas, a once affluent shopping arcade built around 1800, now sadly come down in the world. The interior (*above*) is one of the sights of Paris, an eclectic yet coherent antiquarian confection designed to evoke the late Middle Ages and the early Renaissance. The walls are faced with stout paper stamped and painted to imitate Spanish leather hangings. The panelling and woodwork are made up of genuine and not-so-genuine antique fragments. The interior is thought to date from the second half of the ninteenth century and may well be contemporary with the comparable Hôtel de Gaillard (page 86).

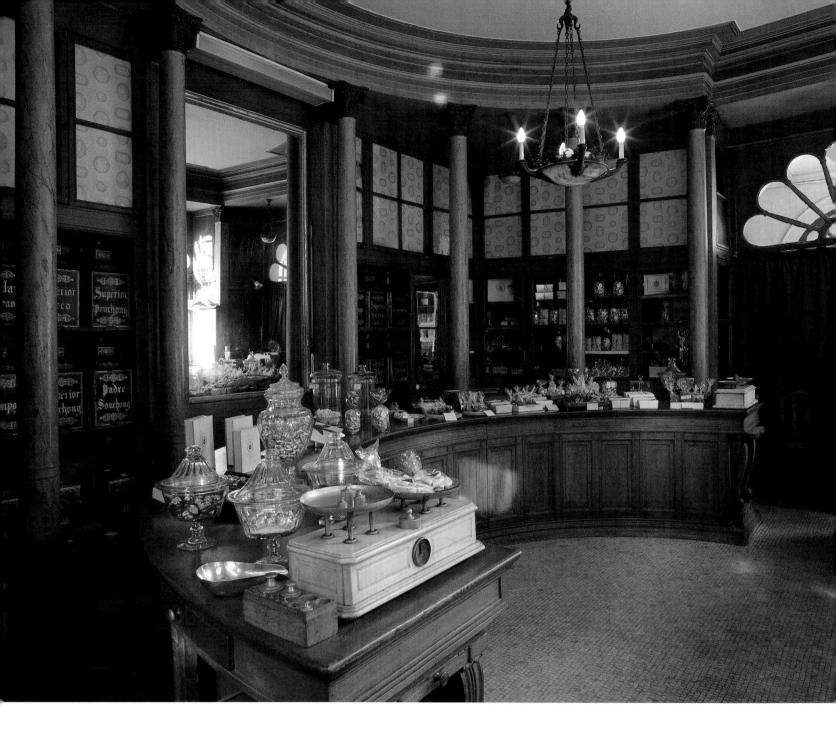

DEBAUVE ET GALLAIS

\mathscr{C}OMPLETED around 1819, the interior of Debauve et Gallais dates back to the reign of Louis XVIII. The style, however, is typically Napoleonic, which probably explains why the shop has often been attributed to Percier and Fontaine, the emperor's official architects. A crescent-shaped counter in carved oak is ringed by a screen of eight Corinthian colonnettes. The shafts are painted in imitation of marble, while the capitals are ornamented with the classical symbol of medicine, the caduceus, a reminder that the shop was not originally a simple *chocolatier*, but a pharmacy specializing in medicinal chocolates said to cure chest pains and muscular spasms.

BACCARAT

\mathscr{T}HE Directoire dining room on the right is not strictly speaking a dining room; nor does it date from the Directoire. It is in fact a shop or showroom built by the famous crystal manufacturers Baccarat towards the end of the Second Empire. The idea was to show potential customers the effect of Baccarat crystal in the context of a fully-integrated period interior. The dining room forms part of a suite of interiors, each decorated in a different style to evoke a particular period. Visible through the open doorway is the Louis XV salon, which leads in turn to a Régence boudoir and a Louis XVI anteroom.

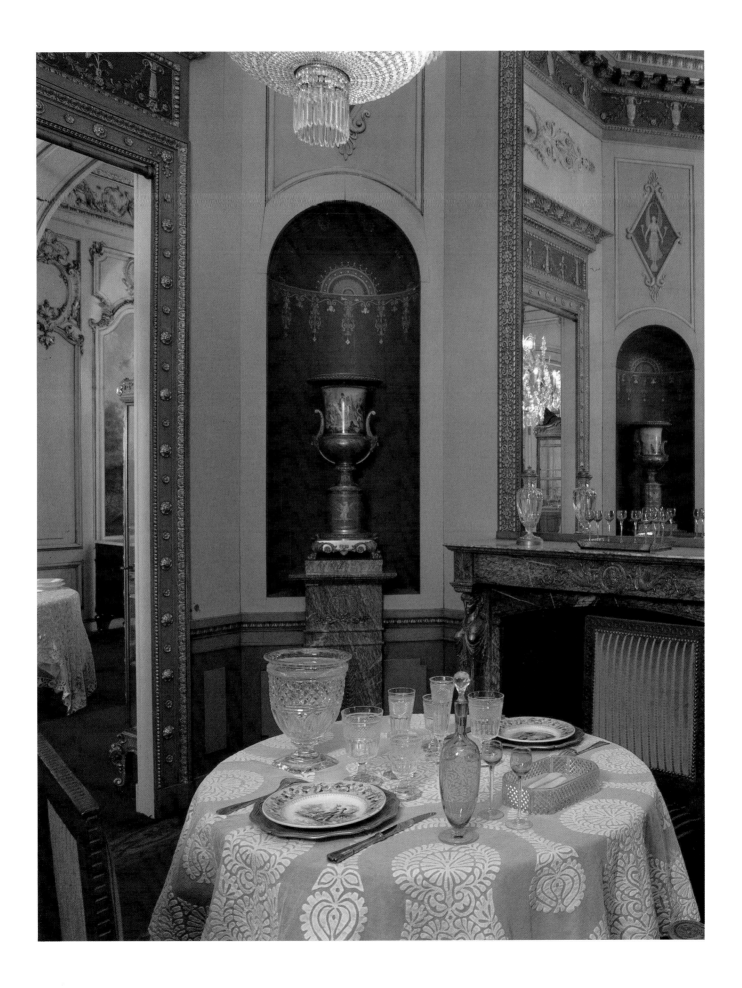

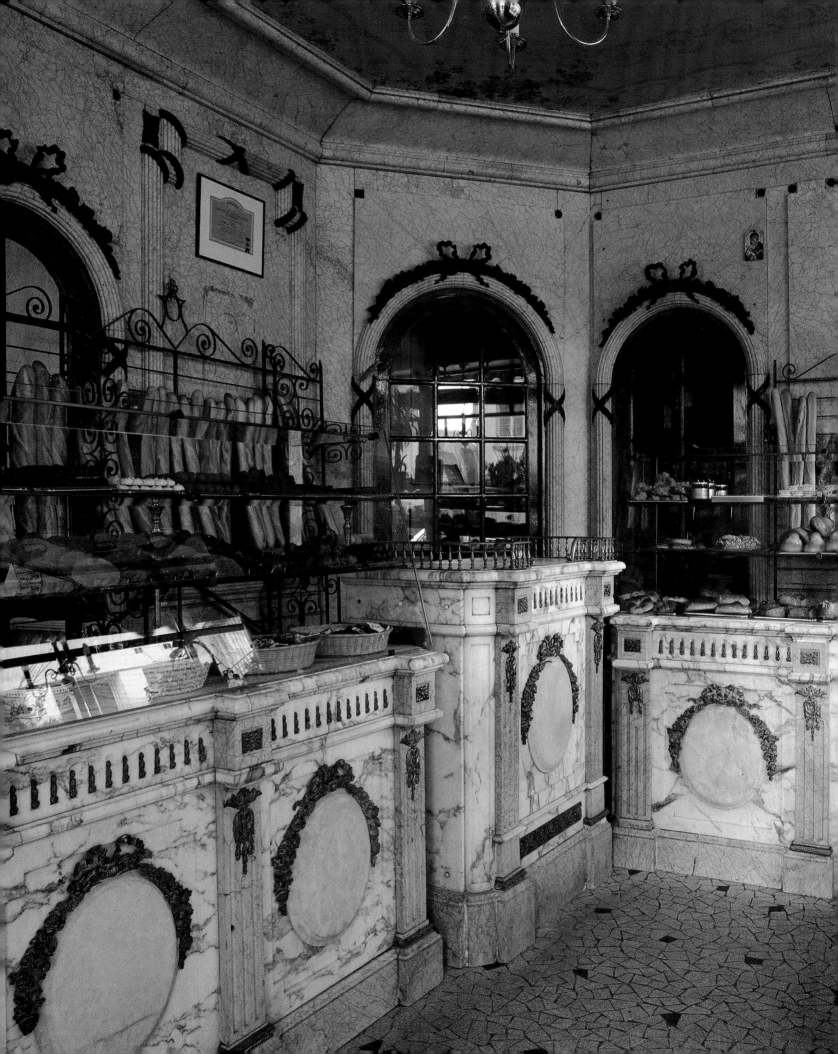

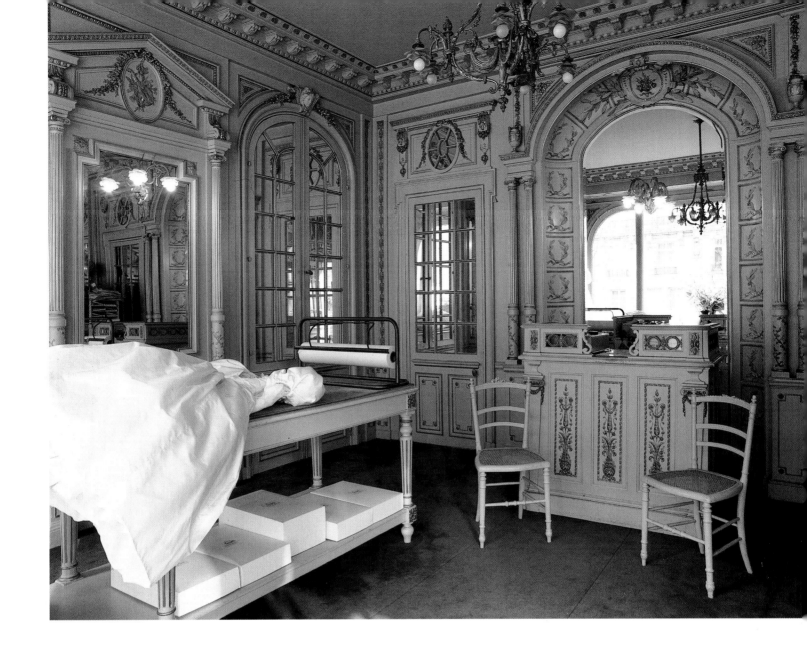

BOULANGERIE AZRAK

*T*HE traditional French boulangerie is decorated with painted panels representing windmills, sheaves of grain, and allegories of farming and baking. The Boulangerie Azrak breaks completely with this tradition. Built around 1910, it is a rare and early example of a bakery fitted out in the Louis XVI style. Particularly impressive are the counters and walls, panelled in marble and enriched with bronze ornaments representing garlands and ribbons.

TEINTURERIE HUGUET

*T*HERE is only one place to take your laundry and dry-cleaning in Paris and that is the Teinturerie Huguet. Originally known as the Grande Teinturerie de Chaillot, the business was founded around the middle of the nineteenth century by a certain Lallemand. The interior is of eighteenth-century inspiration, with elegant pale grey and gilt panelling and matching furniture and light fittings.

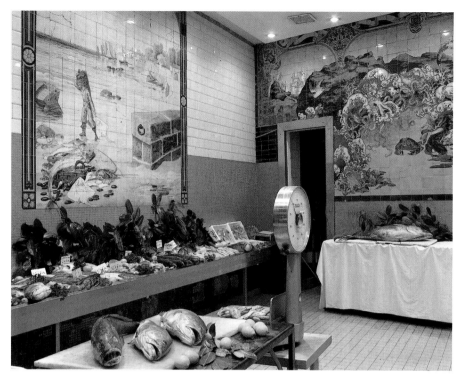

AUX CINQ POISSONS

THE owner will tell you that this is 'the oldest fishmonger's in Paris, France, the world!' Certainly it is one of the most spectacular. The interior dates from the late nineteenth century and is fitted out with glazed ceramic tiles from the celebrated Sarreguemines studio. The panel on the left represents a coastline in Brittany patrolled by a fisherman whose catch is proudly displayed on the shore. The rear panel illustrates a bewildering variety of fish, seafood, and marine vegetation, set against a seascape with rocks, sailing ships, and a medieval castle. The style shows the influence of Japanese prints, and more particularly the work of Hokusai, from whom many French artists drew inspiraton at this time.

A LA MÈRE DE FAMILLE

THIS traditional French delicatessen is said to have been founded in 1761 and was renowned at one time for a miraculous eye lotion, the secret of which was learned from a nun sheltered here during the Revolution after the dissolution of her convent. The interior dates from around 1900 and retains many original features, including wooden display stands with enamel labels, a fortress-like cash kiosk, and a richly-patterned tiled floor carrying the name of the shop.

ROBERT MONTAGUT

THE interior of Robert Montagut's pharmaceutical antique shop is something of a paradox (*right*). On the one hand it is by far the oldest shop interior in Paris, with elements dating back to the reign of Louis XIII. On the other it is not strictly speaking Parisian and has stood on its present site for barely two years. The explanation is simple. The shop is a reconstruction of an early seventeenth-century apothecary's in Avignon, purchased by Monsieur Montagut in 1987, transported to Paris and lovingly reassembled.

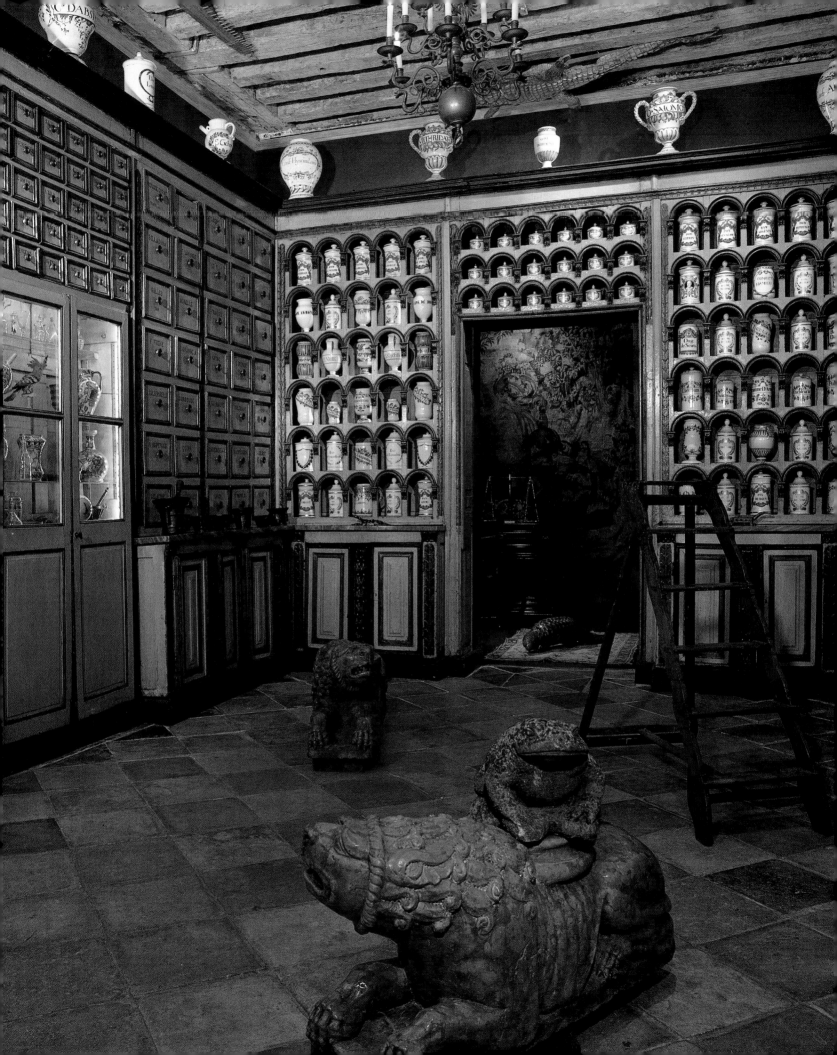

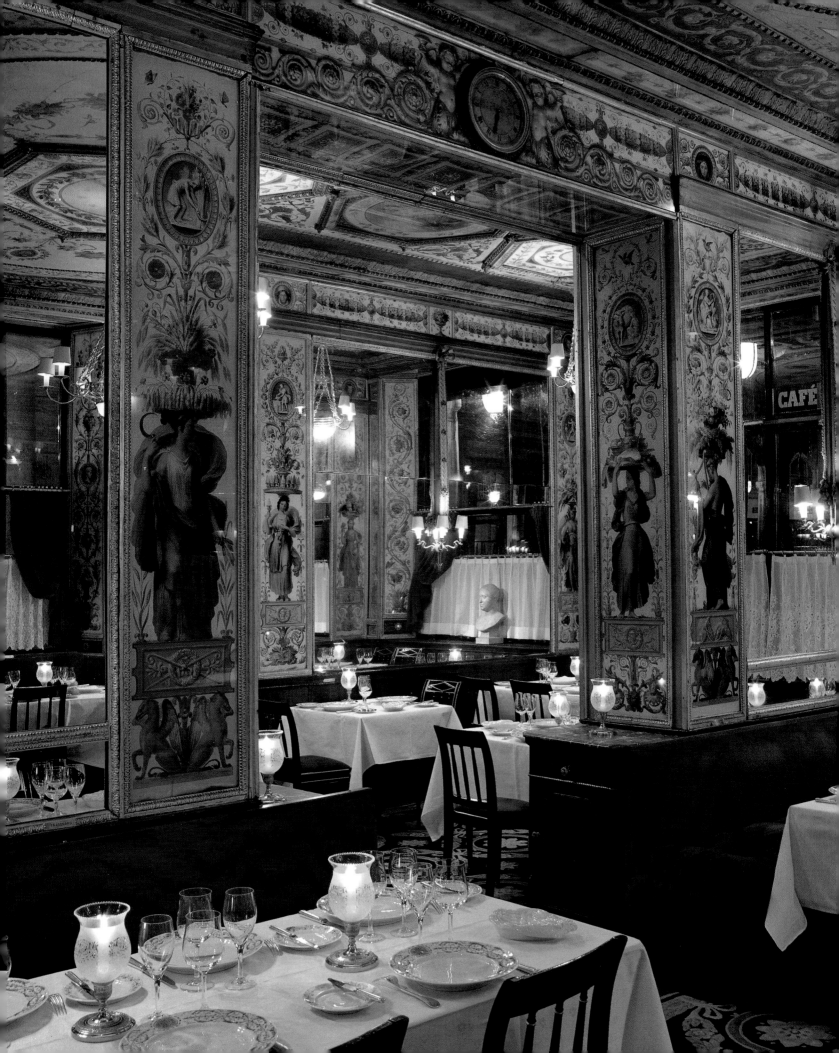

Restaurants and Cafés

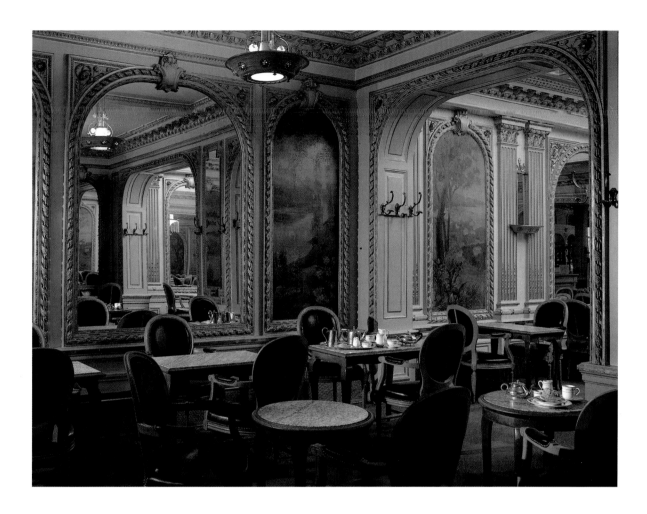

LE GRAND VÉFOUR

THE Grand Véfour is the oldest surviving restaurant in Paris still on its original site, occupying a key position in the Palais Royal, a complex of cafés, shops , theatres, and apartments laid out by the duc de Chartres and the architect Victor Louis in 1781–84. The restaurant was originally known as the Café de Chartres, in deference to the landlord, and the name still appears over the original entrance. In the years leading up to the French Revolution the restaurant became a centre of political intrigue and it has continued to attract politicians ever since, as well as artists and intellectuals such as Victor Hugo, Colette, and Sartre. The interior is decorated in the 'grotesque' style, a style originally inspired by the excavated murals of ancient Rome, with allegorical panels representing Plenty in the form of fruit, fish, game, and other delicacies. Certain elements are thought to date from the late eighteenth century, but it is likely that most were produced around 1820–50.

ANGELINA

ANGELINA was founded in 1903 by a naturalized Austrian pastry chef, Antoine Rumpelmayer, who had already established a successful chain of tea-shops in the South of France. The Provençal connection is recalled in a series of sunny Mediterranean landscapes by the painter Lorant Heilbronn. The Art Deco lanterns date from the mid-1930s, but otherwise the interior is little changed since the turn of the century. Former customers included Marcel Proust, Coco Chanel, and King George V. The hot chocolate is second to none.

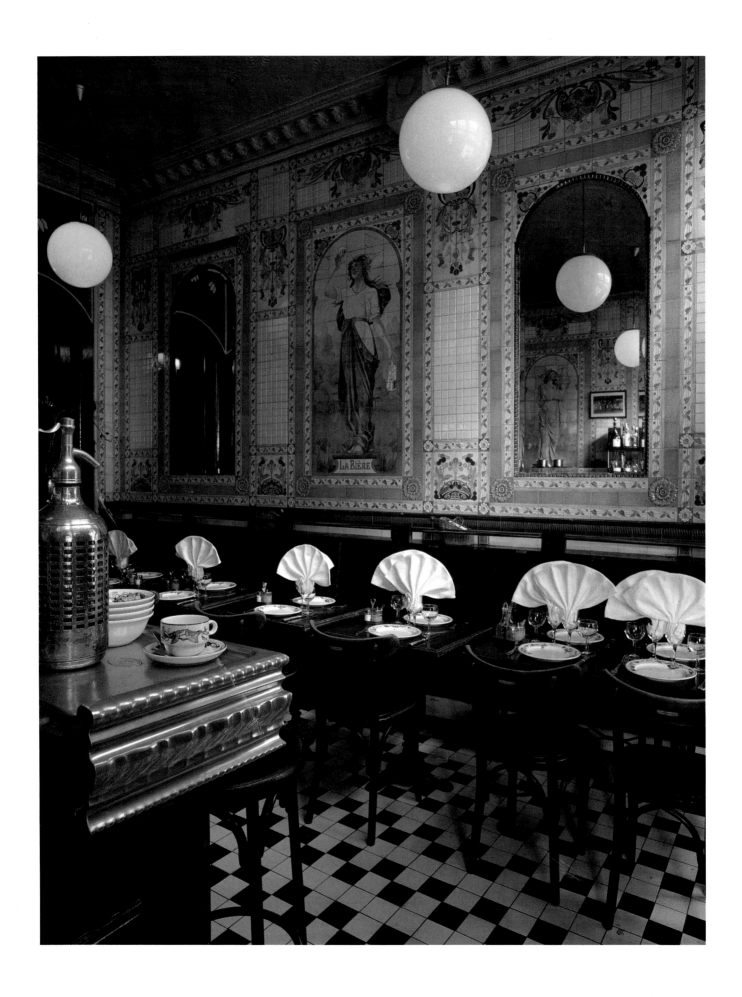

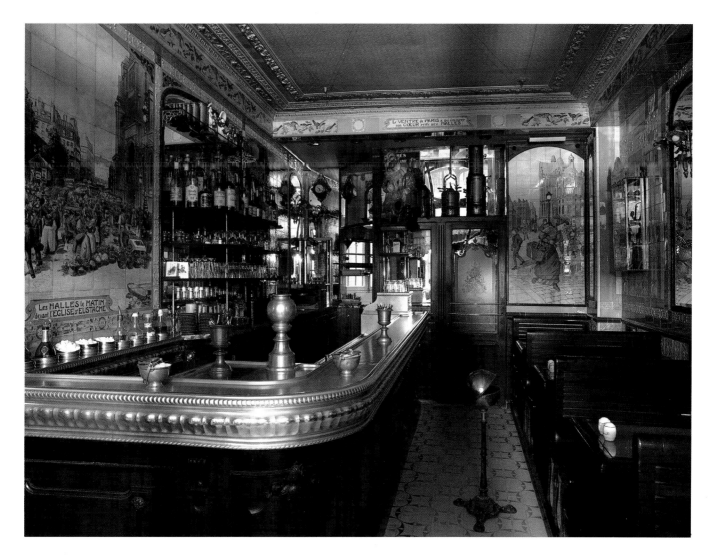

LA POTÉE DES HALLES

*S*ITUATED, as its name suggests, in the former market area of Les Halles, this turn-of-the-century bistro (*left*) retains its original ceramic decoration by the Sarreguemines studio. The walls above the tables and bar are ornamented with allegories of beer and coffee, represented by commanding female figures enjoining customers to drink up and reorder.

LE COCHON À L'OREILLE

*S*ET IN the heart of Les Halles, the old market district, the Cochon à l'Oreille (*above*) is far and away the most complete example of a late nineteenth-century café in Paris. The walls are decorated with glazed ceramic panels from the Sarreguemines studio, representing scenes from the life of Les Halles, and indeed the café still keeps market hours, opening at 4 am and closing at 3 pm. The fitted benches are an original feature, as are the tiled floor, the engraved glass panel to the rear, and the magnificent hand-beaten counter.

LE TRAIN BLEU

*T*HE Train Bleu (*overleaf*) is the grandest station restaurant in Paris, occupying a vast suite of rooms on the first floor of the Gare de Lyon, built around the turn of the century by the architect Denis Toudoire. One contemporary critic likened the interior to that of a casino; but opulence was what the client wanted. The client was the P.L.M. private railway company, whose trains ran from Paris (P) to Lyon (L) to the Mediterranean (M). Set into the walls and ceiling are panels by renowned Salon painters of the day representing the principal towns and regions served by P.L.M. trains, including Savoy, Nice, Grenoble, and even Algeria. Powerful iron supports underpin the colossal depressed arches which span the entire width of the main dining room, otherwise decorated with plaster figures by Lefèvre and furniture by Danon & Colin.

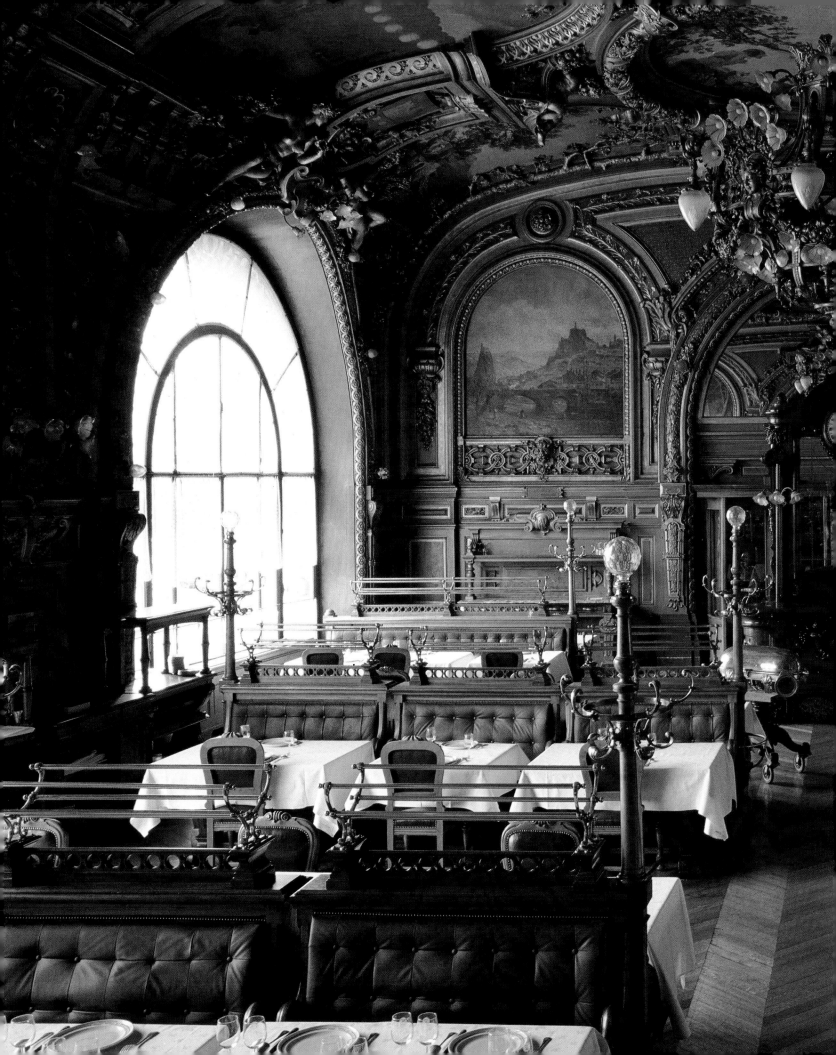

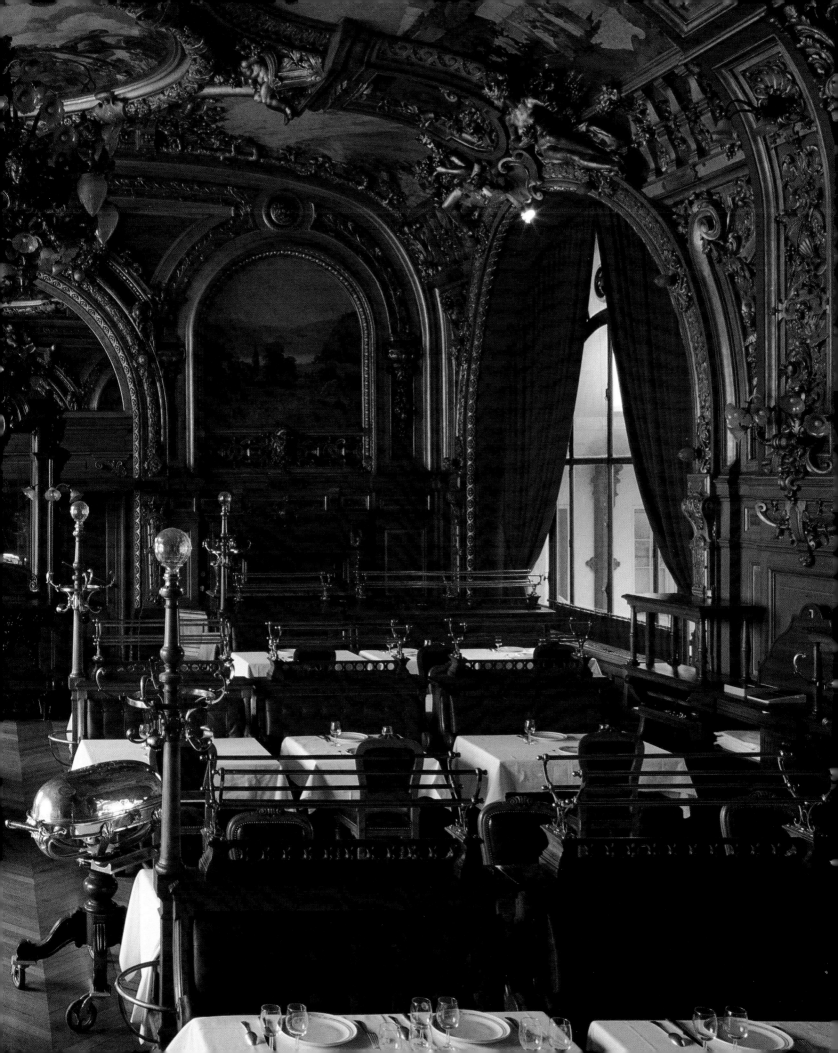

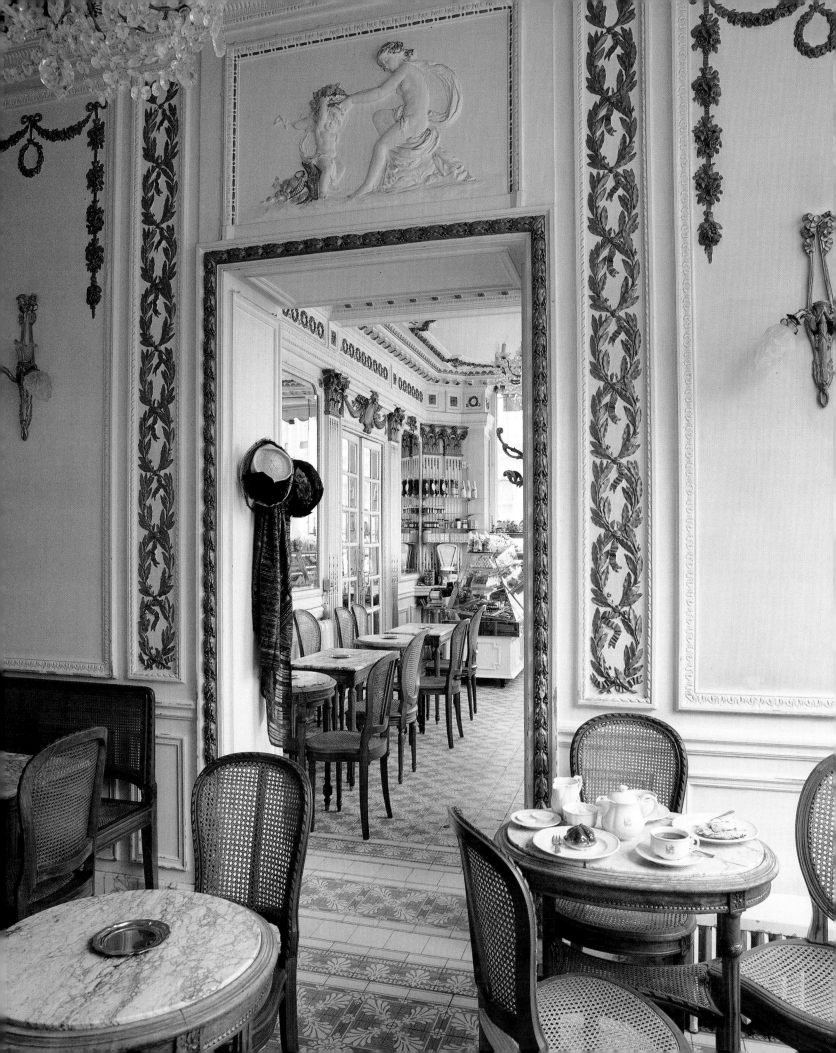

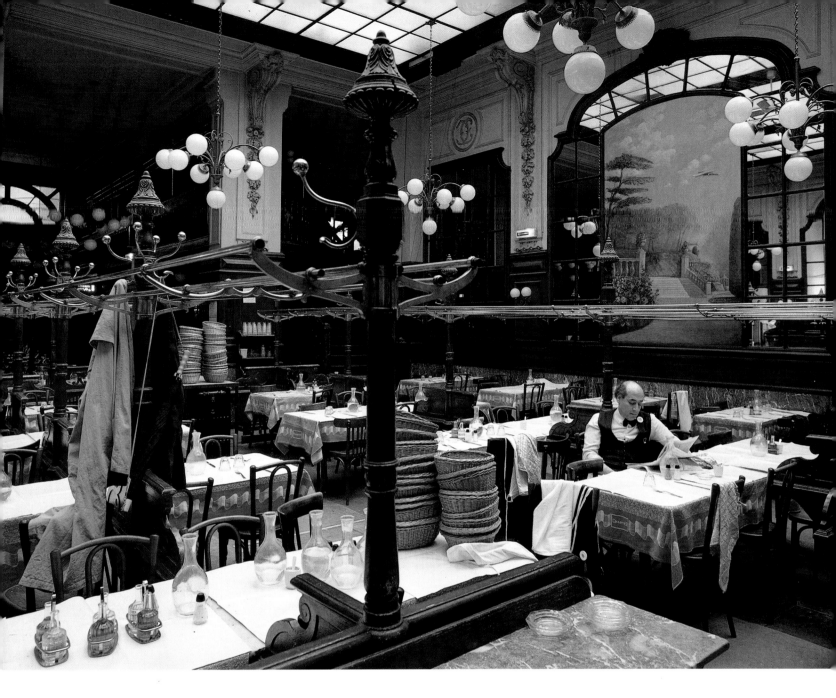

CADOR

*C*ADOR is a charming Louis XVI-style tea shop with a fine view of the east front of the Louvre. The interior is thought to date from the 1880s and is decorated with white and gilt panelling enriched with pilasters, garlands, and an allegorical relief of Love, represented by Venus and Cupid. The tea-shop also retains its original green and white tiled floor ornamented with palmettes, a motif originating in classical Greece.

CHARTIER

*C*HARTIER is fast food French style, a hangar-like, split-level eatery dating from the late 1890s, long before the American hamburger boom. The restaurant was founded by the brothers Chartier, Edouard and Camille, who in the last years of the nineteenth century and the early part of the twentieth built up a large chain of rapid-service bistros which at one time included the Vagenende (page 35). The family monogram, a pair of interlaced C's, appears in the plaster decoration over the mirrors.

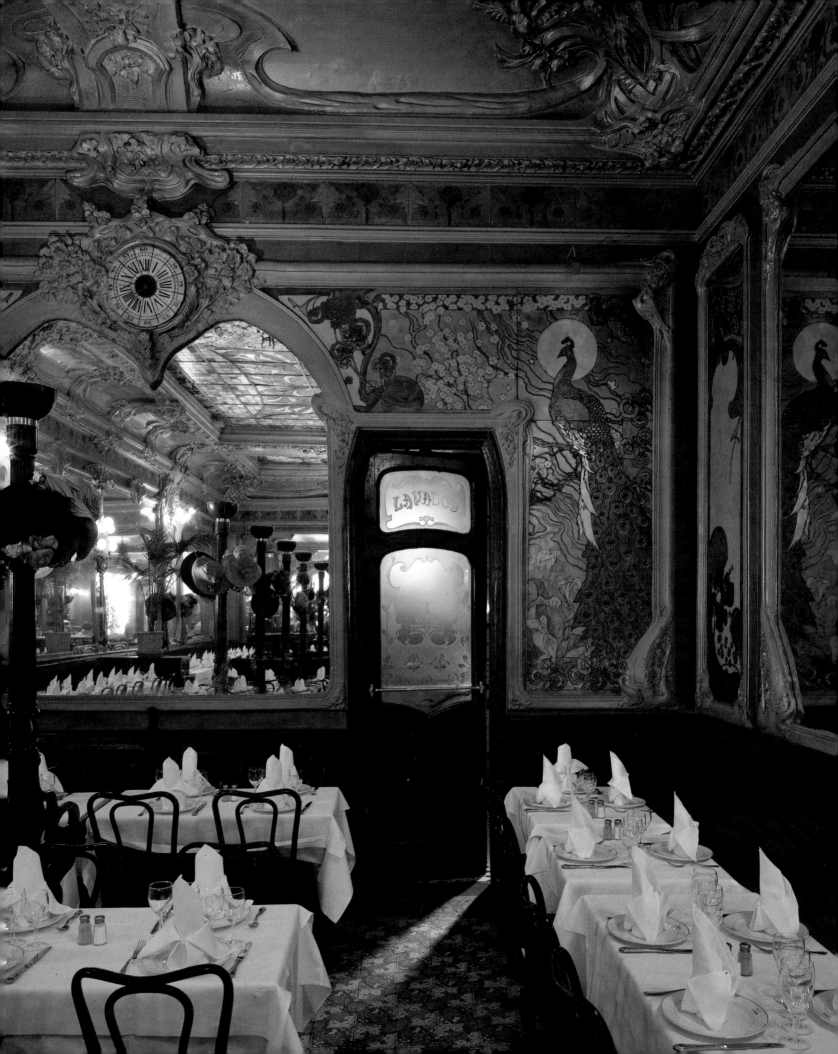

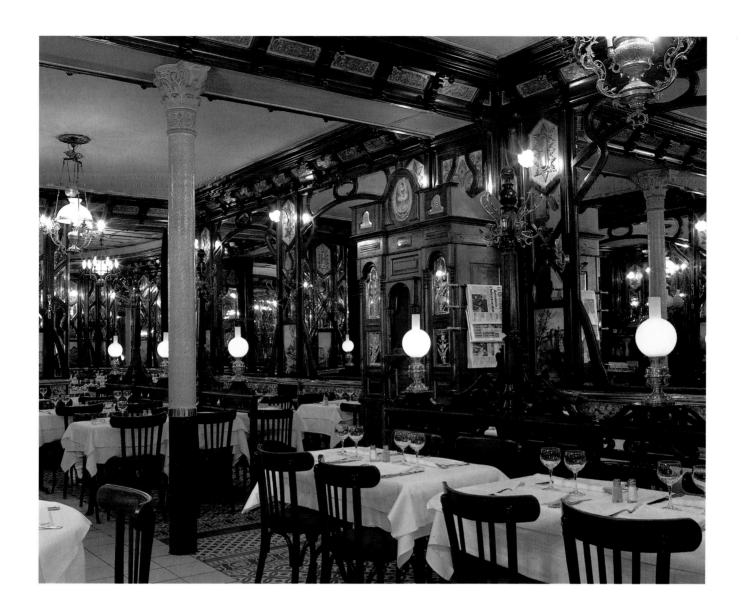

JULIEN

*T*HIS jewel-like brasserie was built to coincide with the great Paris Fair of 1889, and the interior captures perfectly the epicurean spirit of the Belle Epoque. The ceilings and walls are decorated with exuberant plasterwork representing clusters of fruit and vegetables, interspersed with vibrant glazed ceramic tiles. A peacock appears in a blossoming tree, silhouetted against the moon, alongside a door with engraved glass panels giving access to the *lavabos* or wash-rooms. Visible in the mirror are a magnificent stained-glass skylight and a display of antique hats collected by the present owner.

LE VAGENENDE

*B*UILT around 1902 by the Chartier brothers, the Vagenende is a spectacular Art Nouveau brasserie overlooking the Boulevard Saint Germain. The name is a curious one, pronounced by the Parisians in a variety of ways, and is thought by some to be Alsatian dialect for 'journey's end'. In fact the brasserie takes its name from the restaurateur who purchased it in 1920, before which time it was known as the Bouillon Chartier. Typical of the period is the *nouille* or noodle-style woodwork covering the mirrors like so much vermicelli, and the glazed ceramic panels, some of which represent miniature landscapes by the painter Pivain.

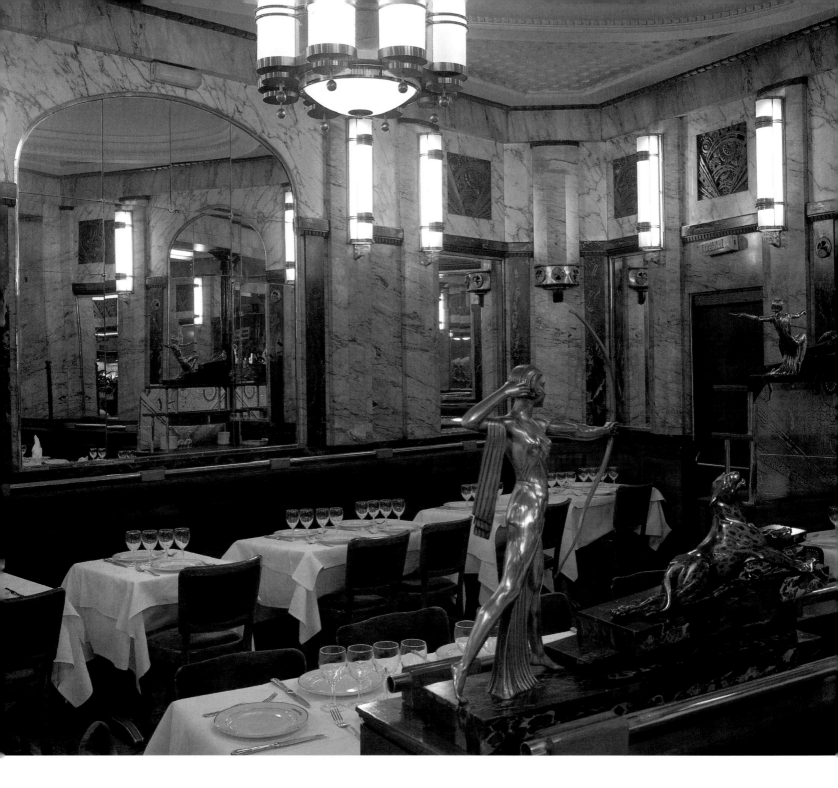

LE VAUDEVILLE

*S*ITUATED opposite the Paris stock exchange, the Vaudeville is a resplendent Art Deco brasserie retaining almost all its original features. The walls are panelled in several varieties of marble, with bronze reliefs and futuristic light fittings. A geometric tiled floor and 1920s figurines complete the picture.

LE PIGALLE

*R*ECENTLY listed (grade II), this proto-psychedelic brasserie was built around 1954 by the architect Gridaine and occupies a key position in the life and geography of Paris's red light district. The walls of the restaurant are decorated with disturbing surrealist murals by the painter Lecoq, while those of the bar (*right*) are faced with vertical black bands studded with multi-coloured kidney-shaped ornaments in padded plastic. Not for the weak of heart.

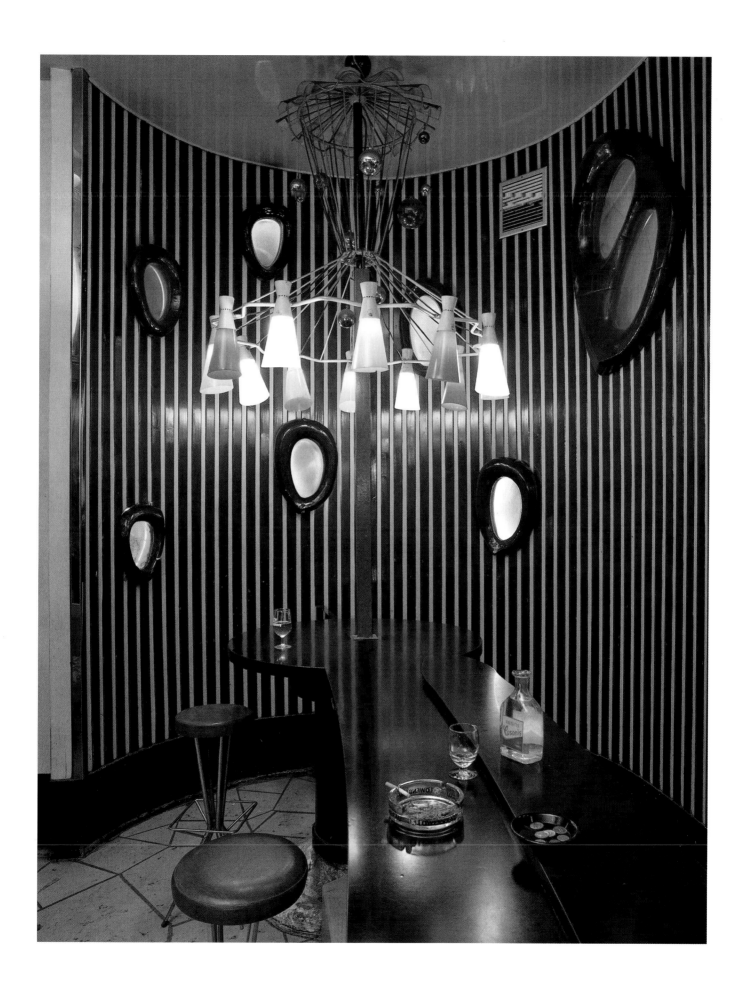

Hotels

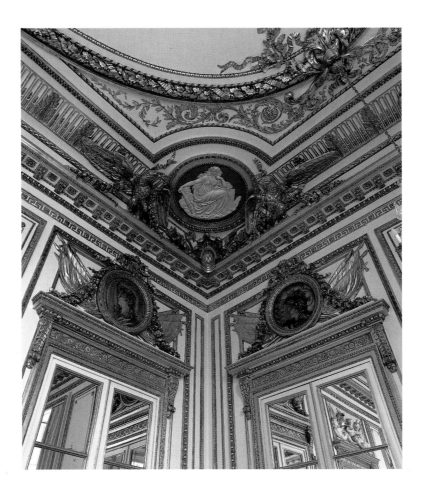

HÔTEL CRILLON

*S*ITUATED in the Place de La Concorde, with views across the Seine to the National Assembly and the Eiffel Tower, the Crillon is perhaps the best-placed hotel in Paris. The building was originally a private house erected in the 1770s and first occupied by the duc d'Aumont, *directeur des menus-plaisirs*, or '*master of revels*', at the court of Louis XVI. In 1788 the house was acquired by the comte de Crillon, whose heirs sold it in 1907 for development as a hotel. The interior has been extensively remodelled, but the Salon des Aigles (*above*) retains the greater part of its original Louis XVI decoration, attributed to the architect Pierre-Adrien Pâris. The doors are surmounted by garlanded portraits of classical heroes and *putti* supporting military trophies. Above the cornice, in each of the four corners, are the gilded eagles from which the room derives its name, together with allegorical medallions representing the virtues of truth, strength, wisdom, and prosperity.

GRAND HOTEL

*T*HE Grand Hotel was built in 1861–62 in anticipation of the Paris Fair of 1867, which brought thousands of visitors to the capital. The hotel originally boasted the then extravagant total of fifteen bathrooms and a towering ball room, inaugurated by the Empress Eugénie. The ball room is sometimes attributed to Charles Garnier, architect of the Paris Opera (page 40), but was designed in fact by a team of artist-craftsmen headed by the architect Armand. The interior is ringed by a double colonnade of superimposed Corinthian columns and is lit by a giant stained-glass skylight in the form of a stylized flower with overlapping petals. Skylights of this size and style are not unusual in French buildings of the period . Similar examples can be found nearby at the department stores Galeries Lafayette and Printemps and in the banking hall of the Société Générale on the Boulevard Haussmann.

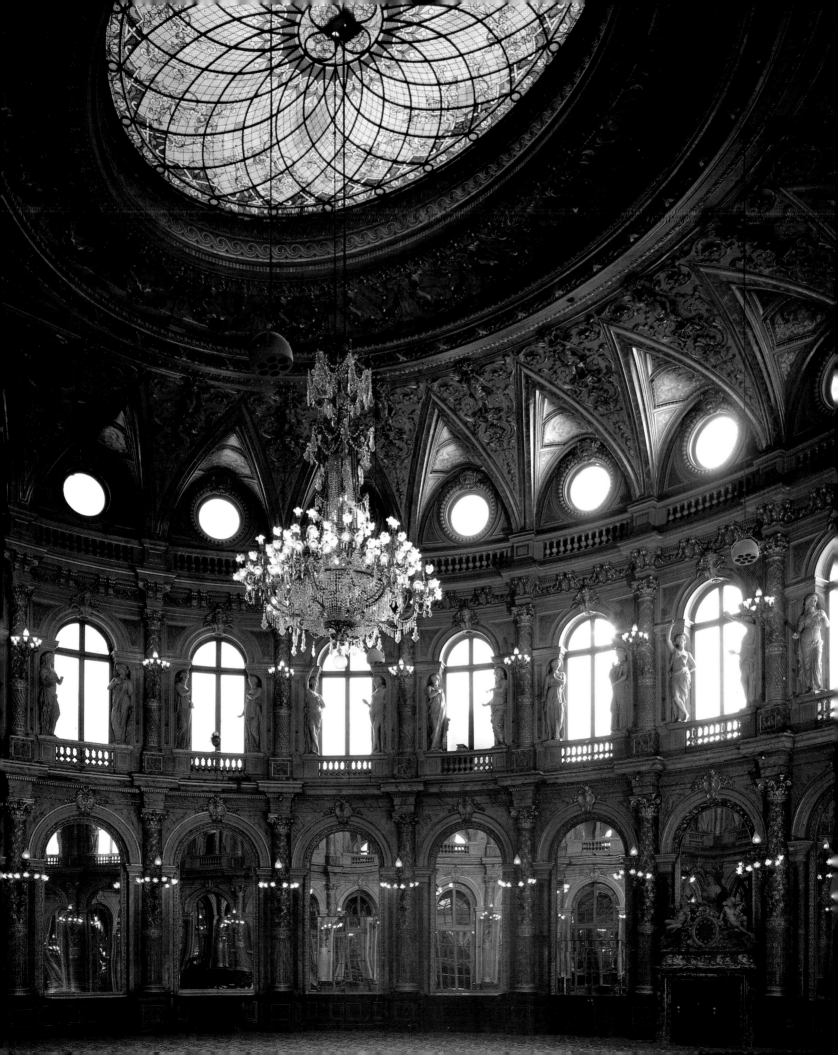

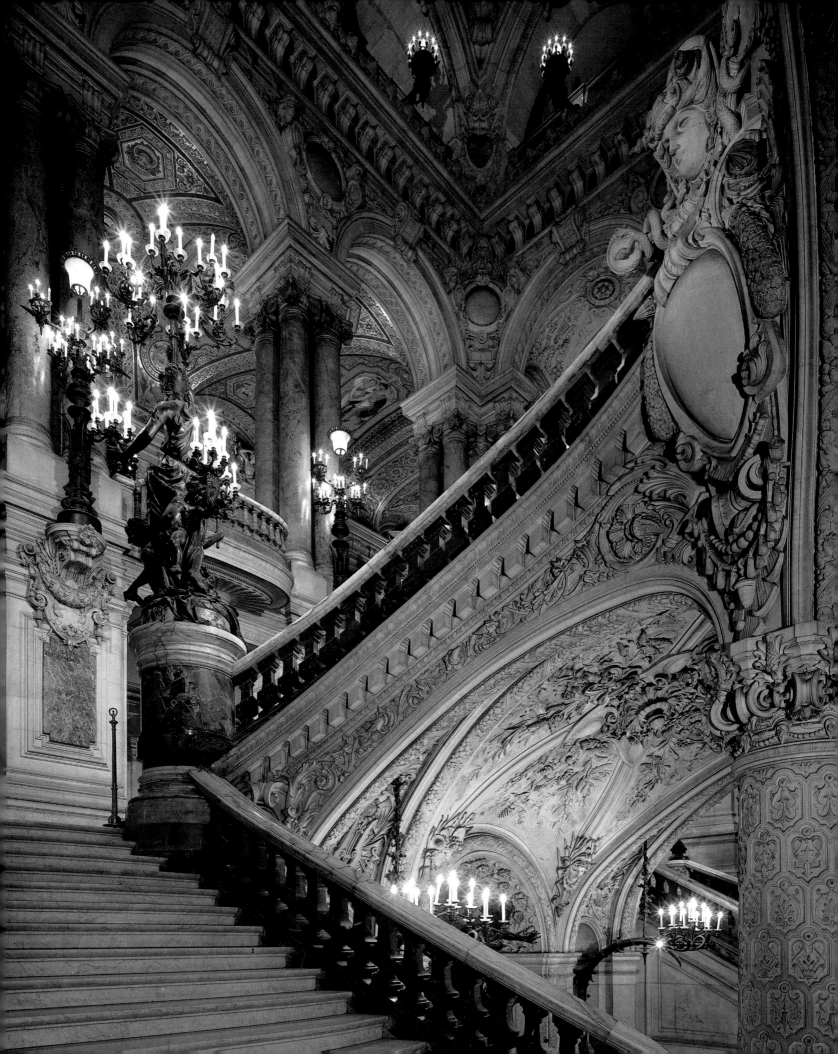

Theatres and Cinemas

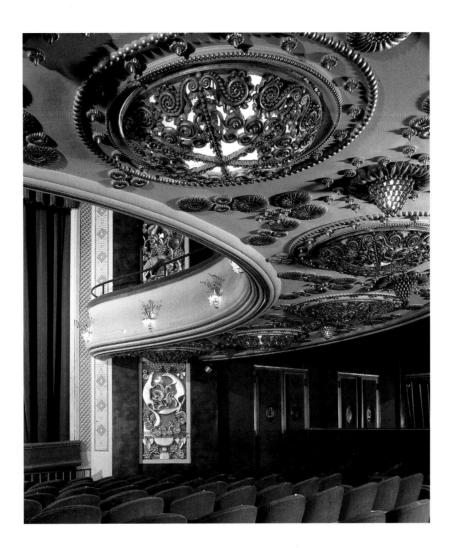

THE PARIS OPÉRA

*T*HE Paris Opéra is a giant of a building, a colossal temple of the arts consecrated to opera and ballet. Begun in 1862, it took thirteen years to build and involved almost every major French artist and craftsman of the day. The architect was Charles Garnier, whom a jury selected from over 170 competitors to head the most important public building project of the Second Empire. The style is eclectic, a heady synthesis of forms and ornaments culled from a wide spectrum of architectural and natural sources. When asked by the Empress Eugénie to describe this style, Garnier replied that it was neither Louis XIV, nor Louis XV, nor even Louis XVI, but something wholly new: Napoleon III.

THÉÂTRE DAUNOU

*T*HE auditorium of the Théâtre Daunou (*above*) dates from 1921 and was designed by Armand Rateau, artistic director at Lanvin Décoration, the decorating company founded by the celebrated *couturière* Jeanne Lanvin. The colour scheme is unusual for a French theatre, combining blue and gold as opposed to the more traditional blend of crimson and gold, and may well have been inspired by the eighteenth-century opera house at Versailles. The carvings on the right of the stage show the influence of Indonesian sculpture, for which Rateau had a special admiration.

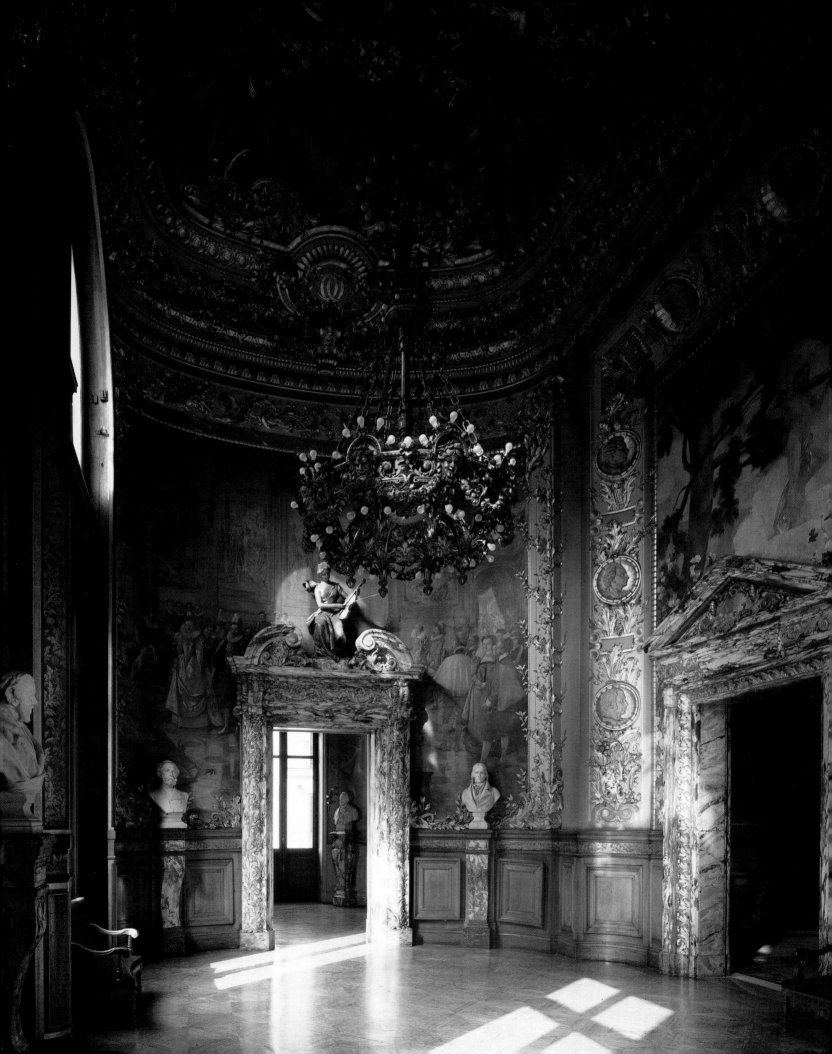

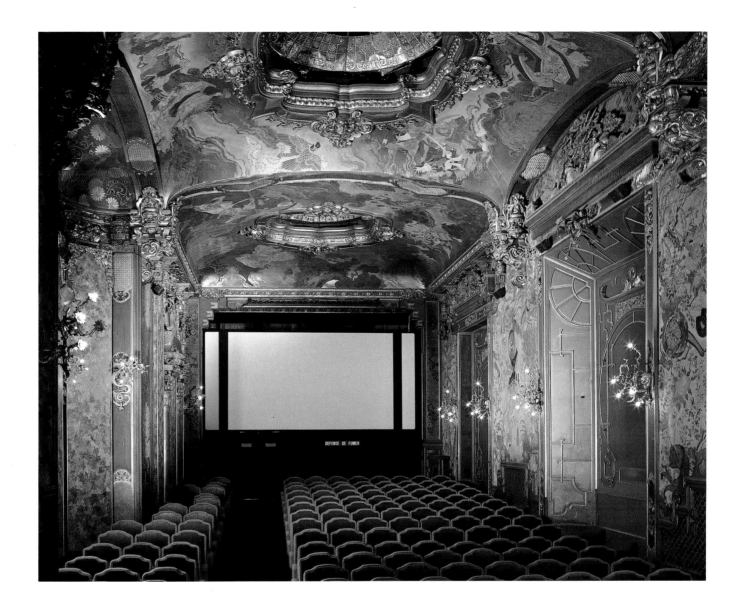

OPÉRA COMIQUE

ʟɪᴋᴇ it or not (and many contemporary critics did not), the Opéra Comique is a tour de force of architecture, sculpture, and decorative painting completed under the direction of architect Bernier in 1898. The Grand Foyer is typical of the interior, small in scale and light-hearted in spirit, but no less opulent than Garnier's Opéra (page 40), which it consciously emulates. On the far wall a mural by Gerveix represents a courtly ballet, while in the centre an angelic violinist by Gasq presides from the broken pediment of a Baroque marble doorway. The mural on the right is by Albert Maignan, as is the painted ceiling. The portrait medallions represent famous composers, librettists, and actors and actresses.

LA PAGODE

ɪꜰ the Rex is the most spectacular cinema in Paris (pages 48–9), La Pagode is surely the most extraordinary: a genuine nineteenth-century Japanese pagoda shipped to France at the height of the Oriental vogue in 1896 and reassembled in the heart of the Faubourg Saint Germain. The architect was Alexandre Marcel, the client a certain Morin, a department store director, who presented the building to his wife as a pleasure house. According to legend, the Chinese considered purchasing it as an embassy in 1927 but turned away in disgust when they discovered a mural depicting the Chinese army suffering humiliating defeats at the hands of their Japanese neighbours.

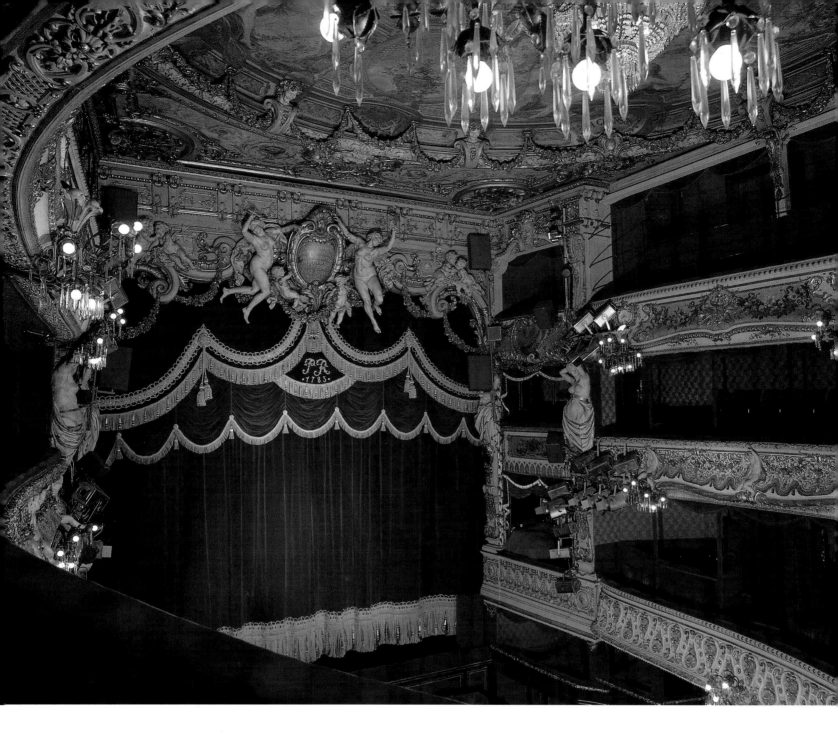

THÉÂTRE DU PALAIS ROYAL

*T*HERE is something coquettish and yet at the same time slightly sinister about the auditorium of the Théâtre du Palais Royal (above), which perfectly evokes the period in which it was built. Designed by Paul Sédille, the theatre was completed around 1880, the latest in a long line of playhouses on this site. The date on the curtain, 1783, refers back to the inauguration of the first, the Théâtre de Beaujolais.

THÉÂTRE DU CONSERVATOIRE

*T*HE Théâtre du Conservatoire was built in 1811 by Delannoy, architect of the Galerie Vivienne (page 17), but little survives of the original First Empire decoration, which was overlaid in 1866 in a style inspired by the brightly-coloured murals discovered at Pompeii and Herculaneum. The foyer of the theatre forms an impressive classical atrium with serried columns in tones of red and yellow; but the climax is reached in the auditorium (*right*), decorated with striped and banded columns, classical lyres and masks, and a vaulted ceiling ornamented with angels.

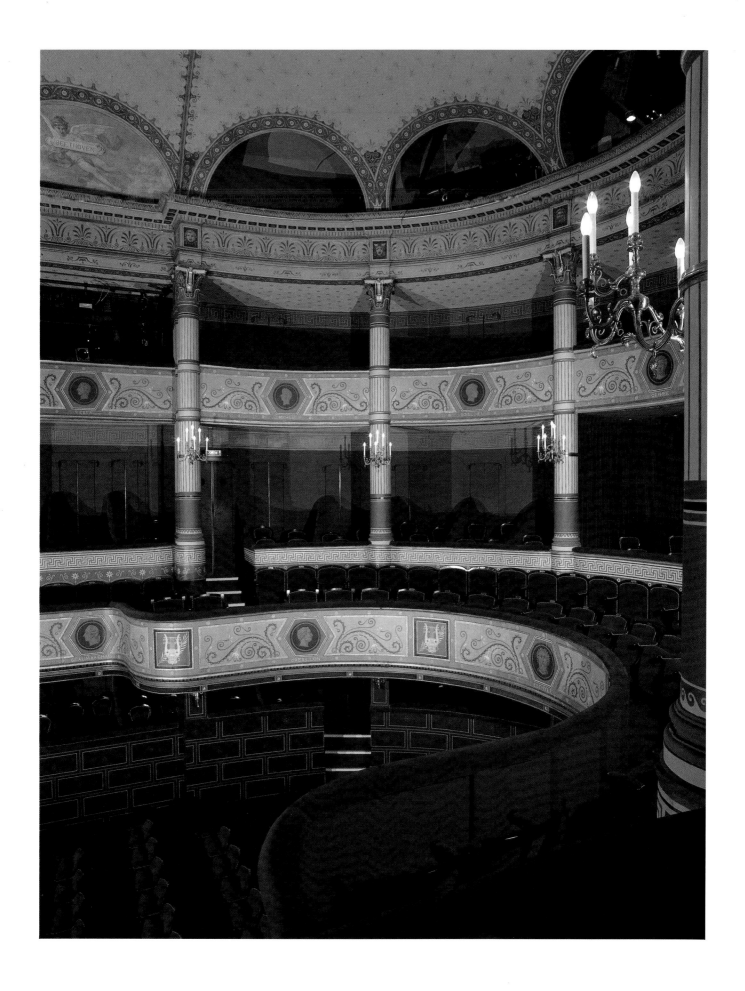

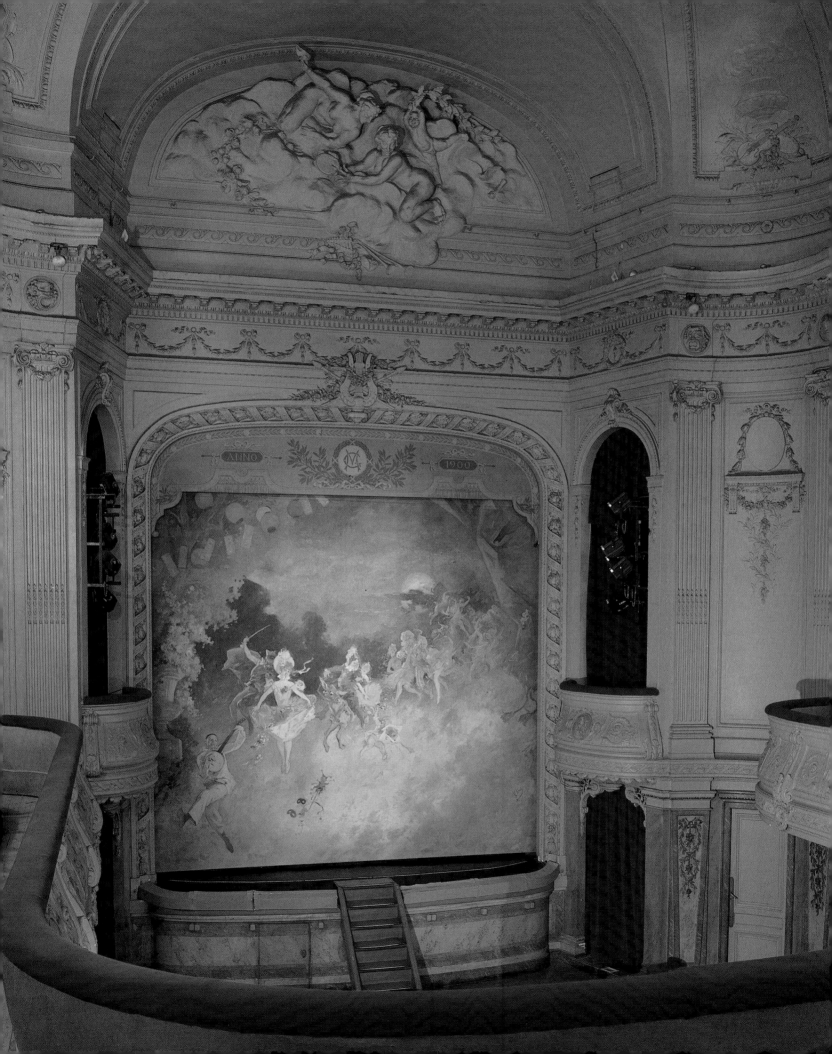

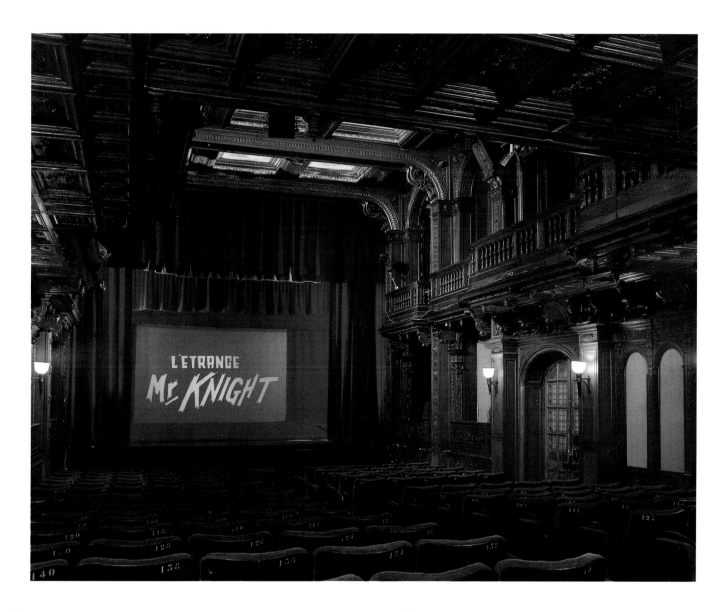

THÉÂTRE GRÉVIN

*T*HE theatre of the Musée Grévin (*left*) was originally known as the Théâtre Joli, and little wonder; it is one of the prettiest theatres in Paris. Above the stage is a spirited allegorical group by the sculptor Bourdelle, but the eye is immediately drawn to the brightly-painted safety curtain by Chéret representing a carnival scene with figures from the Harlequinade. Completed in 1900, the theatre seats only 350 spectators, but several stars have made their debuts here, including the mime artist Marcel Marceau.

LE RANELAGH

*T*HE Ranelagh (*above*) is a Neo-Renaissance music hall built in 1890. Despite its conversion for use as a cinema, the auditorium retains many original features, including a remarkable coffered ceiling and panelling carved with arabesques and mythological beasts.

LE REX

*B*UILT in 1932, the Rex (*overleaf*) is surely the most spectacular cinema in Paris. The auditorium is an outstanding example of the 'atmospheric' style, a style based on fantasy and exoticism which was first developed in picture houses on the West Coast of America in the 1920s. The style was introduced to Europe by its originator, John Eberson, who collaborated on the design of the Rex with the French architect Auguste Bluysen. The auditorium seats almost 3,000 spectators and is decorated with outlandish architectural scenery ranging in style from the Moorish to the Neo-classical. The proscenium forms a luminous red arch, with fountains dancing on the stage beyond.

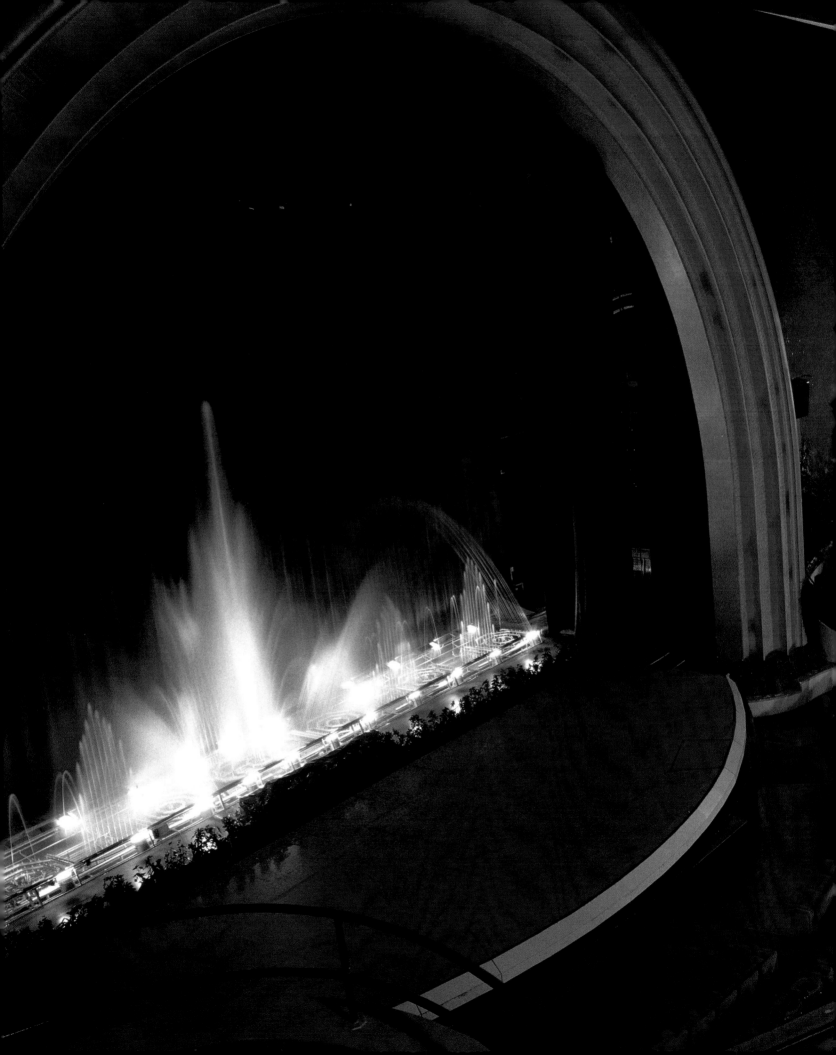

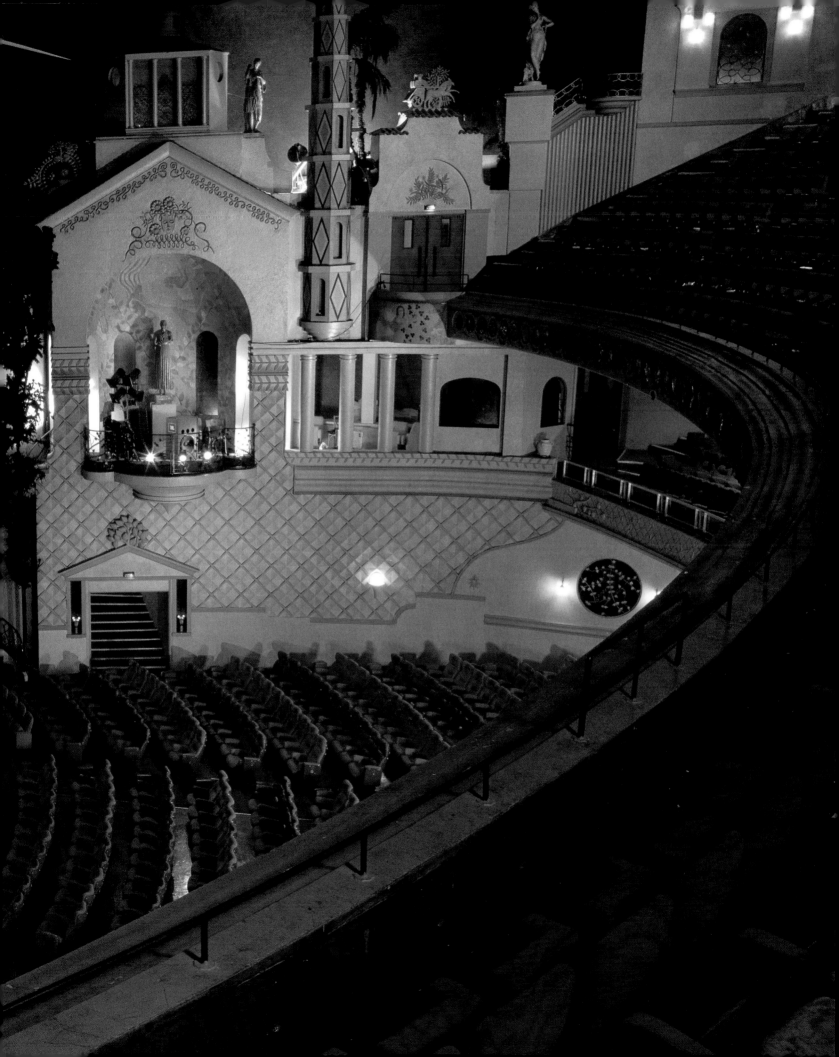

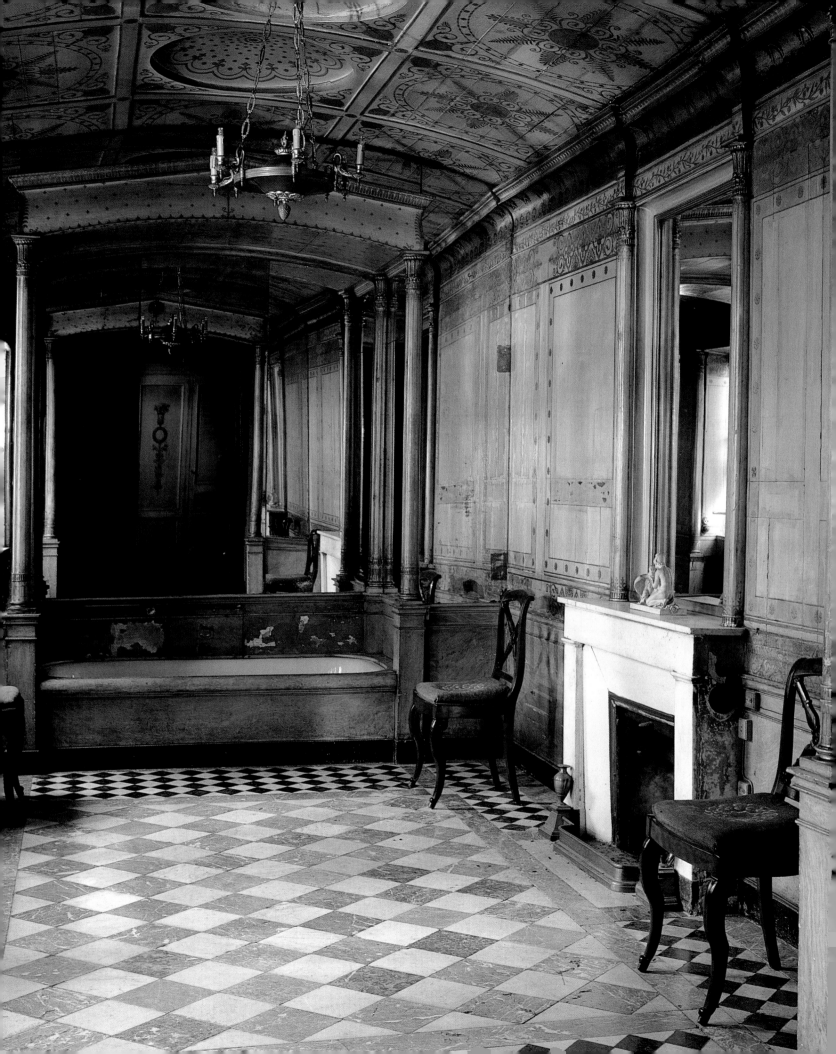

Private Houses

HÔTEL DE BOURRIENNE

THE interior of the Hôtel de Bourrienne is hard to date. The house was built around 1787 but was redecorated twice within the space of less than fifteen years, first by Bélanger around 1793 and again by Lecomte around 1801. The bathroom (*left*) is classical in style but also shows the influence of Egypt, from which many French designers drew inspiration around the time of Napoleon's Egyptian Campaign (1799–1801). If this analysis is correct the bathroom is almost certainly the work of Lecomte and may well be the only surviving 'Retour d'Egypte' interior

in Paris. High in the attic is a remarkable Art Nouveau studio (*above*), built around 1900 by Charles Tuleu, director of a famous printing works founded by the novelist Balzac, and great-uncle of the house's present occupants. The mosaic floor and stencilled paintwork are typical of the period, as are the stove, the stained-glass window, and the shelf at cornice level, which retains a number of the vases and ornaments with which it would originally have been filled.

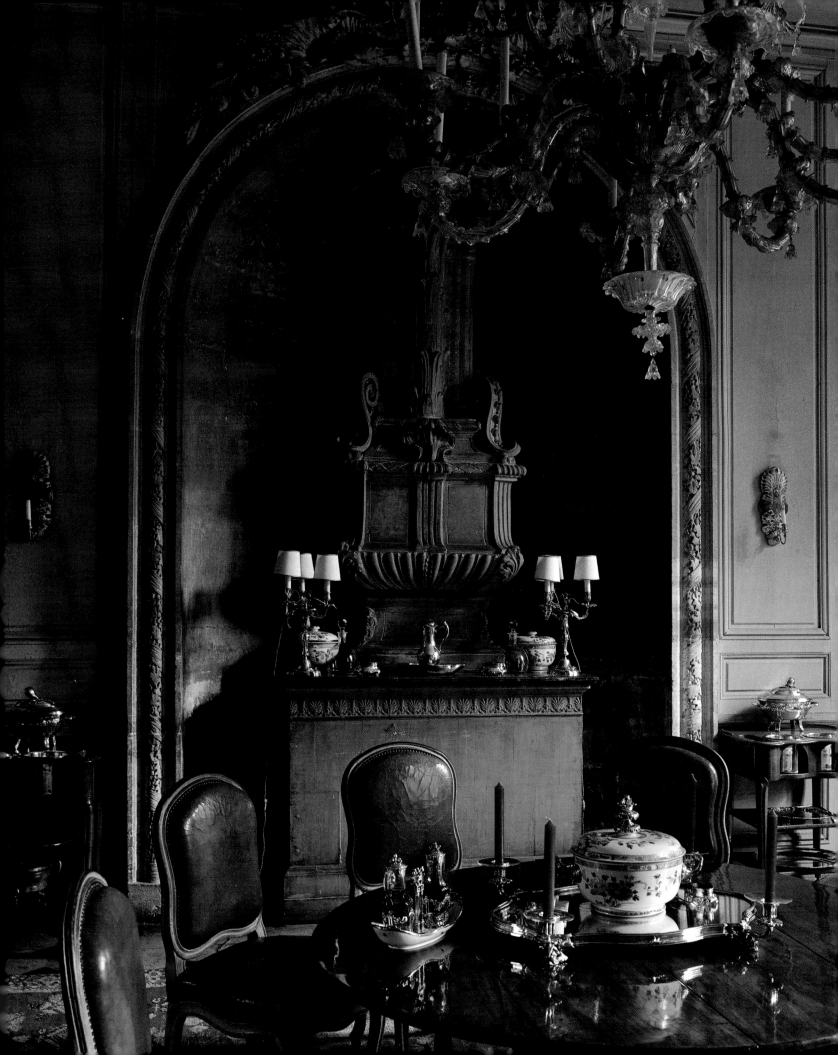

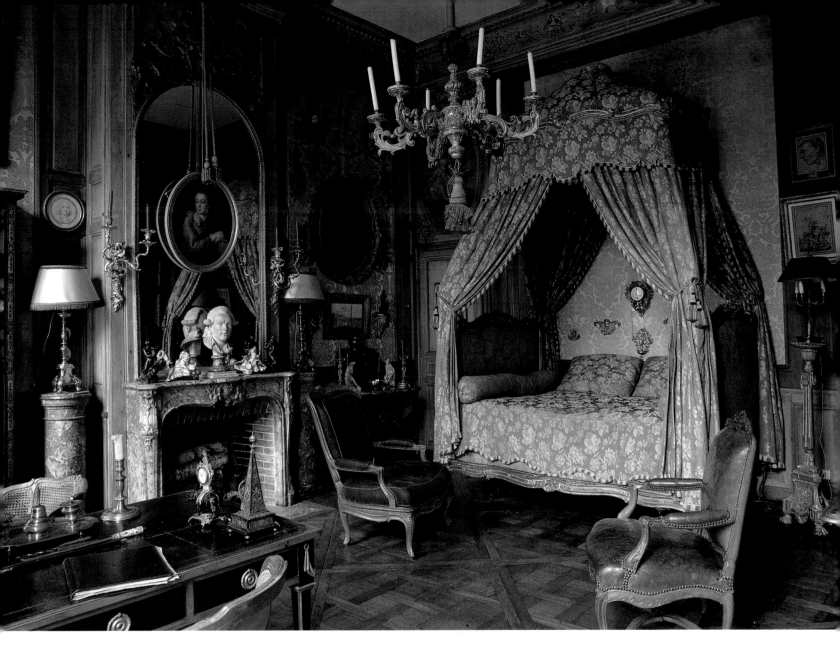

HÔTEL GOUFFIER DE THOIX

*T*HE interior of the Hôtel Gouffier de Thoix is like an illustration from Proust, an allusive web of pictures, fabrics, furniture, and ornaments leading the mind off in a dozen different directions. The house dates from the Régence and has strong connections with England. It was built for Henriette Penancouët de Kéroualle, marquise de Thoix and formerly Countess of Pembroke, whose younger sister Louise became Duchess of Portsmouth and mistress of Charles II. The bedchamber (*above*) is decorated with rococo panelling and a magnificent *lit à la polonaise* evoking the reign of Louis XV. The dining room (*left*) is thought to date from the reign of Louis XVI and features a remarkable wood-burning stove in the form of a palm tree, supported by an early nineteenth-century pedestal ornamented with classical palmettes. The mahogany tables and leather-upholstered chairs show the influence of England. The chandelier is Venetian.

HÔTEL MANSART

*O*CCUPIED today by interior designer Jacques Garcia, this late seventeenth-century town house (*overleaf*) was designed and built by the architect Jules Hardouin Mansart, who lived here until his death in 1708 and whose best known works include the Galerie des Glaces and Grand Trianon at Versailles, and the Place Vendôme and Place des Victoires in Paris. The interior features original murals and ceiling paintings attributed to Le Brun and Mignard and a superb collection of seventeeth- and eighteenth-century French furniture, much of it of royal provenance, amassed by the present owner. The decoration of the salon is based on a description of the room drawn up after Mansart's death. The approach is academic, even archaeological, but the effect is warm and romantic, displaying great ingenuity and a rare sense of period.

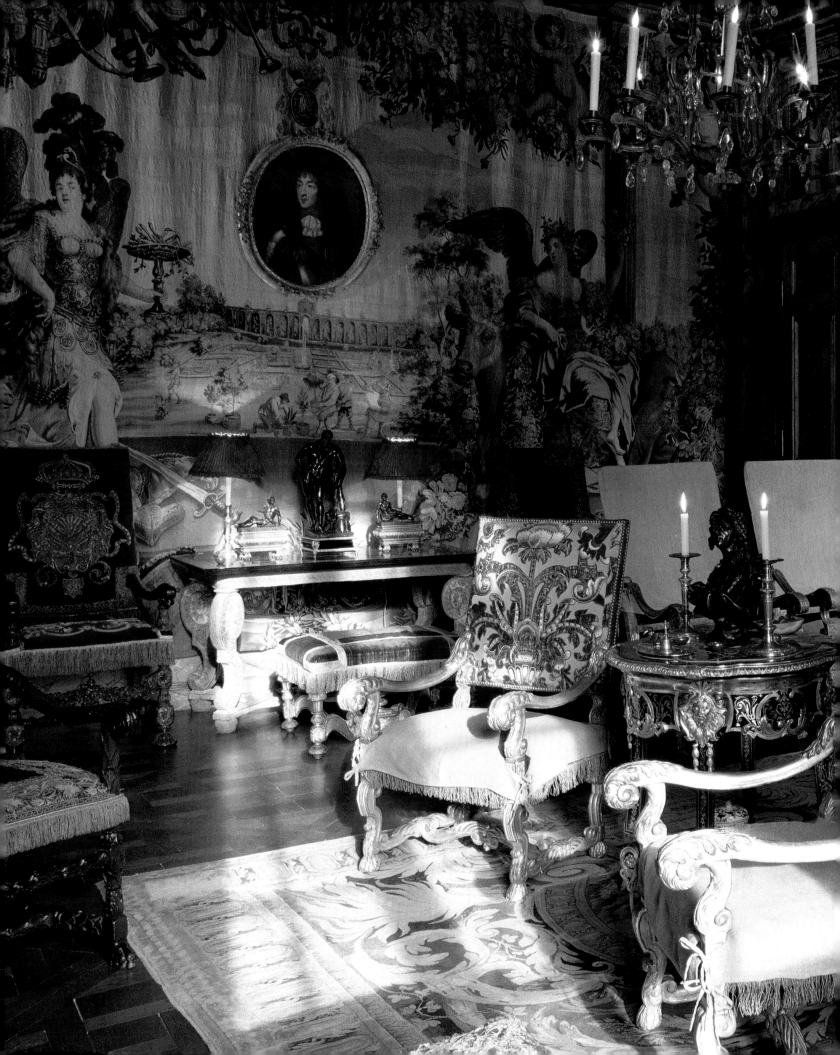

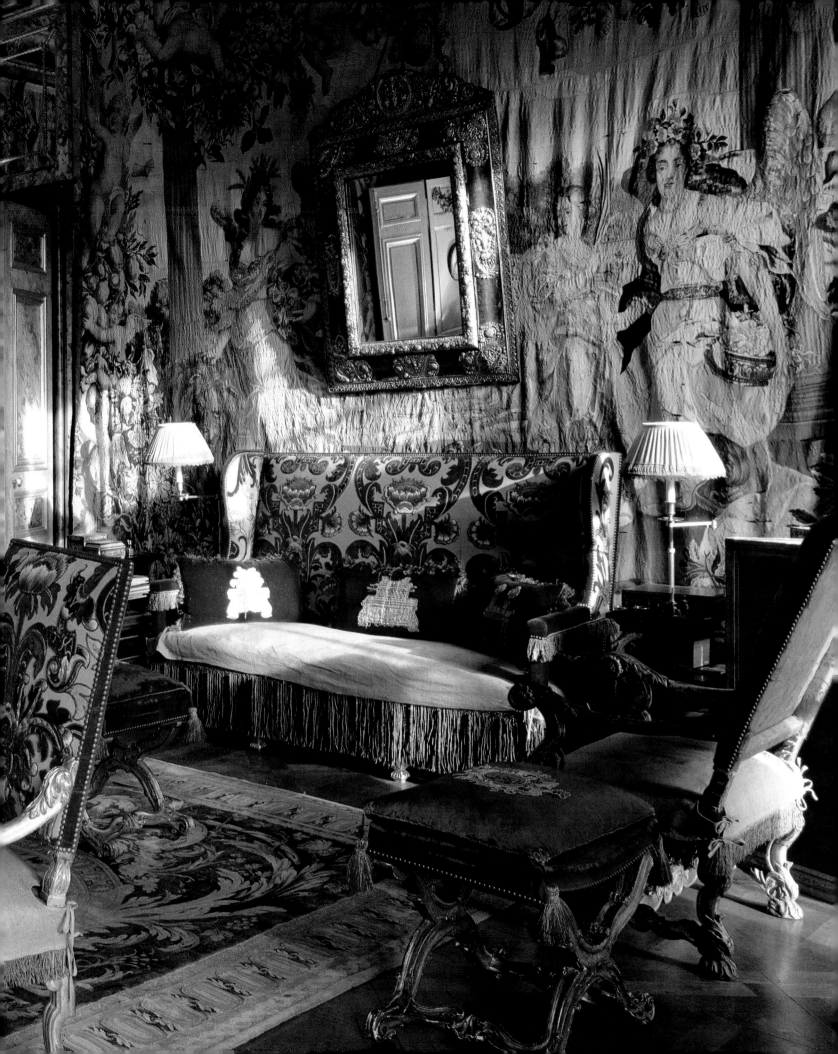

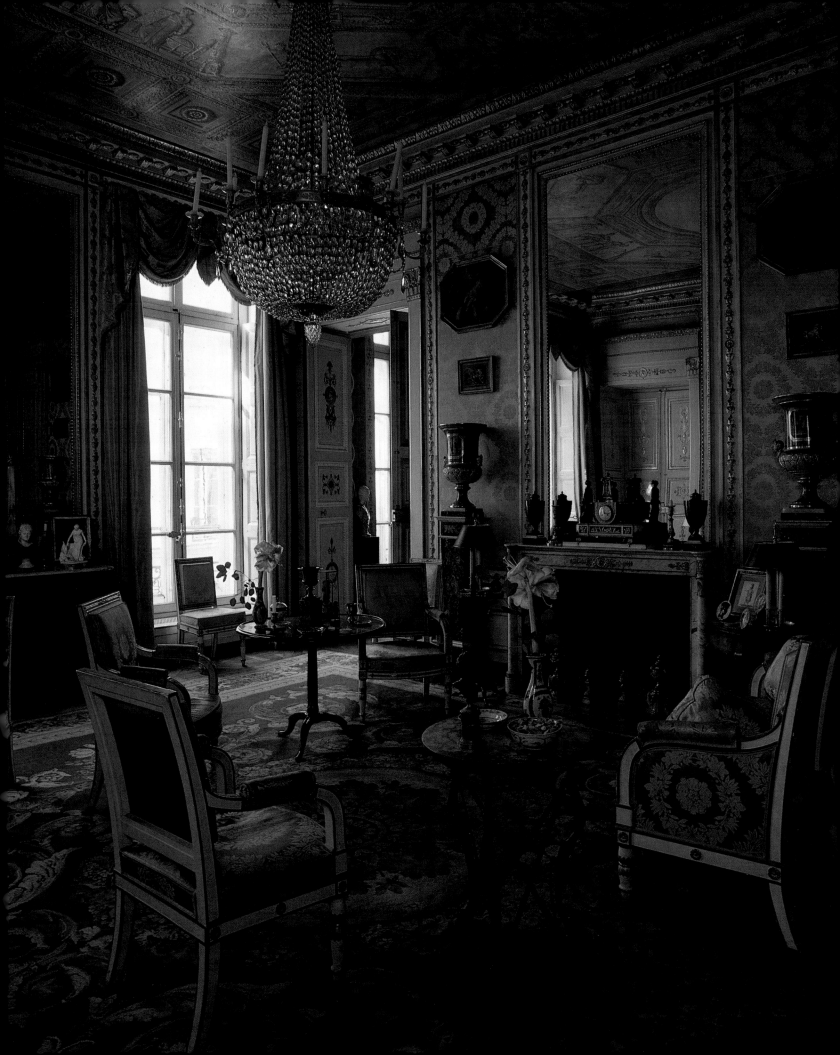

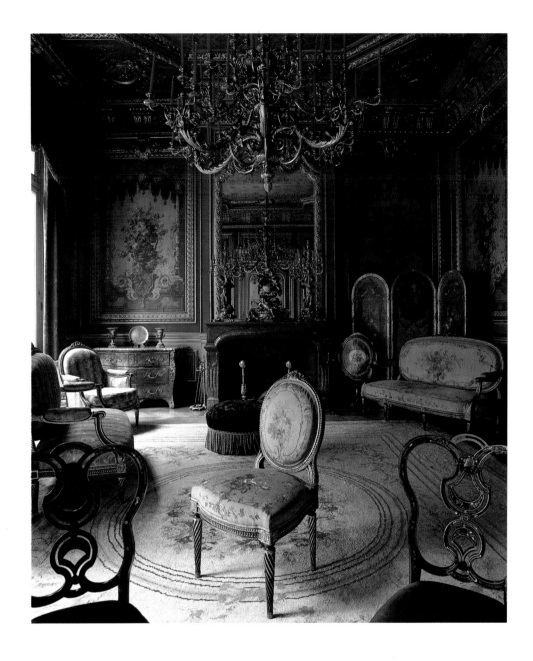

MAISON OPÉRA

So-called because it is generally attributed to Garnier, architect of the Paris Opéra, this atmospheric town house (*above*) marks the transition from the Second Empire to the Third Republic. It was begun around 1867 for the marquis de Luzarches d'Azay, but was sold while still in construction to Léopold Bourlon de Rouvre, *préfet* of the 8th Arrondissement, in 1871. The Salon is in the 'Tous les Louis' or 'Louis the Who?' style, with decorative elements drawn from a wide range of seventeenth- and eighteenth-century sources. An unusual feature is the decoration of the walls, painted in imitation of tapestries representing bouquets of flowers.

HÔTEL DE SALM-DYCK

This gracious drawing room (*left*) was once the setting for a distinguished *salon* frequented by the literary and artistic lions of the First Empire, the actor Talma, the writer Stendhal, the sculptor Pajou, and the painters Girodet and Vernet. The *salon* was presided over by Constance de Theïs, Princesse de Salm-Dyck, herself a well-known poetess, for whom the room was decorated around 1810 by the architect Antoine Vaudoyer. The ceiling is painted with classical allegories representing the Four Elements as well as the pursuit of Poetry, the Arts, Warfare, and Science, the last intended as a tribute perhaps to the Princess's husband, a keen botanist with a passion for cacti.

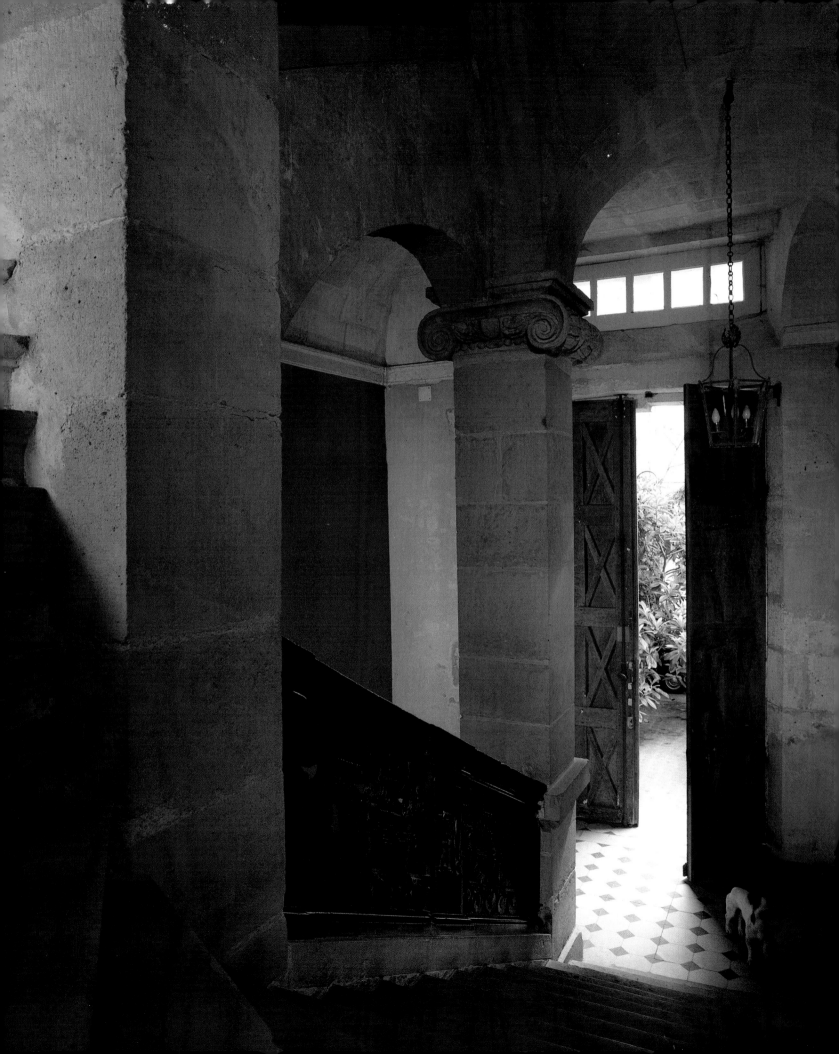

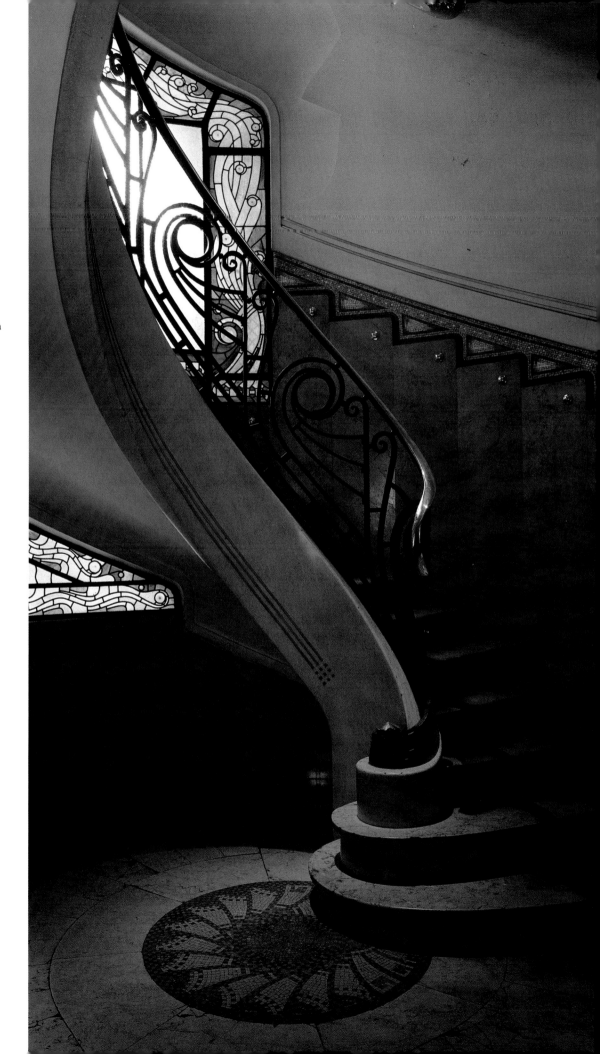

HÔTEL DE FIEUBET

\mathcal{S}TEPPING into the staircase hall of the Hôtel de Fieubet (*left*) is like stepping back into the seventeenth century. The house was built in 1646–47 and has been attributed to the architect Pierre Le Muet. The staircase, simple yet majestic, is dominated by a monumental stone pier surmounted by the classical volutes of an Ionic capital and a massive oak balustrade carved with the monograms of the original occupants Gaspard de Fieubet and his wife Marie Ardier.

NO 67 BOULEVARD RASPAIL

\mathcal{T}HIS remarkable apartment building dates from 1913 and was designed by the architect Tissier, a fringe member of the School of Vienna. The staircase hall (*right*) is perhaps the only example in Paris of an interior decorated in the Secessionist style. The serpentine balustrade was produced by the partnership of sculptor Henri Bouchard and metalworker Bellery-Desfontaine. The stained-glass windows were reputedly supplied by the famous Daum Studio.

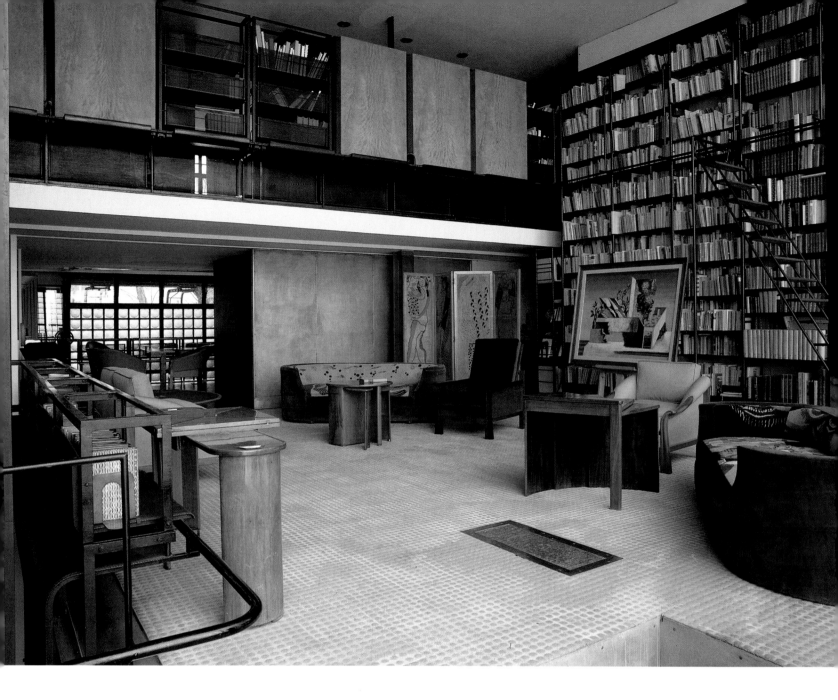

Maison de Verre

\mathscr{T}HE Maison de Verre (House of Glass) is unique among modernist houses in Paris in that it was built in the city centre rather than on the outskirts. The house stands on the site of an eighteenth-century *hôtel particulier* in the heart of the aristocratic Faubourg Saint Germain, and although the architecture is uncompromisingly modern there is something almost *dix-huitième* about the minute attention to detail and the extraordinary level of comfort. The house was designed by the architect Pierre Chareau for gynaecologist Jean Dalsace and his wife Anna Bernheim, who hosted a *salon* frequented by such distinguished modern artists as Max Ernst, Fernand Léger, Robert Delaunay, and the poet Max Jacob. Guests would gather in the main reception room (*above*), whose flexible plan and informal arrangement of furniture contrasts sharply with the relatively rigid interior of Le Corbusier's

Villa La Roche, built a few years earlier (page 61). Light enters the room through a wall of frosted glass, just out of view behind the camera. Rising from floor to ceiling are twin girders and a towering bookcase with shelves and a step-ladder running on rails. Wooden panels and metal grills mask the private apartments on the upper storey, while below a duralumin screen draws back to reveal a second reception room with views over a geometric garden. The floor is laid with original non-synthetic rubber tiles. The furniture was produced to Chareau's designs by the well-known *ébéniste* Eugène Printz, while the upholstery is by Jean Lurçat, who also designed the folding screen decorated with figures from the Harlequinade. The Maison de Verre is still in family ownership, beautifully maintained by the descendants of the original occupants.

Clubs and Institutions

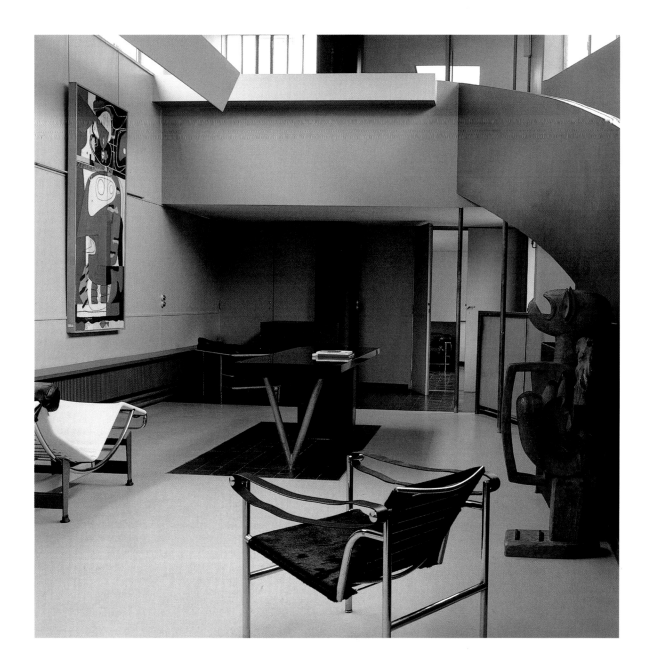

FONDATION LE CORBUSIER
Villa La Roche

*R*ATIONAL, rigorous, unyielding: these are words often used to describe the architecture of Le Corbusier, a leader of the Modern Movement. The Villa La Roche is typical of his work in the domestic sphere, one of several such houses, or 'living-machines', dotted about the outskirts of Paris. It is true there is something rigid about the arrangement of the interior. In the Salon (*above*), for instance, the table is fixed to the floor and the occupant is powerless to move it. The simplicity of the room seems to resist the introduction of surplus furniture and useless bric-a-brac. And yet there is something almost sensuous about the sweeping ramp on the right and the combination of contrasting colours and materials. The house dates from 1923–25 and was originally occupied by Raoul La Roche, a collector of modern art. Today it is the headquarters of the Le Corbusier Foundation.

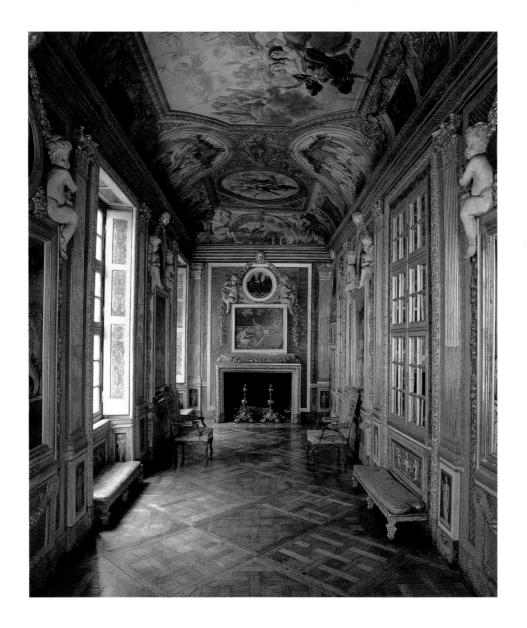

FONDATION PAUL-LOUIS WEILLER
Hôtel des Ambassadeurs de Hollande

*S*ITUATED in the Marais district, this mid seventeenth-century town house was designed by Pierre Cottard, a contemporary of Lepautre, architect of the neighbouring Hôtel de Beauvaios (p.68). Occupied originally by Denis Amelot de Bisseuil, it was later let to a Protestant chaplain in the service of the Dutch Ambassador, and by the middle of the eighteenth century had become known as the Hôtel des Ambassadeurs de Hollande, the name by which it is generally referred to today. Confiscated during the Revolution and subsequently vandalized, the house has largely been restored by the Fondation Paul-Louis Weiller, a charitable organization which took possession in 1951. The Galerie Psyché (*above*) retains its original painted ceiling by Pierre Corneille representing scenes from the legend of Psyche.

FONDATION NATIONALE DES ARTS GRAPHIQUES ET PLASTIQUES
Hôtel Salomon de Rothschild

*S*INCE 1967 the Hôtel Salomon de Rothschild has been occupied by the Fondation Nationale des Arts Graphiques et Plastiques. The house dates from the 1870s and was built for the widow of Baron Salomon de Rothschild, who left it to the state. The interior has largely been modernized to provide streamlined offices and exhibition halls; but as in a fairy tale one room has been left untouched, the *Cabinet des Curiosités* (*right*), an atmospheric late nineteenth-century study crammed with the most extraordinary jumble of seemingly irreconcilable objects, from mandolins to Oriental armour.

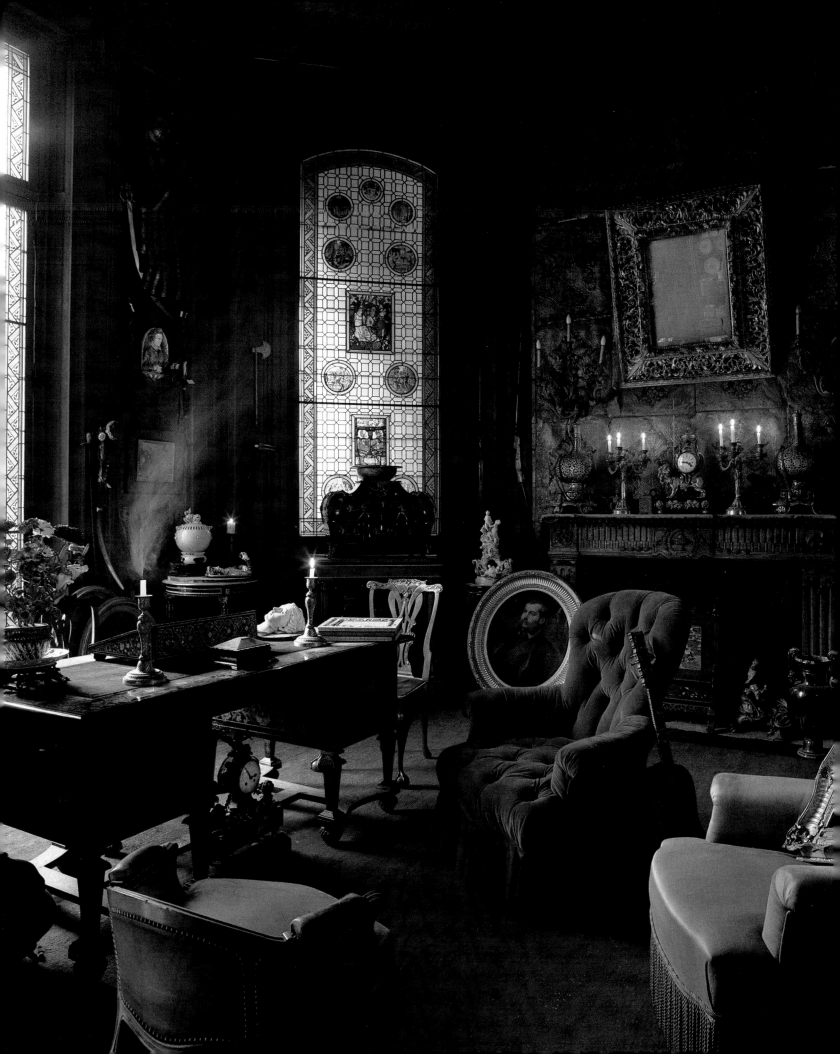

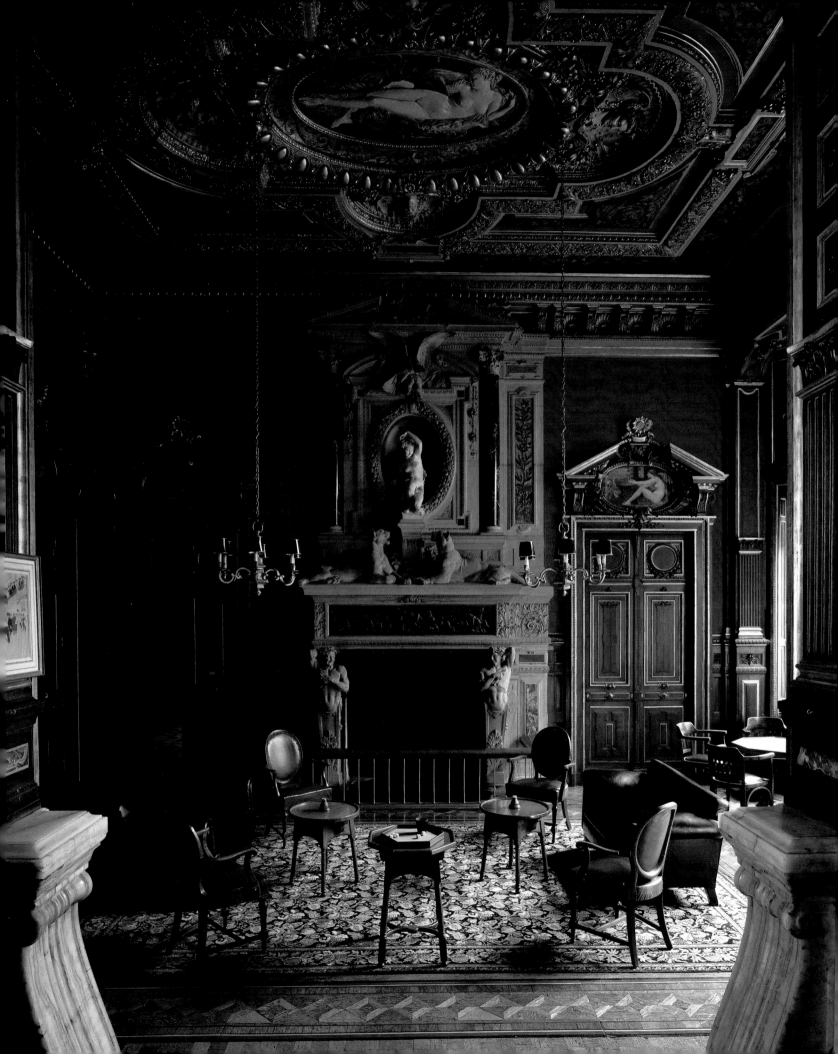

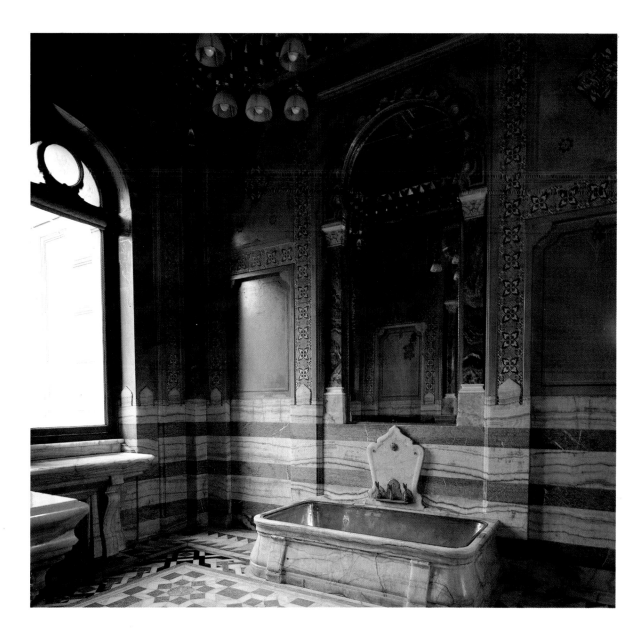

TRAVELLERS CLUB
Hôtel de Païva

*T*HE Travellers Club occupies the Old Hôtel de Païva, a spectacular Neo-Renaissance palace on the Champs-Elysées built in the middle years of the nineteenth century for Esther Lackmann, marquise de Païva, a notorious adventuress whose life story reads like a novel by Balzac. Born into a family of penniless Polish Jewish immigrants in Moscow, she blazed a trail across Europe collecting wealthy aristocratic lovers, before settling in Paris, where she married a Portuguese nobleman, the Marquess de Païva. When gambling debts forced the Marquess to blow out his brains Esther took off with her long-standing lover, the Prince von Donnesmarck, ending her days as his Princess in a fairy-tale castle in Silesia built for her pleasure by the French architect Hector Lefuel. The Paris house was designed by Pierre Manguin, who drew upon the talents of the foremost artists and craftsmen of the day, including the sculptor Dalou and the painter Gérôme. The furniture was later dispersed, but the architectural decoration survives intact, despite the fact that the building served in the last years of the nineteenth century as a luxury restaurant. Particularly impressive are the onyx staircase (*back of jacket illustration*) the Moorish bathroom (*above*), and the crimson salon (*left*), rising to a cameo of a sensuous nude.

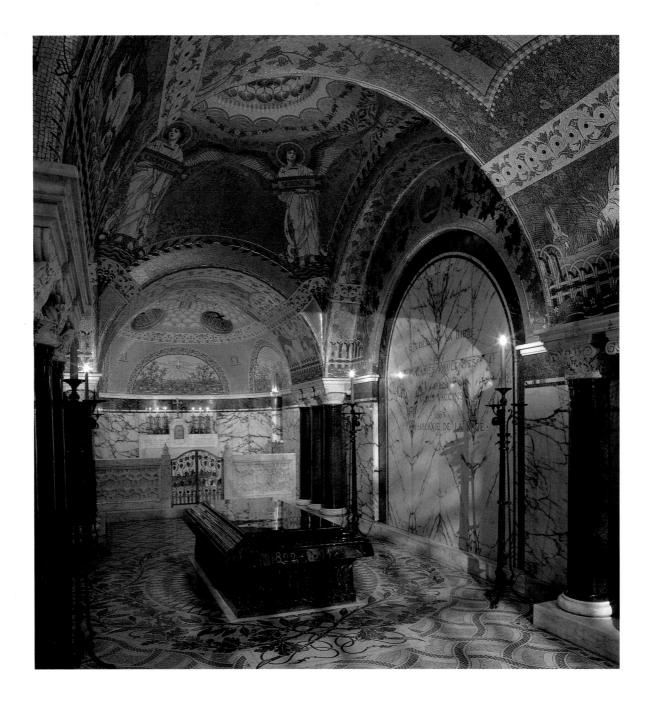

INSTITUT PASTEUR

*T*HE souls of French national heroes go to heaven, their bodies to the Panthéon. Louis Pasteur, pioneer of bacteriology and inventor of the anti-rabies vaccine, was a French national hero like no other. When he died in 1895 the state immediately made ready to transport his remains to that final resting place on the Montagne Sainte Geneviève. His widow, however, refused. Instead she asked that a funerary chapel be built in the basement of the Pasteur Institute, a family house-cum-research centre where she and her husband had lived since 1888. The result was the remarkable interior above, a vaulted Neo-

Romanesque crypt completed in 1896 by the partnership of architect Charles-Louis Girault, painter Luc-Olivier Merson, and mosaic artist Auguste Guilbert-Martin. The theme is that of Pasteur's career and virtues. The innocent-looking rabbits on the right are those on which the scientist tested his vaccine. The menacing hounds on the left are the brutes who carried the virus. Figures of Charity and Science gaze heavenward from the central vault. The family drawing room (*right*) is virtually undisturbed since Madame Pasteur's death in 1910.

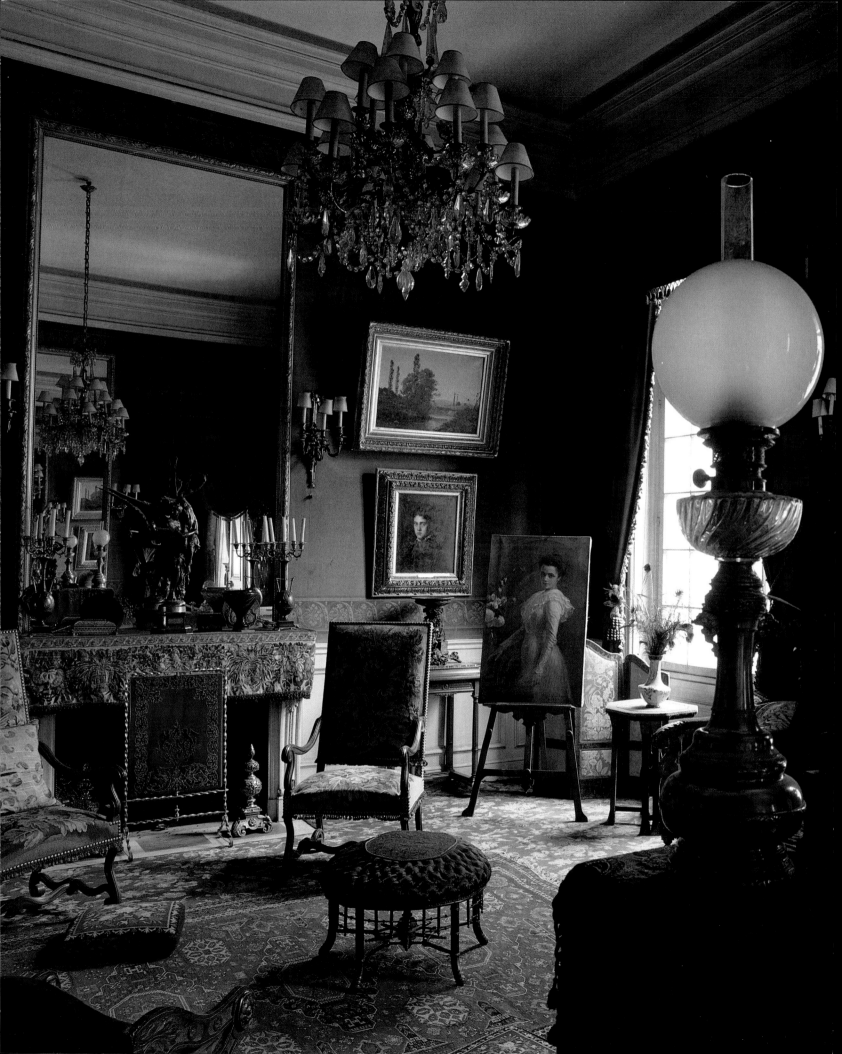

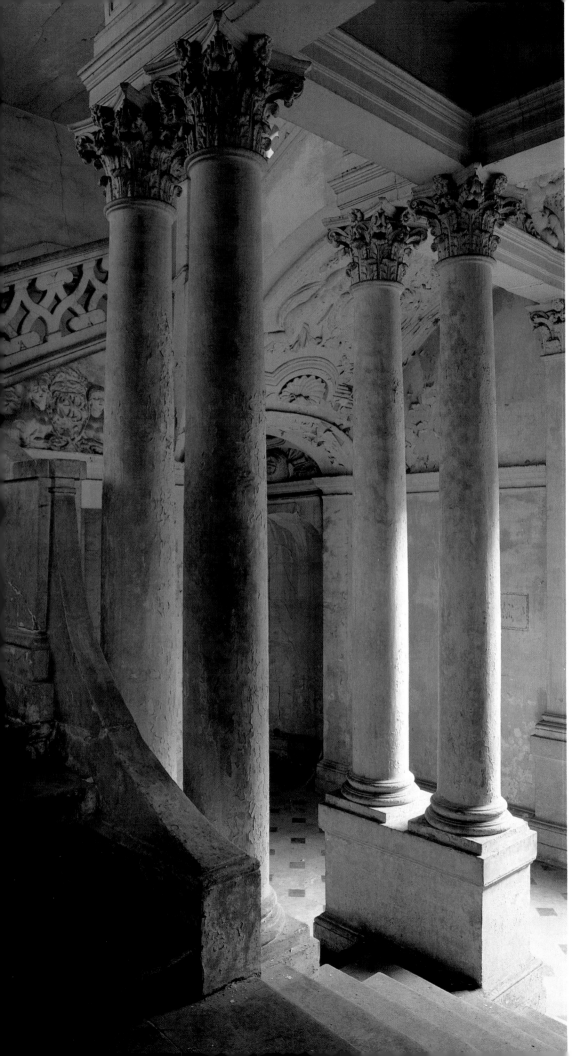

ASSOCIATION POUR LA SAUVEGARDE DE PARIS
Hôtel de Beauvais

*T*HE Hôtel de Beauvais is famous as the house in which the young Mozart stayed in 1763 during a concert tour of France. It was built in the mid seventeenth century by the famous French architect Antoine Le Pautre for Pierre de Beauvais, a former ribbon merchant, whose wife, Catherine-Henriette Bellier, a favourite of Queen Anne of Austria, is reputed to have been entrusted with the sexual initiation of the adolescent Louis XIV. The couple's monogram appears in the carved decoration of the staircase hall, executed by the Flemish sculptor Van den Bogaërt, known to the French as Martin Desjardins. The staircase is virtually all that survives of the original interior, but a vaulted Gothic cellar serves as a reminder that the house was built on the site of a medieval abbey.

THE PARIS CHAMBER OF COMMERCE
Hôtel Potocki

*S*INCE 1923 the Paris Chamber of Commerce has occupied the old Hôtel Potocki, a colossal mansion situated a short distance from the Arc de Triomphe. The house was begun in 1857 for Grégoire Potocki, a Polish Count, but was greatly enlarged around 1881 by his son, Félix-Nicolas, who deliberately set out to rival Versailles, especially in the monumental marble staircase (*right*). The Count's wife, Italian-born Princess Emmanuella Pignatelli, was scandalized by her husband's ostentatious behaviour and, thinking the house resembled some of the more pretentious banks then being built in Paris, dubbed it the 'Crédit Polonais'.

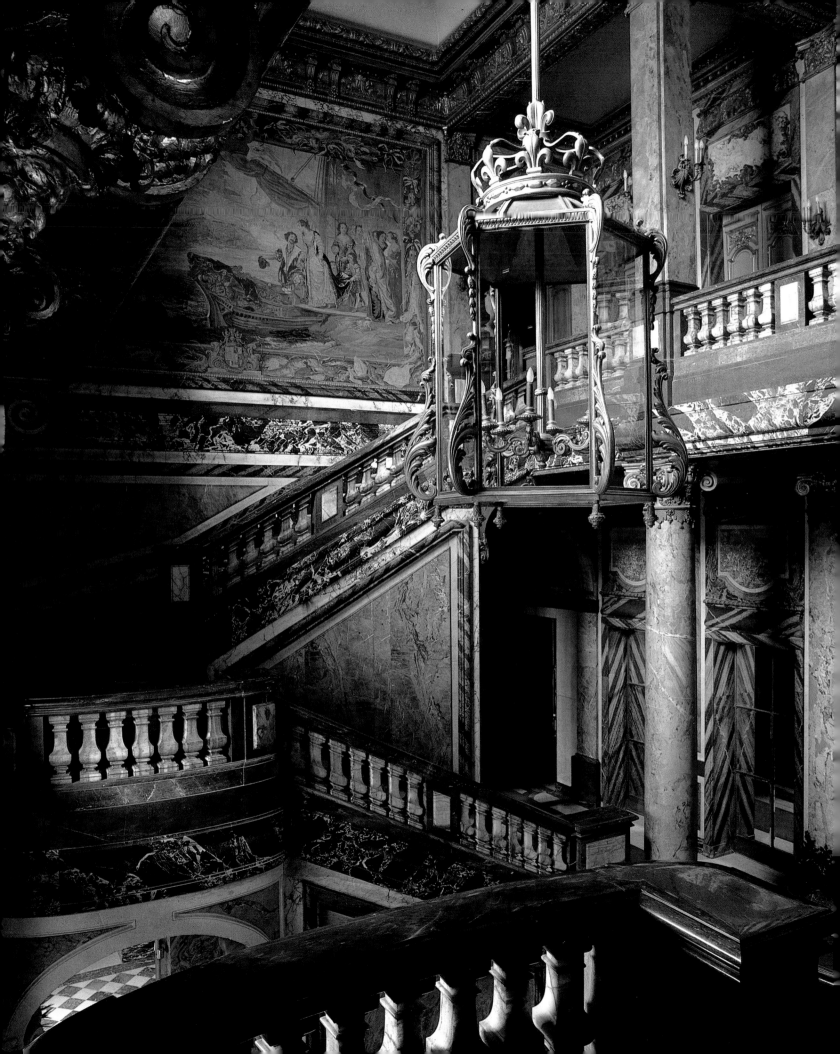

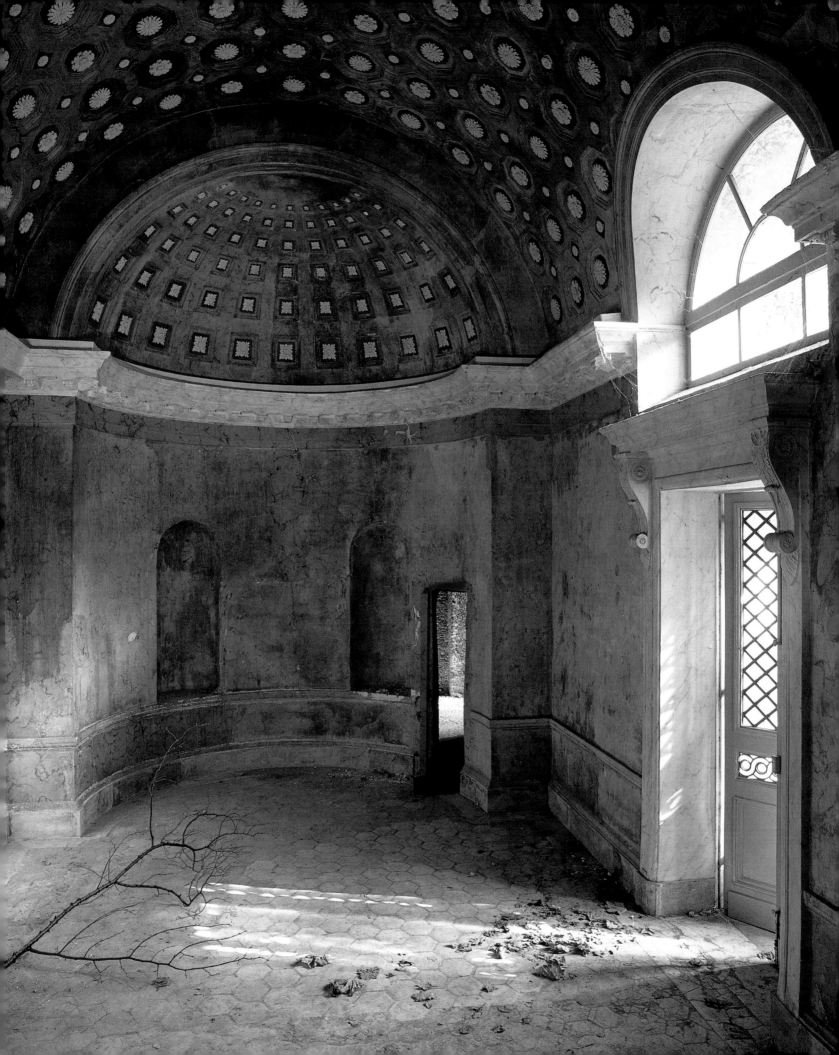

Schools and Colleges

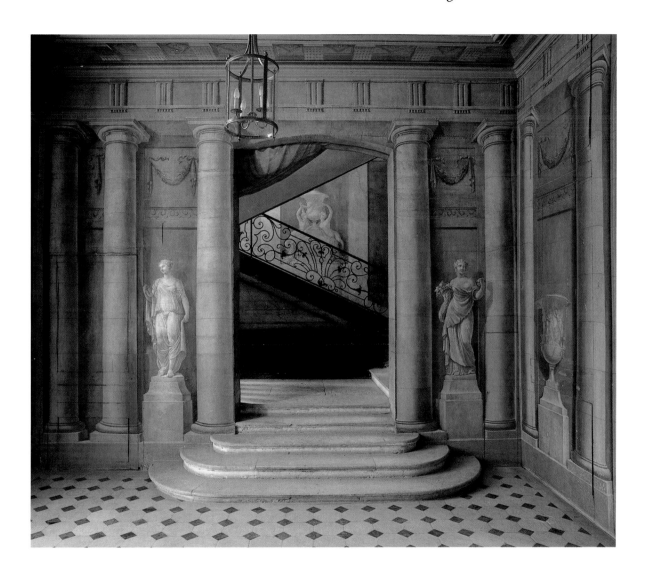

LYCÉE SAINT JAMES

The Lycée Saint James occupies the old Folie Saint James, a Neo-classical villa on the outskirts of Paris built in 1775–80 to the designs of Francois-Joseph Bélanger, architect of the neighbouring Château de Bagatelle (*see jacket*). The word 'folie' means 'folly', 'caprice', even 'madness', but in the eighteenth century it was used to describe a type of building which was then very much in vogue: a small-scale pleasure house generally set in a landscape garden not too distant from the centre of town. 'Saint James' is an anglophile corruption of 'Saint Gemmes', an estate in Anjou owned by the man for whom the Folie was originally built, financier Baudard de Vaudésir. Later occupants included Lucien Bonaparte, the Duke of Wellington, and Madame Récamier, and in

1844 history seemed to be punning when the Folie was acquired by a psychiatric hospital, where the painter Toulouse-Lautrec was treated for alcoholism in 1899. The house serves today as a state secondary school and yet several interiors are virtually unchanged since the late eighteenth century. The entrance (*above*) is decorated with illusionistic murals representing Doric columns, urns, and statuary. An interesting feature is the underside of the staircase, painted to represent a hanging drapery. Especially dramatic is the interior of the 'Grand Rocher' (*left*), a towering rockery in the park, which survives in a Piranesian state of ruin. The entrance is decorated with marbled walls and a coffered vault. Doors at either end lead through to a cavernous suite of pebbled grottoes.

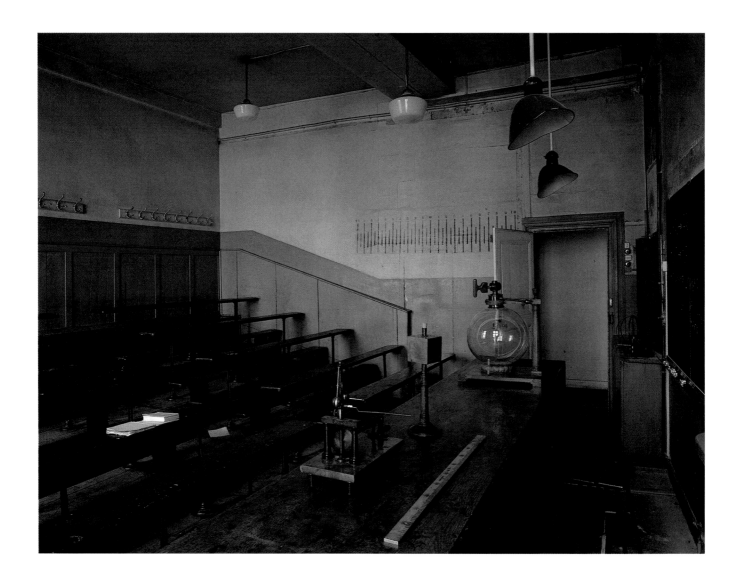

LYCÉE CHARLEMAGNE

*F*OUNDED during the French Revolution, the Lycée
Charlemagne occupies the former headquarters of the Society of
Jesus, expelled from France in 1762. The building was begun in the
seventeenth century and there are several surviving features from
the days of the Jesuits including a magnificent frescoed ceiling
representing the Apotheosis of Saint Louis by the Bolognese
painter Gherardini. Of more recent vintage, but remarkably
unspoilt, is the Salle Joffre (*above*), a nineteenth-century classroom
which takes its name from the famous French war hero, the
Maréchal Joffre, who took lessons here as a boy. Sadly, by the time
this book is published, this evocative interior will almost certainly
have been demolished to make way for a fire exit.

ECOLE DES BEAUX ARTS

*T*HE history of the Ecole des Beaux Arts (School of Fine Arts)
begins in the mid-seventeenth century with the establishment of
the National Academy of Painting and Sculpture. Originally
housed in the Palais du Louvre, the school moved to its present site
on the left bank of the Seine in the early part of the nineteenth
century. The amphitheatre (*right*) forms part of the Palais des
Etudes, begun in 1820 and completed around 1842. Inside and out
the building pays homage to the Italian Renaissance. The
amphitheatre is decorated with a sweeping mural by Delaroche,
directly inspired by Raphael's frescoes at the Vatican.

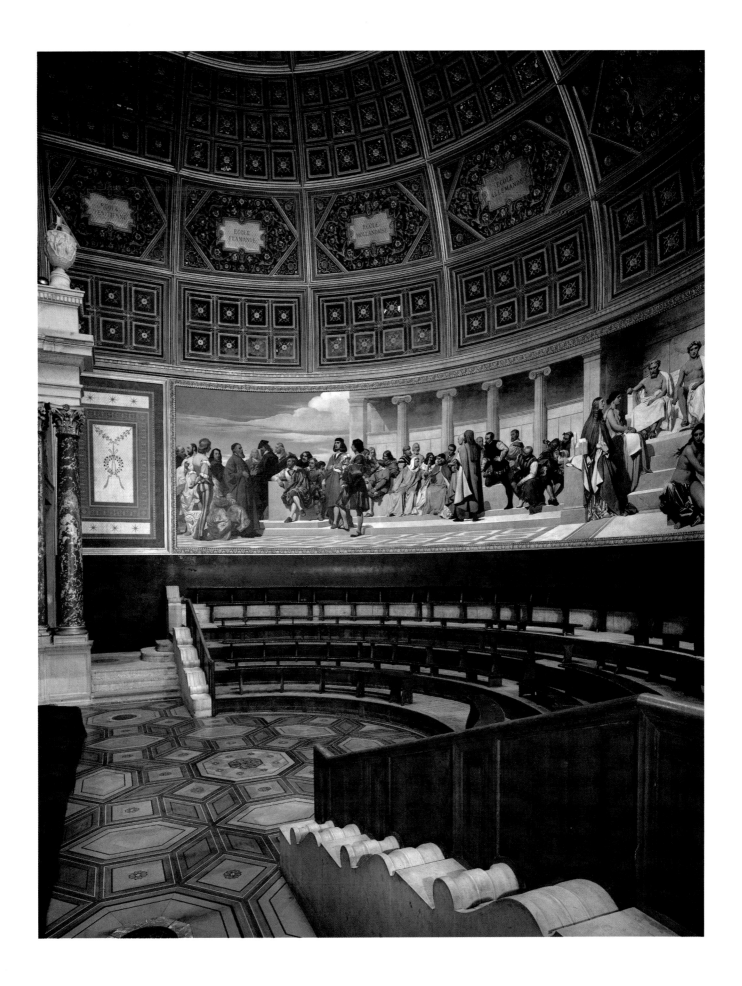

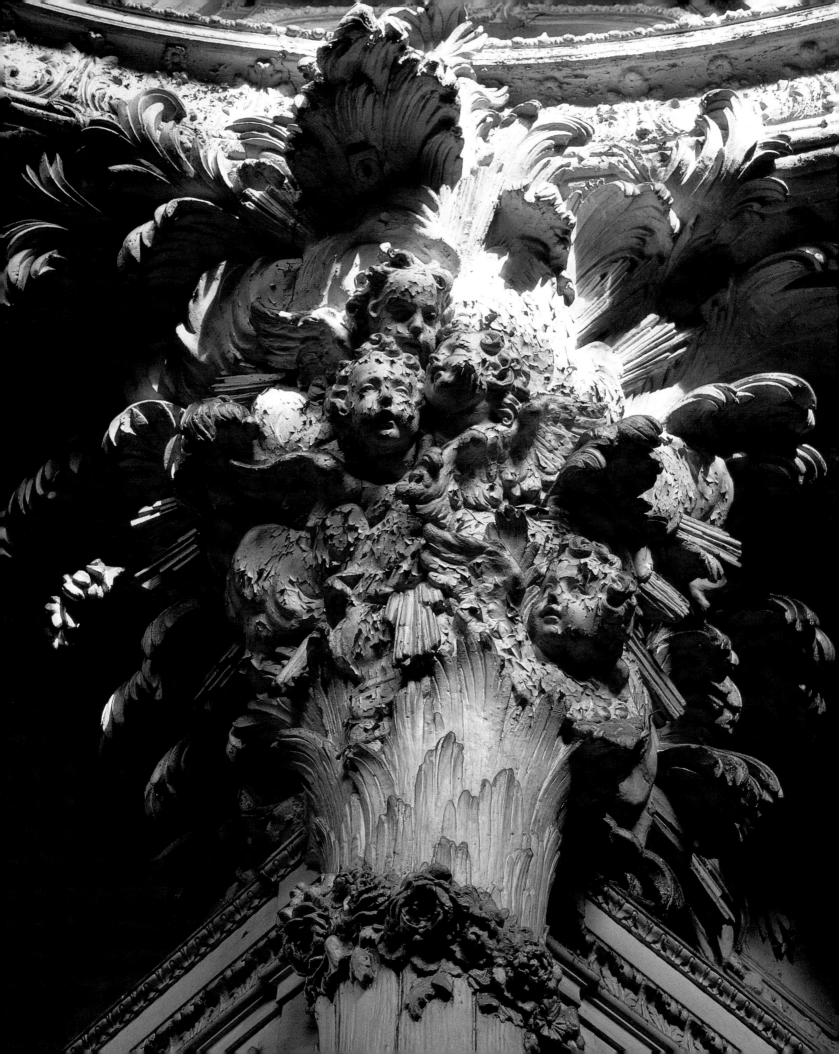

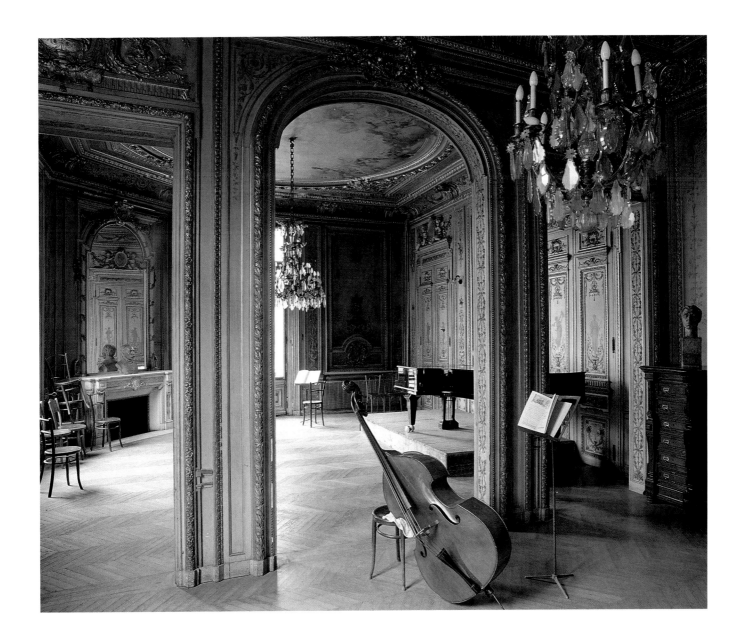

LYCÉE HENRI IV

𝒯HE Lycée Henri IV is housed in the old Abbaye de Sainte
Geneviève, headquarters of a powerful religious foundation
abolished during the French Revolution. The school has been in
occupation since its foundation in 1795, yet the building retains
several original features, including the vestiges of a thirteenth-
century kitchen and refectory. The photograph here shows a detail
from the former library, an exuberant Baroque capital composed of
luxuriant palm fronds and angelic masks. The capital is
surmounted by an astonishing frescoed cupola representing the
Triumph of Saint Augustine, painted by Restout around 1730.

ECOLE NORMALE DE MUSIQUE
ALFRED CORTOT

ℬUILT around 1881 by the architect Cochet, the Alfred Cortot
School of Music is one of the most extraordinary and least-known
buildings in Paris. The street front is relatively undistinguished, a
conventional essay in the neo-Renaissance style, but the interior is
simply breath-taking. The staircase hall (*overleaf*) is especially
impressive, its structure recalling the dizzying architectural
perspectives of the Bibiena brothers. The walls are panelled in
contrasting varieties of marble, while on the first-floor landing an
illusionistic mural gives the impression that one is standing in a
colonnaded loggia overlooking a sun-lit garden filled with
fountains and statuary. More subdued, but equally evocative, is the
eighteenth-century-style salon (*above*), which is used today as a
concert hall.

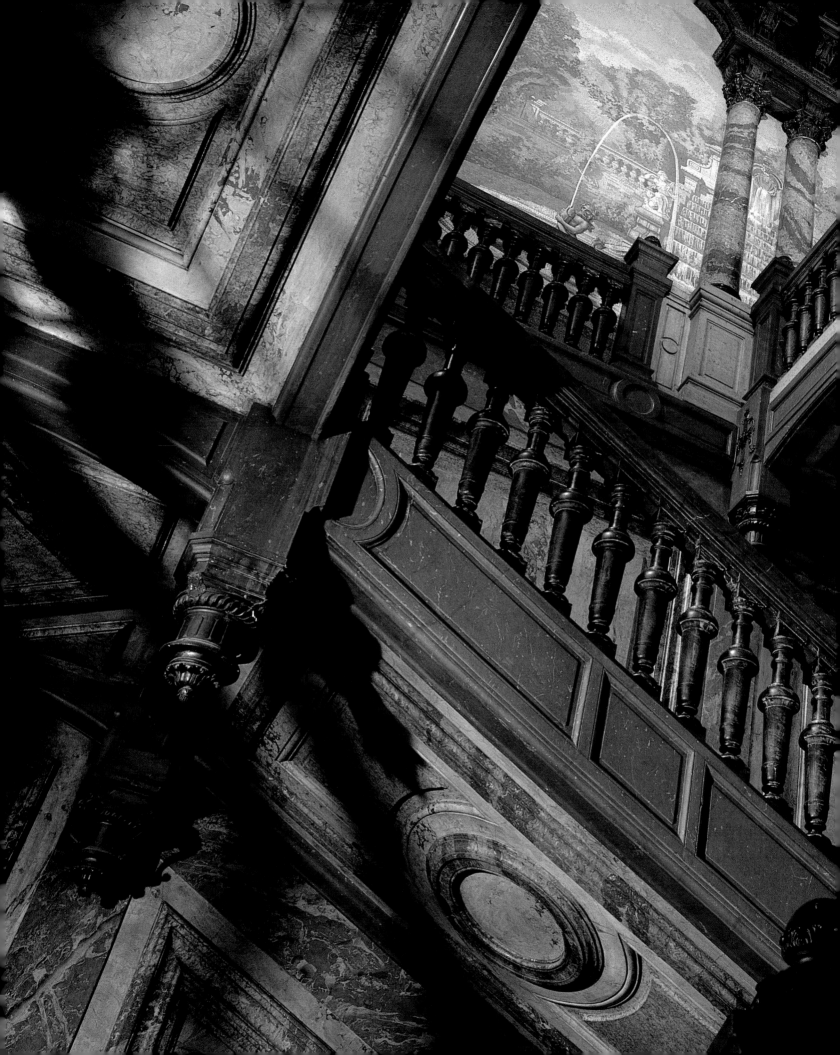

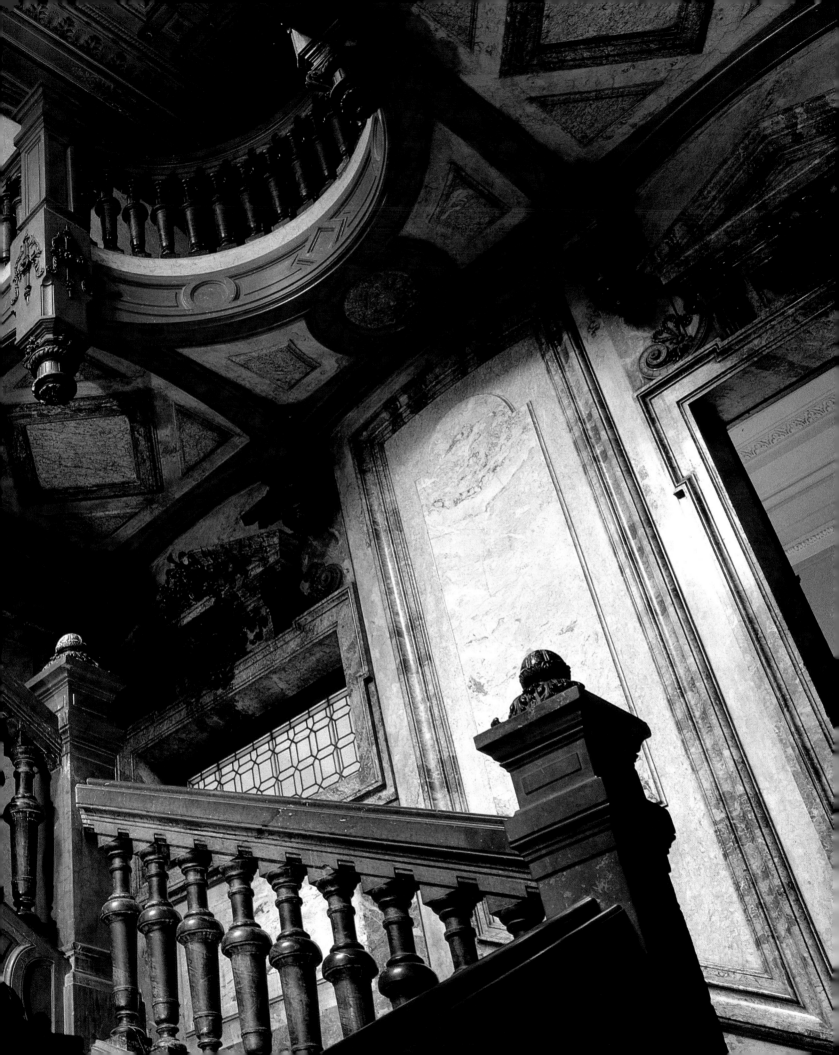

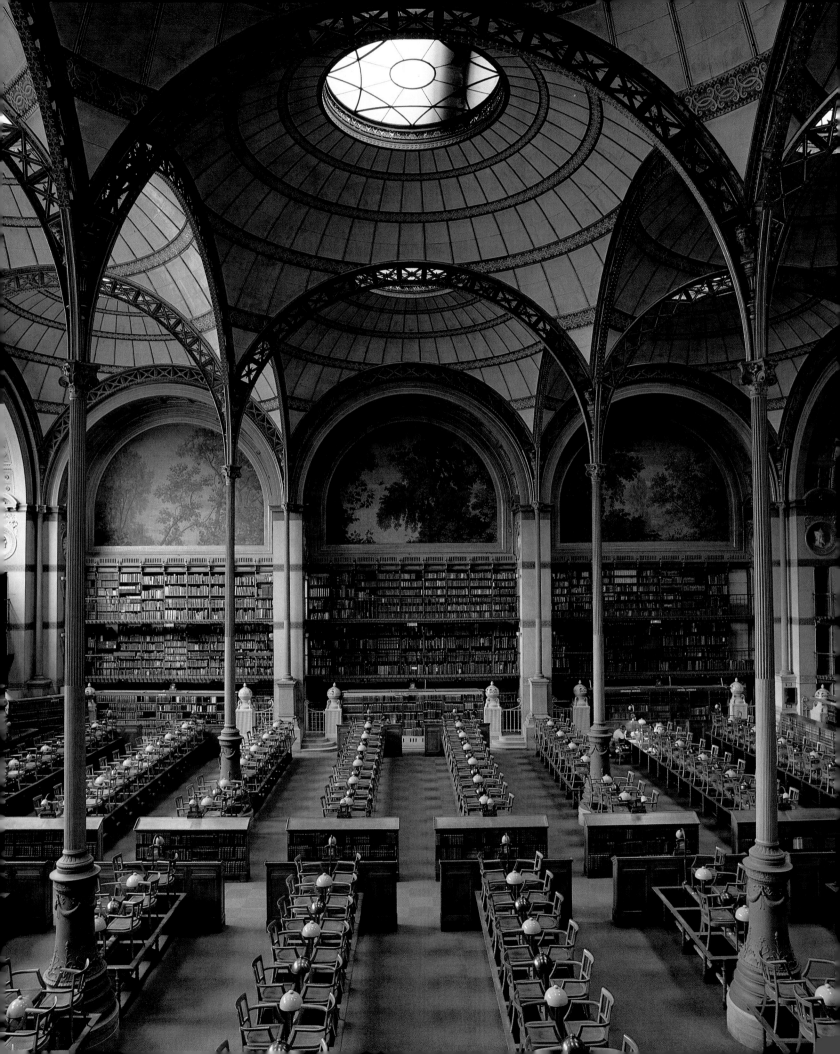

Libraries and Archives

BIBLIOTHÈQUE NATIONALE

*T*HE history of the Bibliothèque Nationale begins in the Middle Ages with the foundation of the Bibliothèque du Roi (King's Library), vestiges of which form the nucleus of the present collection. The library was established on its present site in 1721 and has continued to expand ever since. Today it occupies a wide range of buildings which include the former town house of Cardinal Mazarin, with surviving interiors by Mansart dating back to the 1640s (*see* Gazetteer), the library's chief glory is the dramatic main reading room (*left*), built in the 1860s by Henri Labrouste, architect of the Bibliothèque Sainte Geneviève (see page 80). The interior was designed to be fire-proof and is defined by sixteen metal colonnettes supporting shallow domes with inset ceramic panels and central skylights.

MINUTIER CENTRAL
Hôtel de Rohan

*A*DJOINING the Hôtel de Soubise (page 84) is the Hôtel de Rohan, which has served since 1927 as the Minutier Central, the notarial division of the Archives Nationales. The building was erected in the early eighteenth century and is famous for the *Chevaux du Soleil* (Horses of the Sun), an exquisite equestrian relief carved by the sculptor Adam above the entrance to the former stables; but the interior, though extensively remodelled in the nineteenth century, also has its treasures. Chief among these is the Cabinet des Singes or 'Monkey Room', completed around 1750 by the partnership of painter Christophe Huet and architect Saint-Martin. The room is decorated from floor to ceiling with painted boiseries representing *fêtes galantes* accompanied by mischievous animals, especially monkeys. A detail from one panel is shown above.

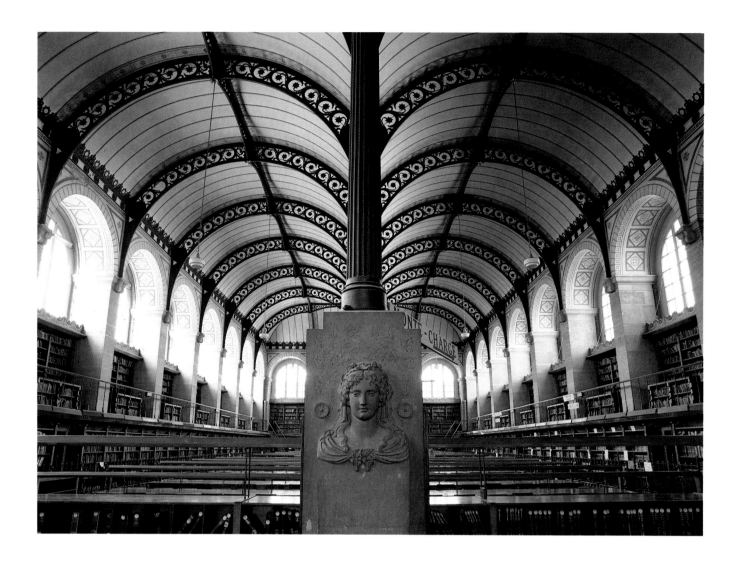

BIBLIOTHÈQUE SAINTE GENEVIÈVE

𝒯HE Bibliothèque Sainte Geneviève was designed and built by
Henri Labrouste, architect of the Bibliothèque Nationale, in
1838–50. The main reading room (*above*) is an early example fo the
use of exposed ironwork and, like that at the Bibliothèque
Nationale (*page 78*) was designed to be fireproof. The interior is
bisected by a central colonnade, a feature borrowed from the
thirteenth-century refectory of the Priory of Saint-Martin, which
Labrouste in fact converted for use as a library around the same
time he built the Bibliothèque Sainte Geneviève. Since the main
axis runs from east to west, the reading room faces the rising and
setting sun, and this is expressed in the decoration of the pedestal
of the central column, carved with female masks representing on
one side Day and on the other Night.

BIBLIOTHÈQUE MAZARINE

𝒯HE Bibliothèque Mazarine occupies a wing of the Palais de
l'Institut, built to the designs of François d'Orbay and Louis Levau
in 1663–84. The building serves today as the headquarters of the
Académie Française but was originally a school, the Collège de
Quatre Nations, founded by Cardinal Mazarin in 1661. The main
reading room (*overleaf*) is a reconstruction of the Cardinal's private
library, a majestic classical interior completed under the direction
of François Mansart around 1649. The library was originally
located in the Cardinal's own house on the opposite bank of the
Seine but was transferred to its present location a few years after
his death, together with a valuable collection of books and
manuscripts. The reading room is approached by a dramatic Neo-
classical staircase ringed by Doric columns and antique busts (*right*)
a chill construction with the funerary atmosphere of a mausoleum.
The staircase dates from 1824 and was designed by the architect
Léon Biet.

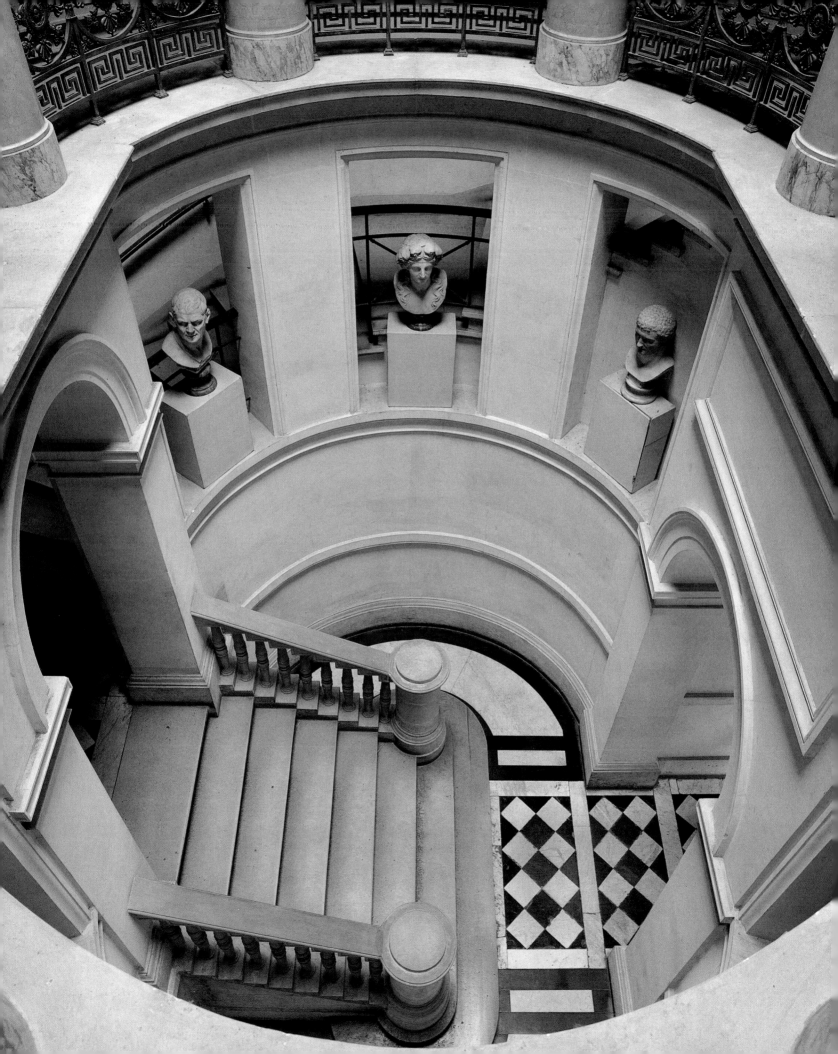

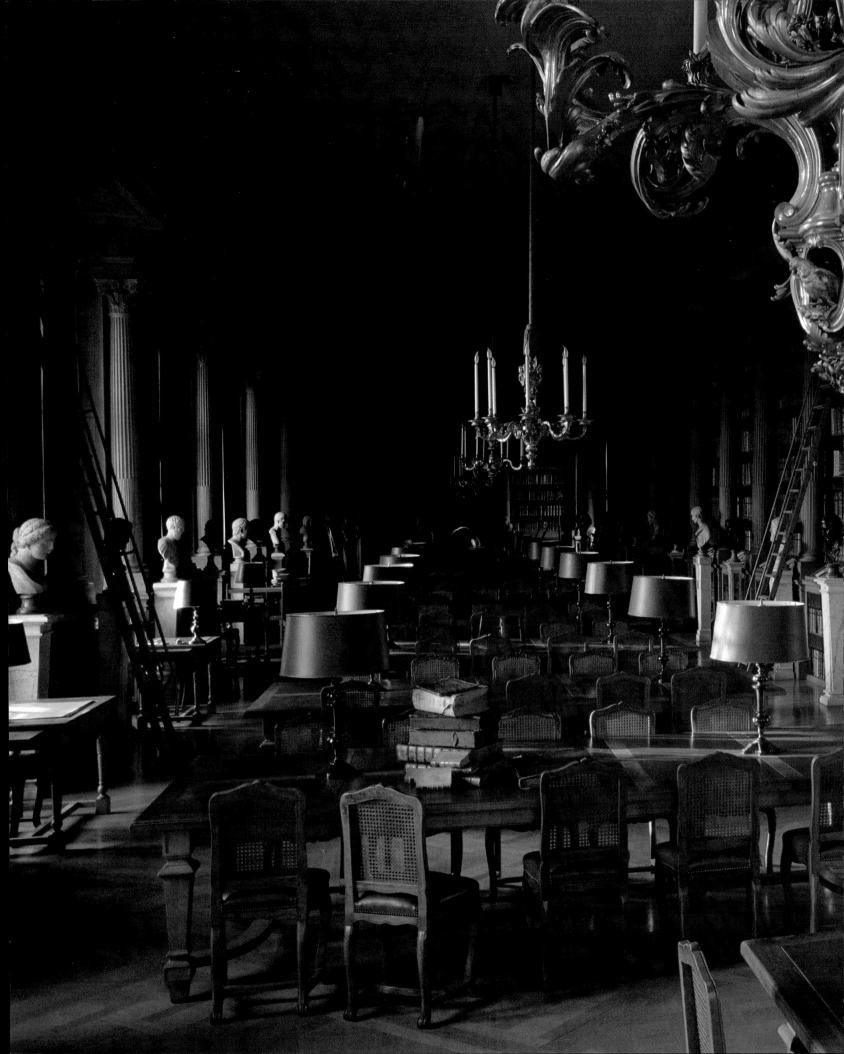

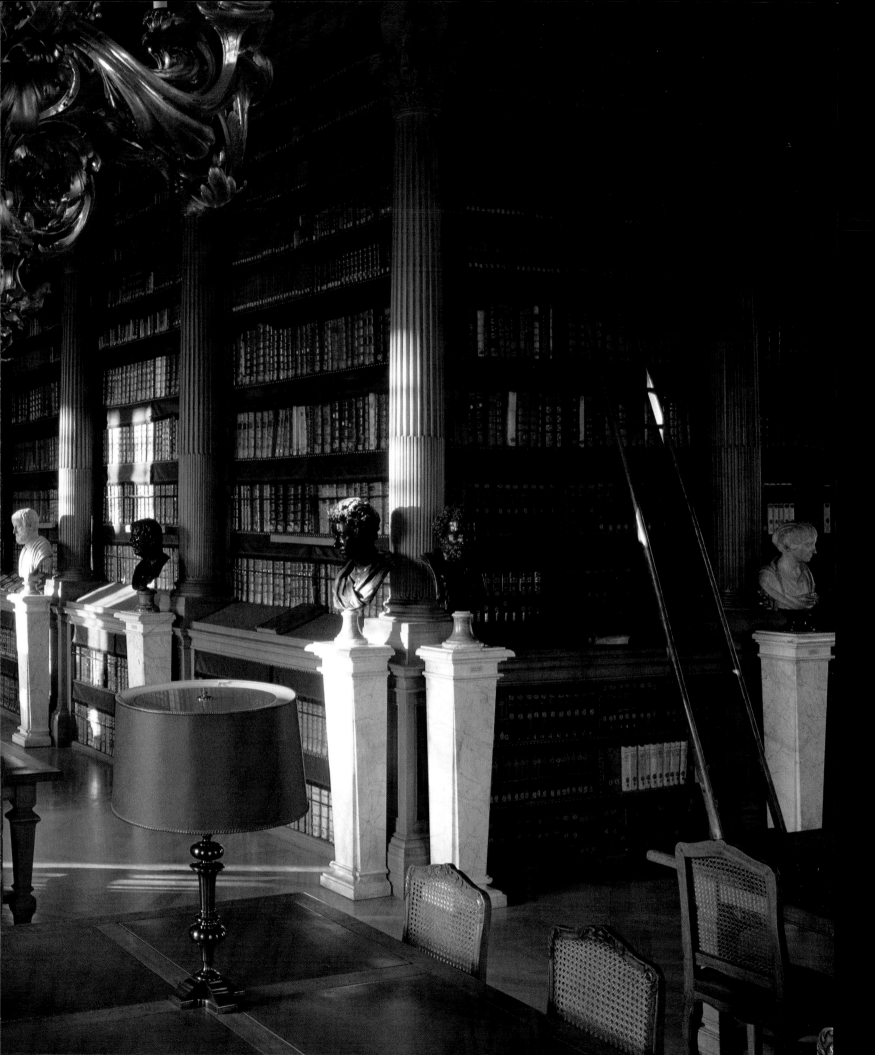

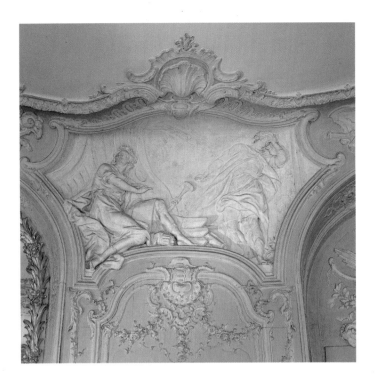

ARCHIVES NATIONALES
Hôtel de Soubise

*T*HE headquarters of France's national archives is the Hôtel de Soubise, a palatial town house in the Marais built by the architect Delamair in the first decade of the eighteenth century for François de Rohan, Prince de Soubise, and his wife, Anne Chabot de Rohan, a mistress of Louis XIV. As was customary, the Prince and Princess occupied separate apartments. The Princes was situated on the ground floor, the Princess' on the first. Both apartments were entirely redecorated in the 1730s by the architect Germain Boffrand who was assisted by some of the finest artists of the day. The sculptor Lemoine is thought to have been responsible for the magnificent carved decoration of the Prince's salon (*top left*). The detail shows a relief of exceptional beauty and poignancy illustrating the power of tragic verse. On the left a seated figure reads from the opening lines of Virgil's *Aeneid*, while on the right a second figure staggers back, masking his emotion with his hand. The decoration of the Princess's apartment (*bottom left*) is equally splendid, but more light-hearted, a virtuoso display of painting, gilding, and sculpture.

BIBLIOTHÈQUE DE L'ARSENAL

*T*HE Bibliothèque de l'Arsenal is a former gun powder factory and cannon foundry converted into a library in the early nineteenth century. The Salon de Musique (*right*) dates from 1745 and originally formed part of the private apartment of the comte d'Eu, Governor of the Arsenal and Grand Master of the King's Artillery. The over-doors are painted in *grisaille* to represent the Four Seasons and were copied from a series of stone reliefs carved by the sculptor Bouchardon for a fountain in the rue de Grenelle.

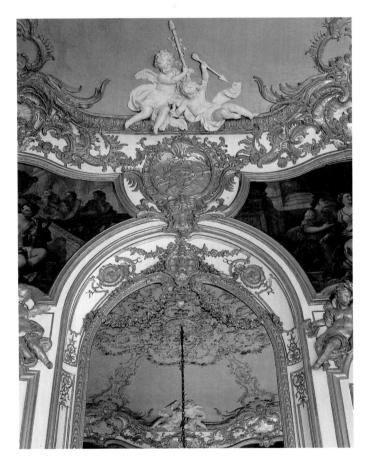

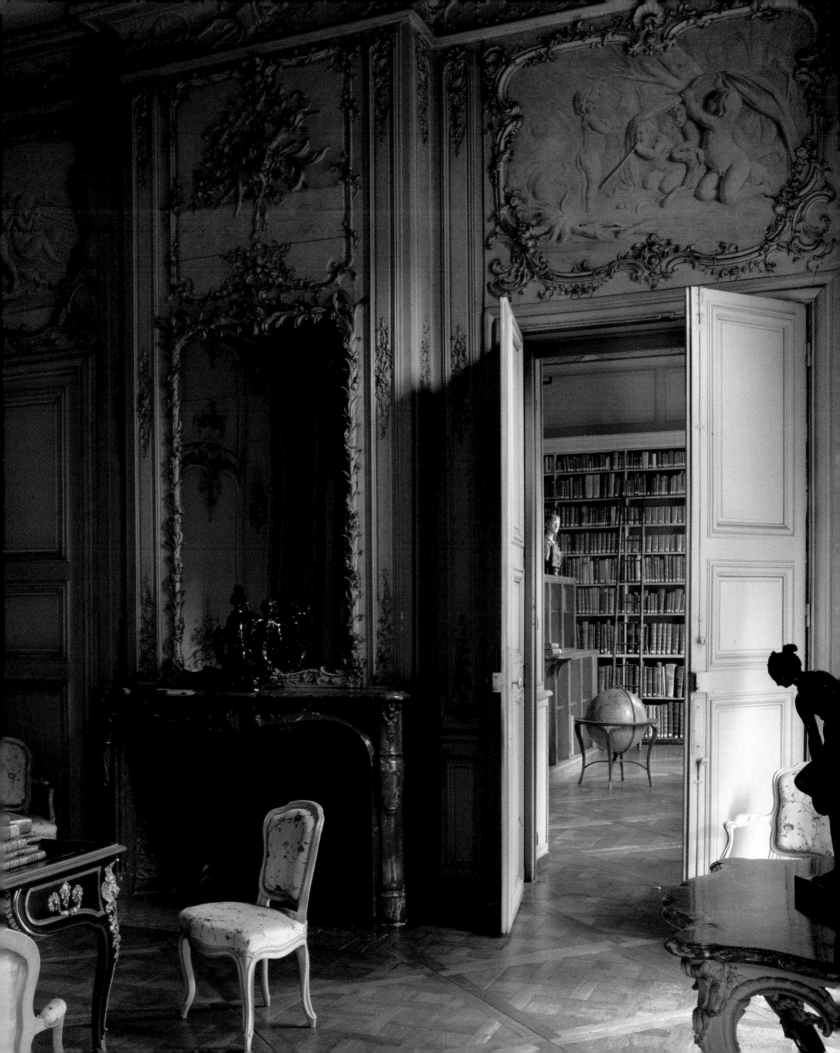

Banks and Offices

BANQUE DE FRANCE
Hôtel Gaillard

THE Hôtel Gaillard is a Neo-Renaissance palace in brick and stone built around 1878–84 for the banker and connoisseur Baron Emile Gaillard. The house was conceived as a setting for Gaillard's immense collection of late medieval and early Renaissance art, furniture, and architectural fragments. After Gaillard's death in 1902 most of the house's contents were sold, but the architectural fragments remained, embedded in the structure. The stone doorway above is reputed to have come from the royal château of Fontainebleau and to date from the reign of François Ier. The miniature winged figure on the staircase is Baron Gaillard himself.

SOCIÉTÉ IMMOBILIÈRE DE LA
CHARCUTERIE FRANÇAISE

THE corporation of French *charcutiers* was founded in the fifteenth century, but it was not until the turn of the twentieth that a headquarters was built in Paris by the architect Jules Michel. The staircase hall (*right*) is quite unique, decorated from floor to ceiling with painted and gilt butchers' signs advertising the wares of donors who helped to finance the building's construction. The interior is lit by an impressive stained glass window symbolizing the virtues of the trade. A bust by Alfred Boucher (no pun intended) honours a former corporation president.

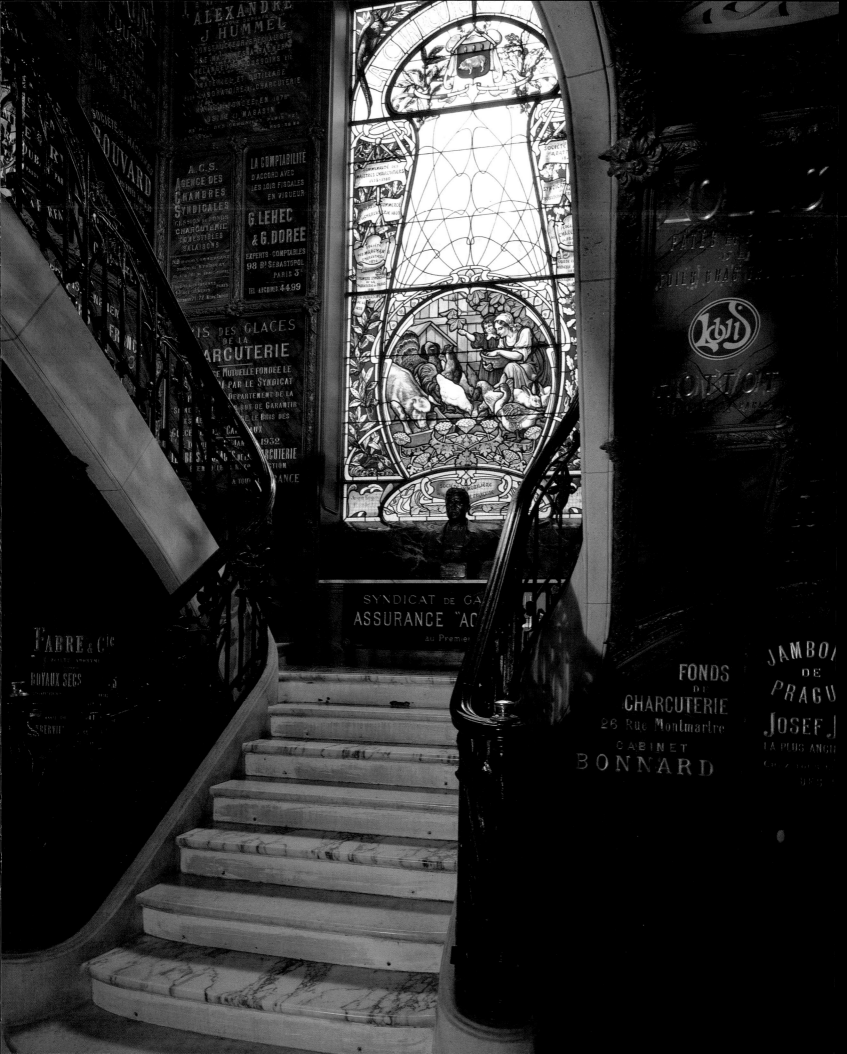

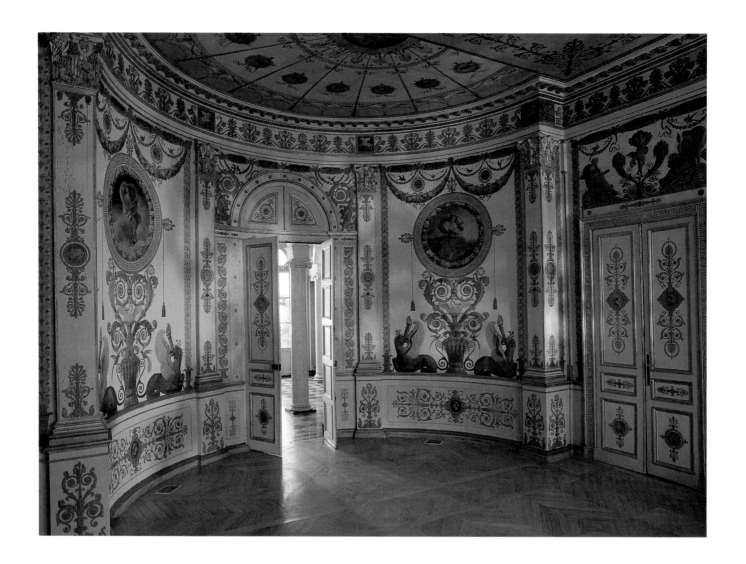

SICOMI
Hôtel de Bony

\mathcal{B}UT for a public outcry in the mid 1970s this outstanding Neo-classical town house might have been demolished. Instead it has been listed (grade I) and restored. The building dates from the late 1820s and is situated in an area known as La Nouvelle France, where several late eighteenth- and early nineteenth-century houses survive, among them the Hôtel Botterel-Quintin (page 90) and the Hôtel de Bourrienne (page 50). The architect was Jules de Joly, a pupil of Percier, whose influence is apparent in the magnificent painted salon (*above*), which serves today as a boardroom leading through to an austere yet elegant entrance hall with Ionic columns in scagliola.

BANQUE DE FRANCE
Hôtel de Toulouse

\mathcal{I}T is hard to believe, but from 1793 to 1808 the Galerie Dorée (*right*) served as a paper store when the Hôtel de Toulouse was occupied by France's national printing works (*right*). The house was built in 1633–43 by the architect François Mansart for the marquis de la Vrillière but was occupied from 1713–37 by Louis-Alexandre de Bourbon, comte de Toulouse, the natural son of Louis XIV and his mistress Madame de Montespan. The proportions of the room are unchanged since its construction, but the ceiling, by François Perrier, which was originally painted in *grisaille*, was 'coloured in' by order of the comte de Toulouse around 1718–19. The panelling too dates from this time and was designed and executed by the partnership of architect Robert de Cotte and sculptor François-Antoine Vassé. The paintings on the walls are copies of original old masters removed to the Louvre in the 1870s when the room was overhauled. Originally intended as a setting for works of art, the Galerie is used today for receptions and conferences.

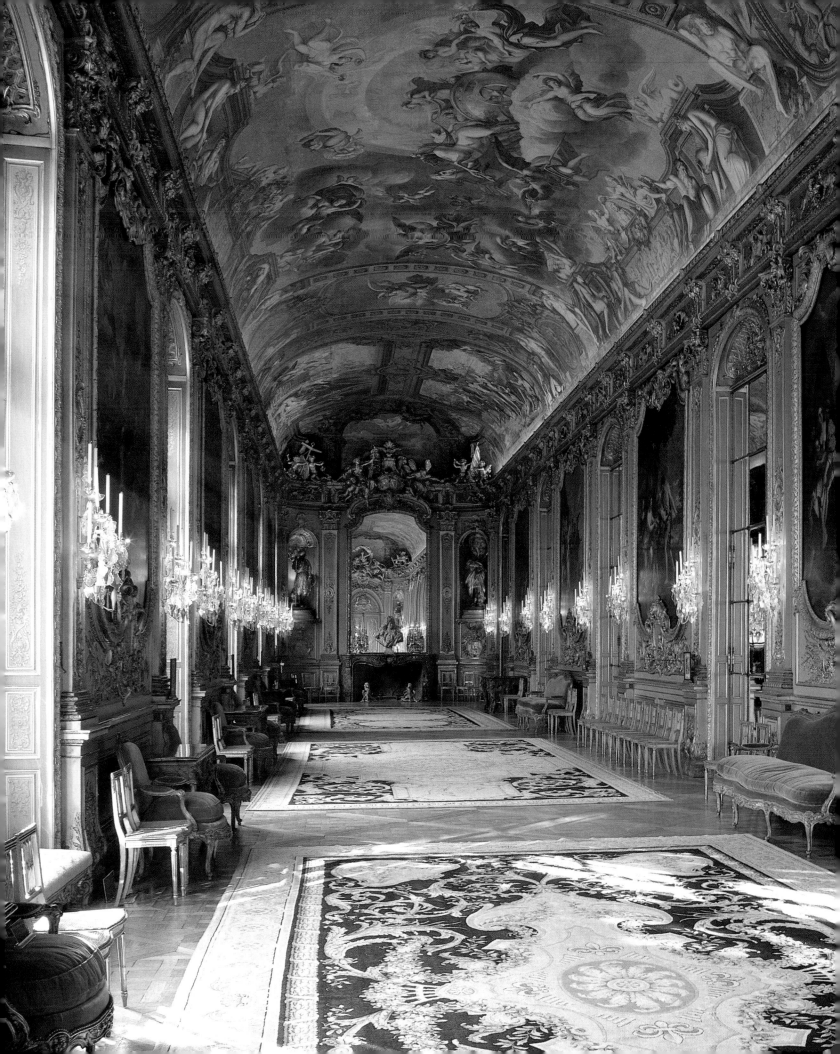

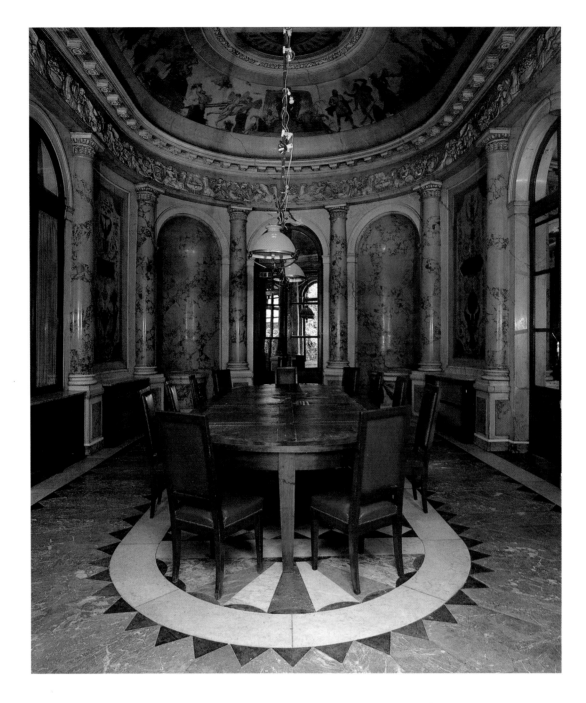

SFICA

Hôtel de Botterel-Quintin

\mathcal{T}HE Hôtel de Botterel-Quintin dates from the early 1780s and is generally attributed to the architect Pérard de Montreuil. The interior is of classical inspiration with a remarkable Pompeiian-style staircase decorated with murals representing miniature chariots driven and drawn by winged insects. The former dining room (*above*), which serves today as a boardroom, has a superb inlaid marble floor and a coved ceiling decorated with a continuous frieze of painted figures. The walls are lined with powerful Doric columns supporting an enriched cornice in high relief, and also with painted panels representing arabesques and mythological figures. Set into the niches are pedestals which must once have supported statues. The interior demonstrates the use of scagliola, a plaster compound imitating marble, which originated in Italy and was very much in vogue in the late eighteenth and early nineteenth centuries.

Museums

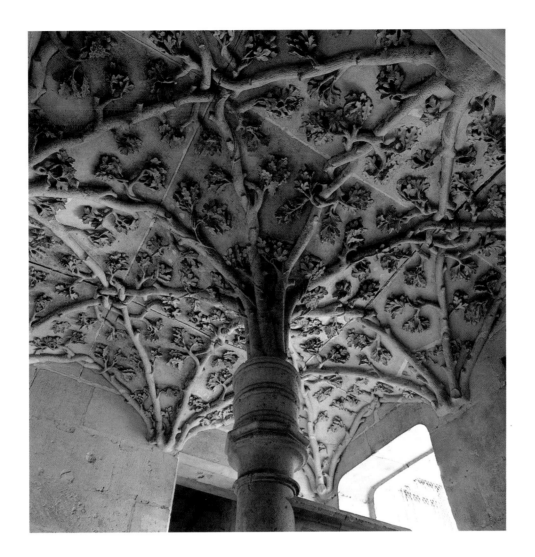

TOUR DE JEAN SANS PEUR

THE Tour de Jean Sans Peur is all that remains of the once magnificent Hôtel de Bourgogne a palace erected in the Middle Ages by the Dukes of Burgundy. The tower, which dates from the early fifteenth century, takes its name from the man who built it Jean, duc de Bourgogne, otherwise known as 'Jean Sans Peur' or 'John the Fearless'. Ironically, the Duke used it as a hideout after murdering the duc d'Orléans, head of the rival house of Armagnac. Rising through the centre of the tower is a dizzying spiral staircase which culminates in a dramatic vaulted ceiling carved in stone with radiating oak branches symbolic of the power and irresistible growth of the house of Burgundy.

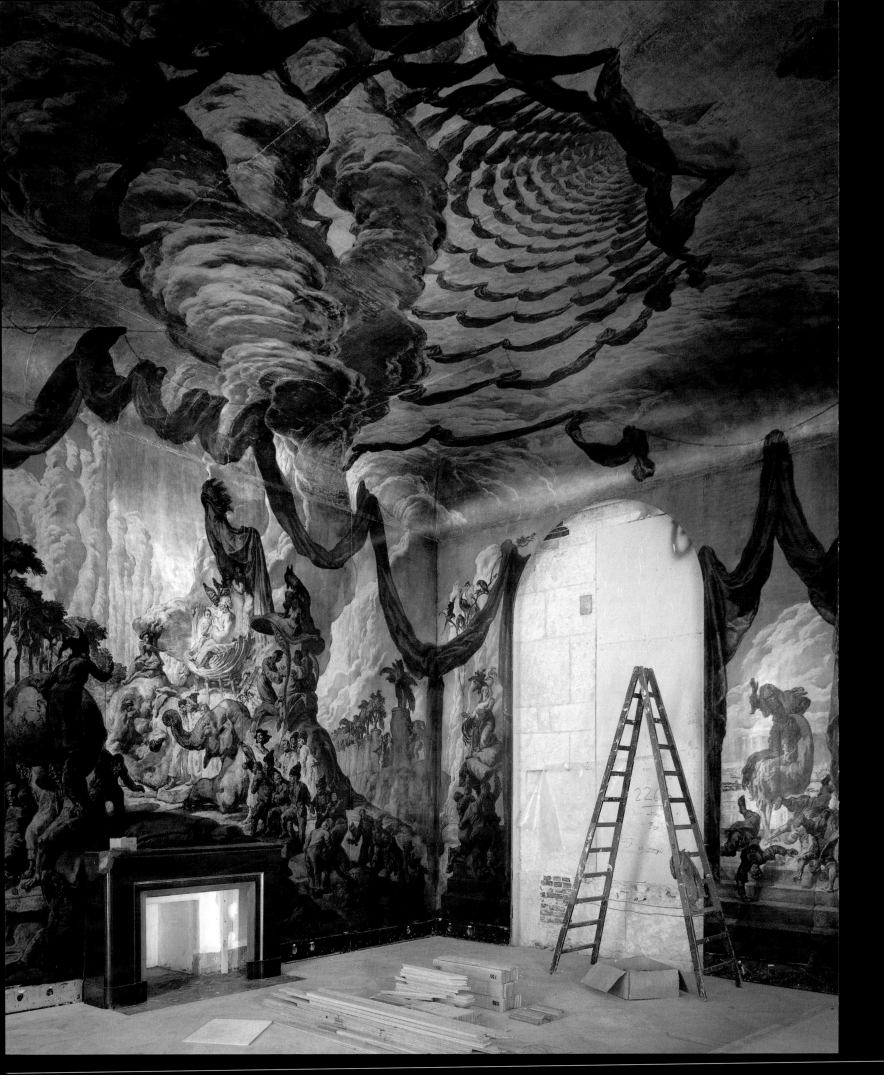

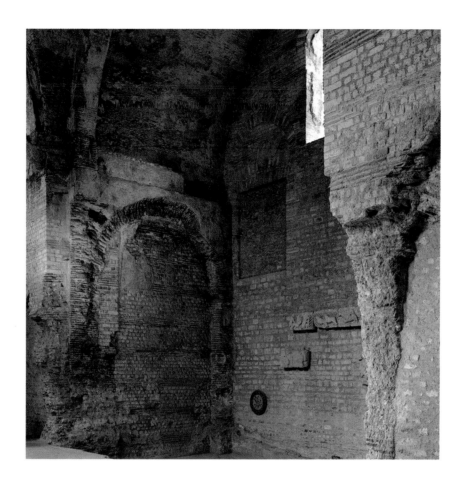

MUSÉE CARNAVALET

*P*HOTOGRAPHED while still under reconstruction, this astonishing ball room (*left*) is one of the most exciting new additions to the Musée Carnavalet, the museum of the history of Paris. The interior was salvaged from the old Hôtel Wandel, a town house which has since been converted into offices. It was decorated in 1923–24 by the Catalan painter José Maria Sert in a style inspired by French and Venetian painting of the eighteenth century. The walls and ceiling are decorated with silver-gilt panels overlaid in sepia and crimson to represent the visit of King Solomon to the Queen of Sheba. The Musée Carnavalet houses several reconstructions of period interiors, the earliest being the mid seventeenth-century *cabinet* from the Hôtel de Colbert-Villacerf. Several more interiors lie in storage, awaiting the day when funds and space will be made available to reassemble them.

HÔTEL DE CLUNY

*T*HE earliest surviving interior in Paris is the Gallo-Roman bath house at the Hôtel de Cluny (above), which has served in its time as a barn, a stable, a coach-house, a cooper's workshop, and a laundry. The bath dates from the reign of Caracalla and was built around the AD 215. Ruined in the Barbarian invasion and trampled by the Normans, much of the building gradually disappeared under a mound of earth and vegetation. Excavations began in 1819 and the bath's true value was finally recognized in 1837, when it was acquired by the city authorities, restored by Albert Lenoir, and handed over to the state, opening as a public museum in 1844. Excavation work continues, but the archaeologists are generally agreed that the building was erected by a powerful guild of boat-builders, whose symbol, the prow, appears below the vaulted ceiling (*top left*).

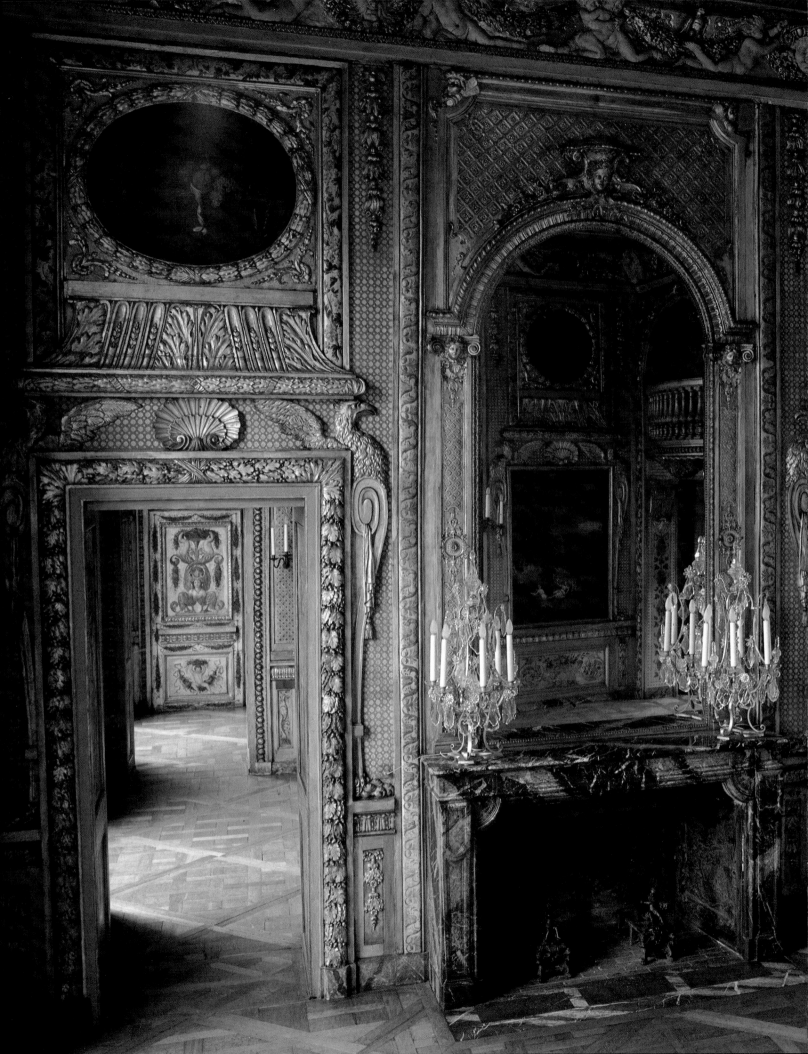

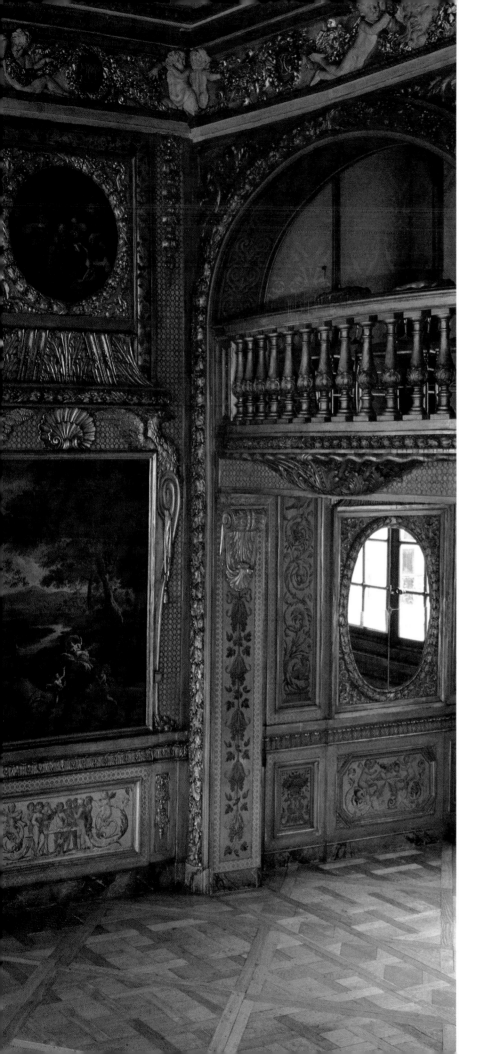

HÔTEL DE LAUZUN

*T*HE Hôtel de Lauzun is a mid seventeenth-century town house situated on the Ile Saint Louis overlooking the Seine. It was built for a war profiteer, Charles Gruyn des Bordes, but takes its name from a later occupant, the duc de Lauzun, who purchased the house in 1681 following his marriage to the Grande Mademoiselle, first cousin of Louis XIV. After the Revolution the building was divided up into units and let, becoming known as the Hôtel des Teinturiers when the ground floor and basement were occupied by a firm of dyers and launderers. The poet Charles Baudelaire was a tenant in the 1840s, as was Théophile Gautier, who used the house as the setting for *Les Haschichins*, a sinister short story about a circle of dope fiends. The story was based on fact, since another tenant, Fernand Boissard, ran a notorious club for hashish smokers. The smoke has since cleared and the house is now a respectable museum; a beautiful one also, incorporating several interiors with surviving seventeenth-century decoration. The Salon de Musique features minstrels' galleries and a painted ceiling attributed to Dorigny, a pupil of Simon Vouet.

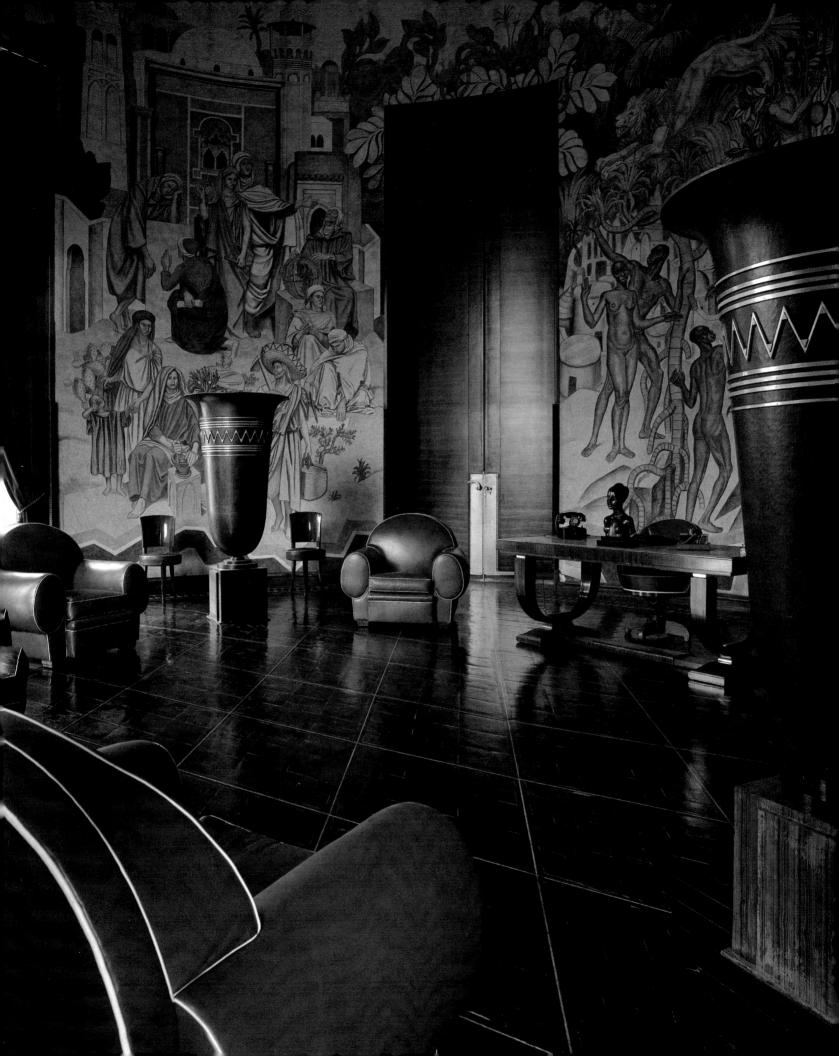

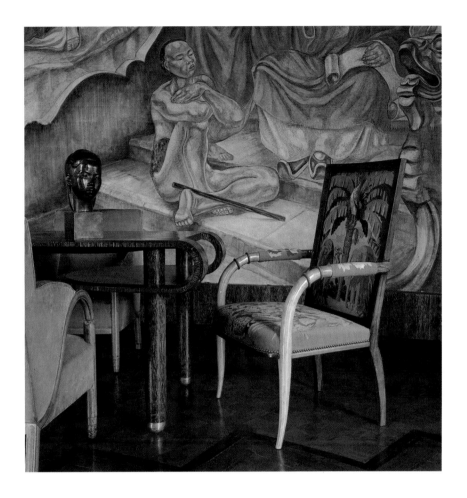

MUSÉE DES ARTS AFRICAINS ET OCÉANIENS

*O*RIGINALLY built for the Exposition Coloniale in 1931, the Musée des Arts Africains et Océaniens is a masterpiece of Art Deco architecture and interior decoration. The Salon Paul Reynaud (*left*) was designed by Jacques-Emile Ruhlmann and is perhaps the most complete interior of its kind in Paris. The salon was named after a former Minister for the Colonies, and it was the colonies which supplied most of the materials for the fittings and furniture. The floor is of inlaid ebony, as is the desk, and there are ivory handles to the doors. The vases are by Edgar Brandt, and the walls are decorated with allegorical frescoes by Louis Bouquet representing the advantages of French colonialization. Equally impressive is the Salon du Marechal Lyautey (*above*) which features a magnificent suite of furniture in exotic woods including an armchair with tapestry covers. Perched in a palm tree, the cockerel of France holds sway.

MUSÉE GRÉVIN

*T*HE Palais des Mirages (*overleaf*) is a metamorphic interior which can be transformed by means of mirrors and machinery from a tropical jungle to an Indian temple to a Moorish palace. The interior dates from 1900 and was designed by the architect Emile Hénard as an exhibit for the Paris World Fair, where it was spotted and afterwards purchased by the director of the Musée Grévin, a famous wax-works museum founded in 1880.

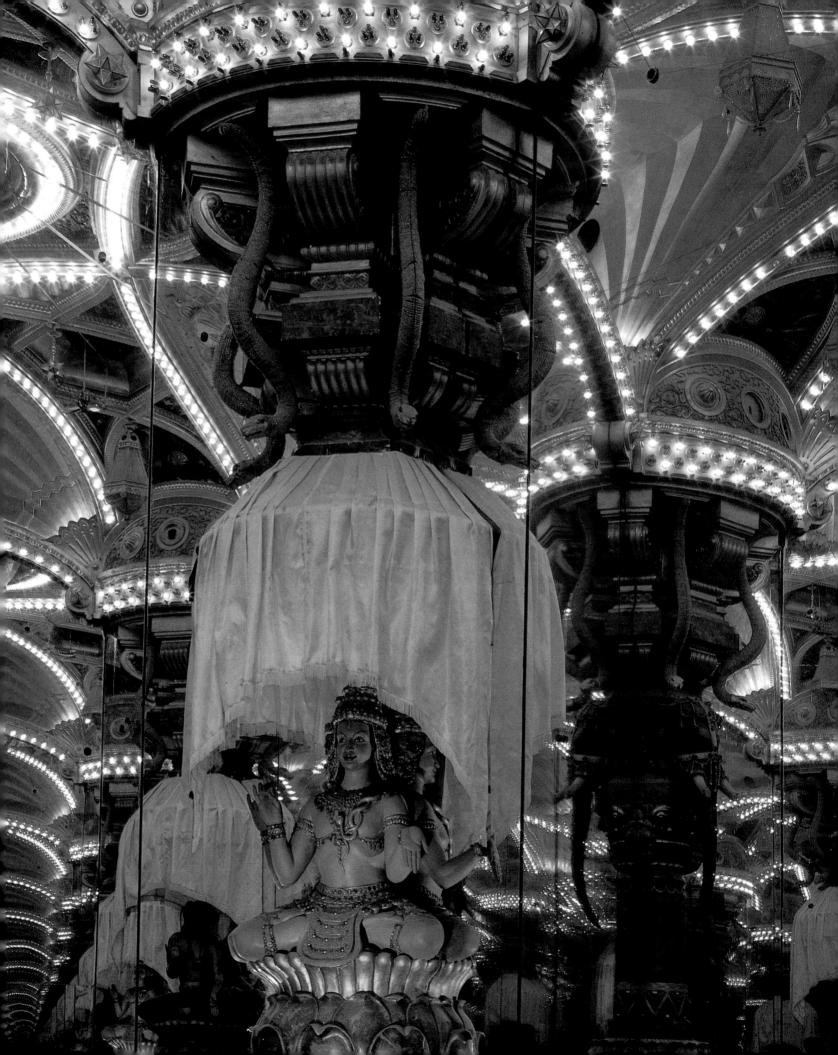

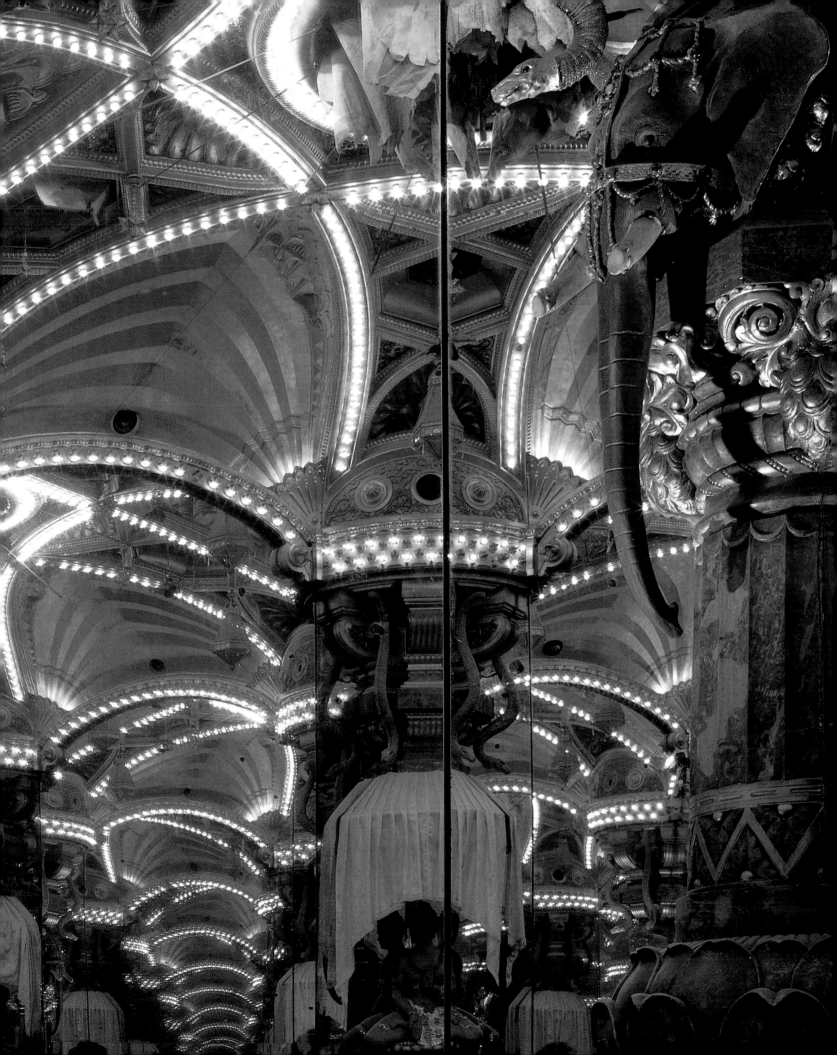

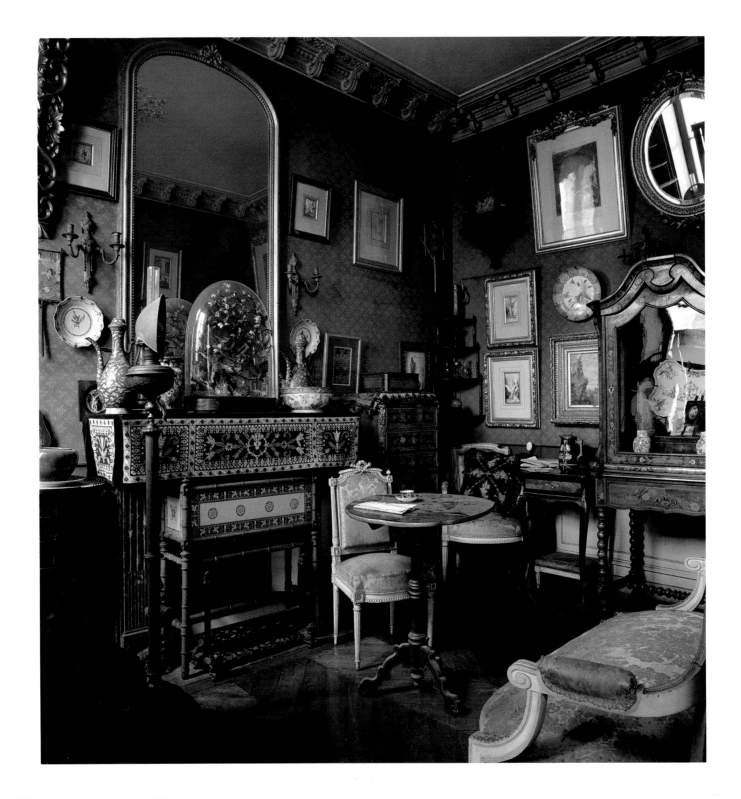

MUSÉE GUSTAVE MOREAU

*T*HE Musée Gustave Moreau is one of the sights of Paris. Thousands of visitors stream through its studios and exhibition rooms each year. But few are ever admitted to the private apartment, originally occupied by Moreau's parents, which is virtually undisturbed since his the artist's death in 1898. The apartment perfectly evokes the atmosphere of a prosperous and cultivated middle class French home in the second half of the nineteenth century. A little too perfectly in fact, for the interiors are not as they were in the lifetime of Moreau's mother and father, but as the artist arranged them in the last years of his life, carefully contriving an idealized family picture for posterity.

Embassies

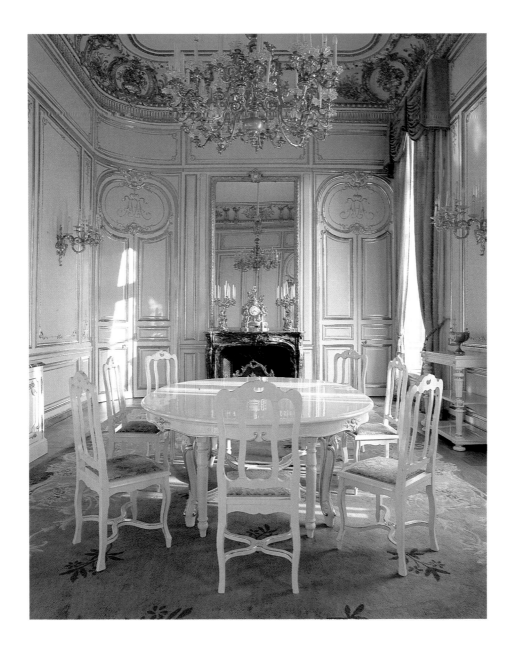

SOVIET EMBASSY
Hôtel d'Estrées

*I*T comes as some surprise to discover that the Soviet Ambassador resides in an eighteenth-century ducal palace, and that in the first-floor dining room (*above*) the overdoors still bear the monogram of a former Tsar, while just out of view the cornice is decorated with the double-headed eagle of Imperial Russia. The interior dates from the 1860s, but the house is earlier. Built in 1711–13 by Robert de Cotte, it has recently been restored by a team of expert conservators from the Hermitage in Leningrad. So much for Bolshevik iconoclasm.

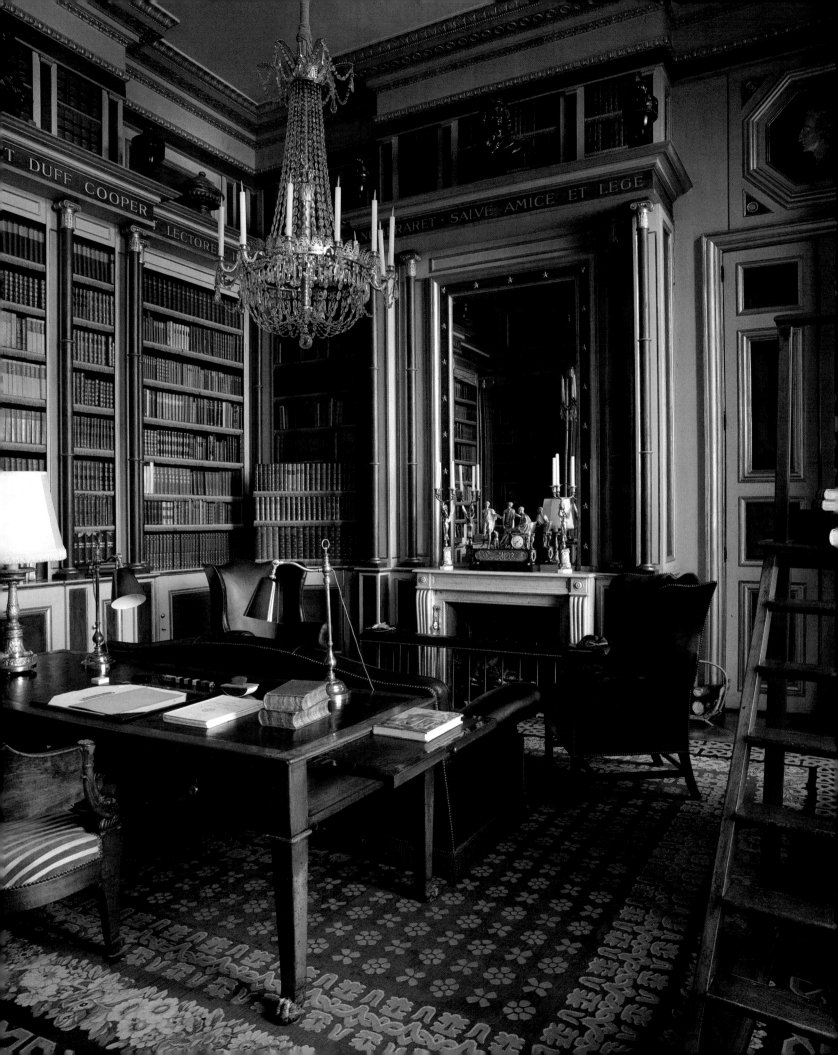

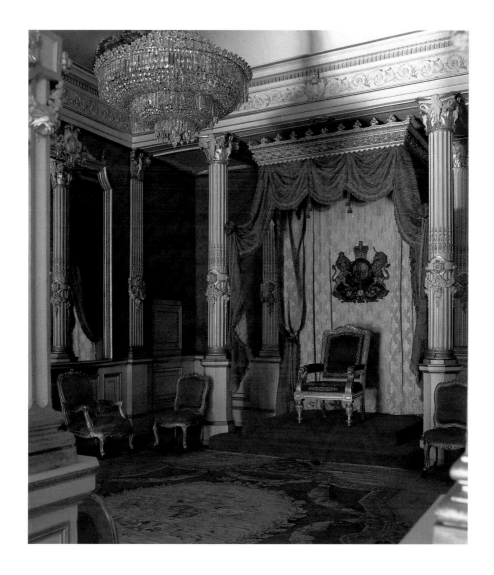

BRITISH EMBASSY
Hôtel de Charost

*T*HE Hotel de Charost has been the official residence of the British Ambassador to France since 1814, when it was purchased by the Duke of Wellington from Pauline Borghese, younger sister of Napoleon, following the collapse of the First Empire. The house was built in the early 1720s for the family of the duc de Charost. It was Britain's first permanent embassy abroad and in architectural terms is still the most distinguished, with interior features from almost every period since the reign of Louis XV, as well as a magnificent collection of First Empire furniture and bronzes dating from the occupation of Pauline Borghese. The Throne Room (*above*) recalls the reign of Queen Victoria, who visited the house on several occasions and whose cypher appears in the carved decoration of the chairs. The royal arms are represented in the centre of the carpet and on the canopy above the throne. The Duff Cooper Library (*left*) dates from 1945 and takes its name from the Ambassador who

commissioned it, Sir Alfred Duff Cooper, whose thankless task it was to mediate between the warring egos of Sir Winston Churchill and General de Gaulle in the period following the liberation of Paris. The interior evokes the period of the First Empire and was conceived by three leading French designers, the architect Georges Geoffroy, the stage designer and painter Christian Bérard, and the millionaire collector and socialite Charles de Beistegui. It was Duff Cooper's idea to add the portrait relief of the Duke of Wellington over the door on the right, which is matched by another on the opposite side of the room representing Pauline Borghese. Funds and materials were extremely limited, and so great ingenuity and thrift were required. The vases and busts are of papier mâché lacquered in imitation of granite, while the panelling and colonettes are of simple hardboard, grained in imitation of mahogany. A Latin inscription bids the reader welcome.

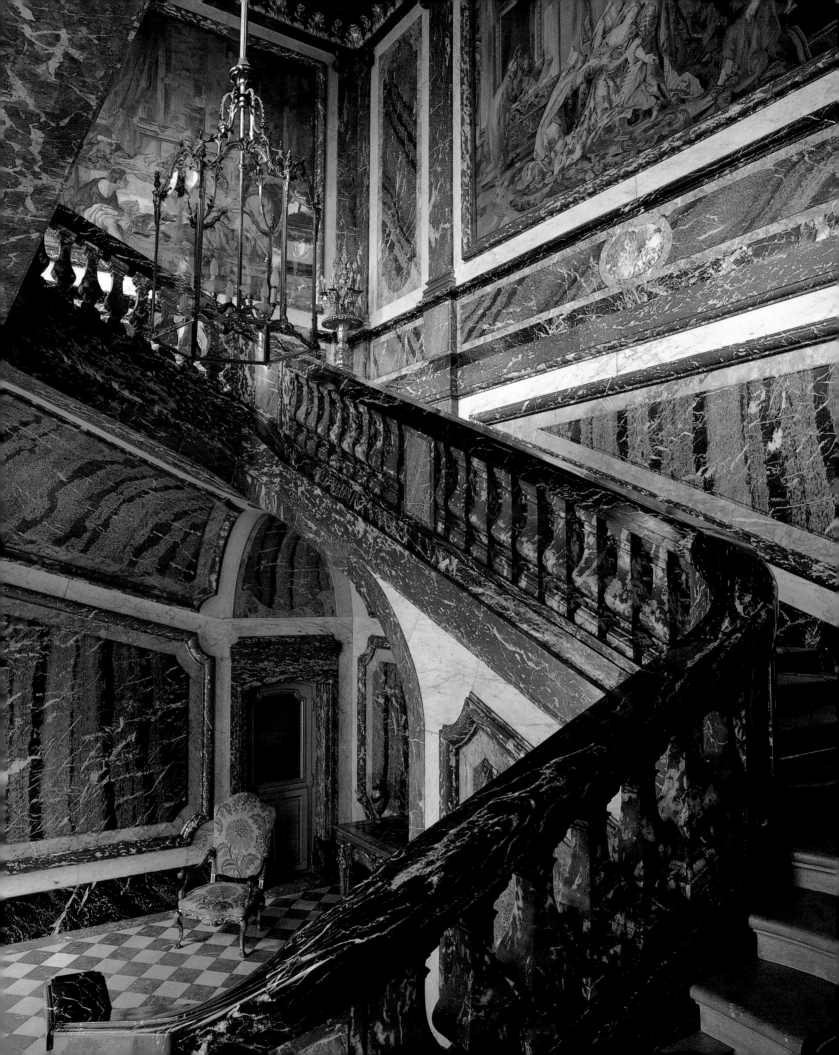

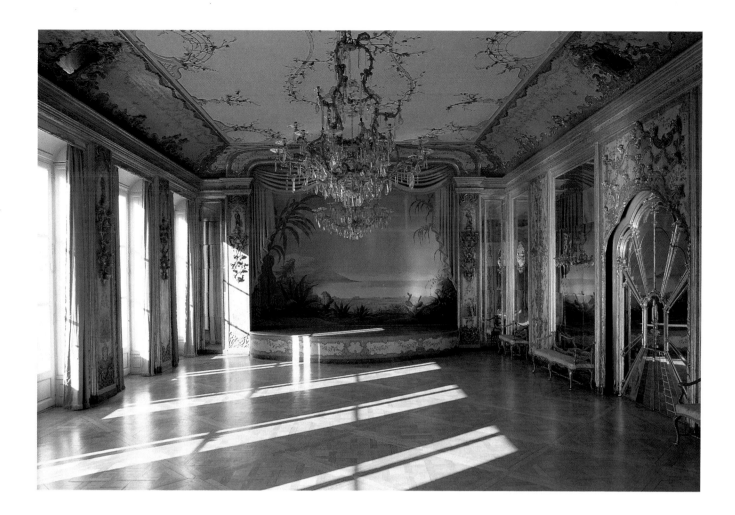

ITALIAN EMBASSY
Hôtel de Boisgelin

*T*HE Italian Embassy occupies the old Hôtel de Boisgelin, built around 1732 and occupied from 1783 to 1792 by Jean de Dieu-Raymond de Boisgelin, Archbishop of Aix. The spectacular marble staircase (*left*) dates from the Second Empire, when the house was remodelled for the duc de Doudeauville-Bisaccia, a notorious prude who used his influence as Minister for the Arts to lengthen the dresses worn by ballerinas at the Paris Opera and to mask the nudity of antique statues in French museums with vine leaves. The Salle de Fêtes (*above*) dates from the late 1930s and is designed to evoke the atmosphere of an eighteenth-century Sicilian theatre. The walls are decorated with carved and gilt panels salvaged from the Palazzo Bagheria near Palermo, while the chandeliers and sconces come from the Palazzo di Pola. The rear of the stage is occupied by a painted backcloth representing a Sicilian seascape, and the ceiling, studded with painted metal garlands, is a replica of another at the old city hospital in Palermo. The interior was conceived by the partnership of French architect Félix Bruneau and Venetian antiquary Adolfo Leovi. It is one of a suite of such rooms, each decorated in a different style to recall a particular region of Italy. The Italian Ambassador need never feel homesick.

POLISH EMBASSY
Hôtel de Monaco

*I*N 1837 the royal palace of Versailles was opened as a public museum. The impact on architecture and the decorative arts was immediate and lasting. The Hôtel de Monaco (*overleaf*), occupied since 1937 by the Polish Embassy, is an early example of the revival of the Louis XIV style, a version of which had been practised in England as early as the 1820s. The house was built for William Williams Hope, a banker and art collector of Dutch extraction, but takes its name from the building it replaced, and which in elevation it emulates, Brongniart's Hôtel de Monaco, built for the princesse de Monaco a few years before the Revolution. Pictured overleaf is one of the first-floor salons, with a magnificent marquetry floor and views through to the marble dining room and a sumptuous reception room hung with green silk damask. The salon serves today as a concert hall, an appropriate choice since the cornice is surmounted by classical lyres.

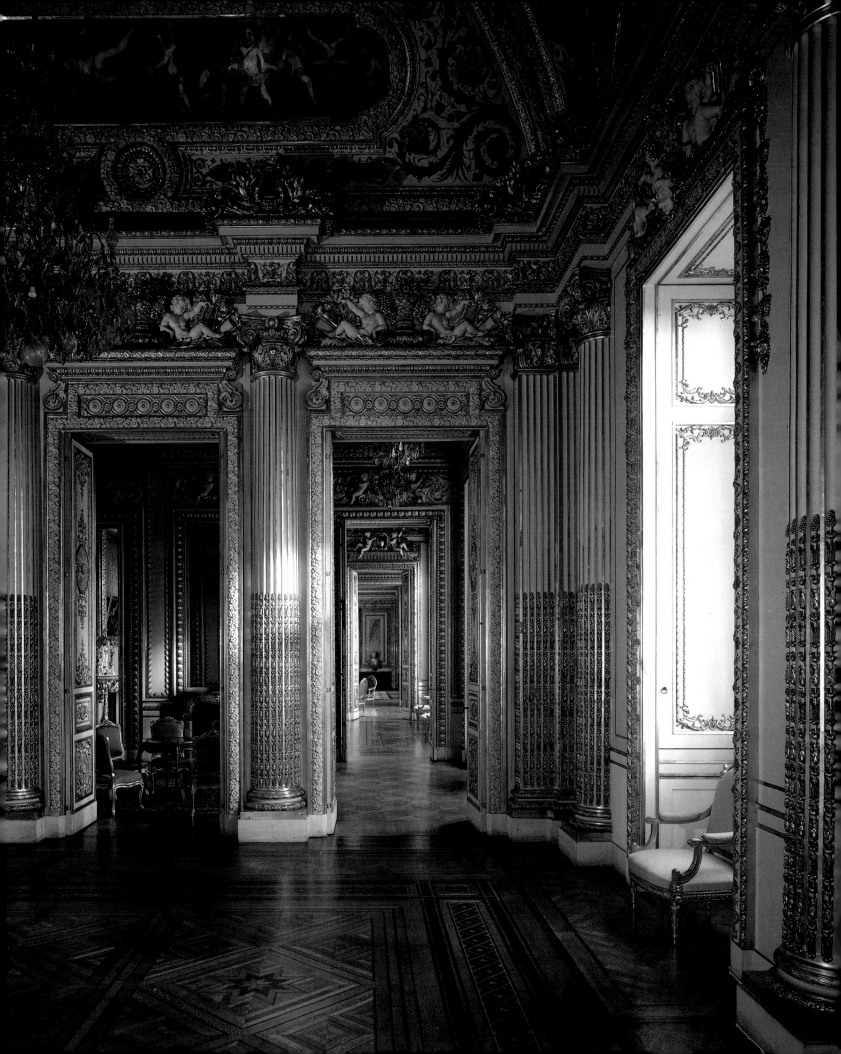

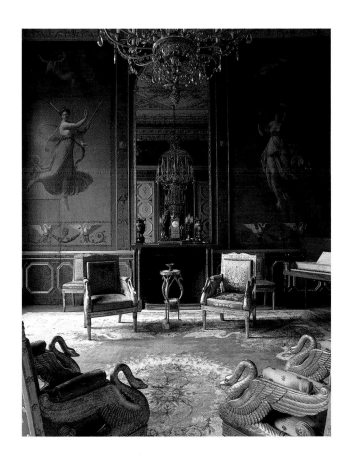

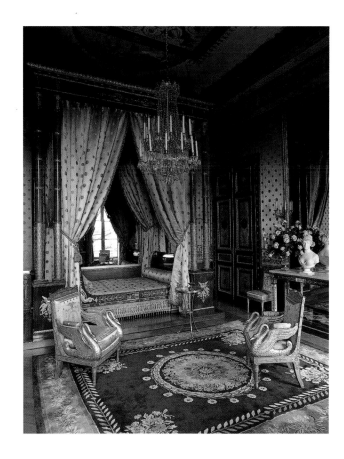

EMBASSY OF THE FEDERAL REPUBLIC OF GERMANY
Hôtel de Beauharnais

*T*HE restoration of historic buildings generally boils down to politics and money. In the case of the Hôtel de Beauharnais, restored in 1965–68, the politics could not have been more favourable, nor the money more plentiful. The house was built in the early eighteenth century by Germain Boffrand, but the interior was entirely redecorated in sumptuous First Empire style by Nicolas Bataille around 1804–06 for Eugène de Beauharnais, stepson of the Emperor Napoleon. In 1818 the house was acquired by Kaiser Friedrich Wilhelm of Prussia, later becoming the offical residence of the German Ambassador. Following the Second World War the building was confiscated by the French Government and used as ministerial offices. Then came the rapprochement between France and the Federal Republic, with at its root the warm personal relationship between the French President General de Gaulle and his West German counterpart Konrad Adenauer. In 1962, as a gesture of reconciliation, the Hôtel de Beauharnais was returned. The Federal Government reciprocated by spending several million deutschmarks on restoring this French architectural treasure. The result is simply spectacular, one of the most thorough-going and inspired restoration projects in recent years. The interiors range from grand state reception rooms to the most intimate private apartments. The Music Room (*above, left*) is decorated with painted female figures

representing the Muses most closely associated with music. The bedchamber (*above, right*) is dominated by a mahogany and gilt-bronze bed flanked by coupled colonettes supporting a canopy, from which embroidered silk curtains are draped. Behind the bed is a sheet of looking glass damaged by a stray shell during the Communard riots of 1871. The console table supports a bust of Hortense de Beauharnais, sister to Eugène, who made occasional use of the house during her brother's long absences from Paris. The Boudoir Turc (page 108) is decorated in the Moorish style, with slender colonettes supporting arcades. The frieze traces the lives of the inmates of a Sultan's harem from the slave market to the seraglio. The bathroom (page 109) is of classical inspiration and is similar in style to the near-contemporary bathroom of Madame Tallien at the Hôtel de Chanaleilles and that of the Hôtel de Bourrienne (page 50). The floor is of inlaid marble and might have come from a villa in Pompeii. Dolphins and classical instruments frame a central panel representing the Rape of Europa. The ceiling is painted with putti and a river goddess, illuminated by an electrified oil-lamp, and is supported by eighteen wooden colonettes painted in imitation of marble. The bathtub is of real marble, studded with gilt-bronze ornaments representing mythological figures.

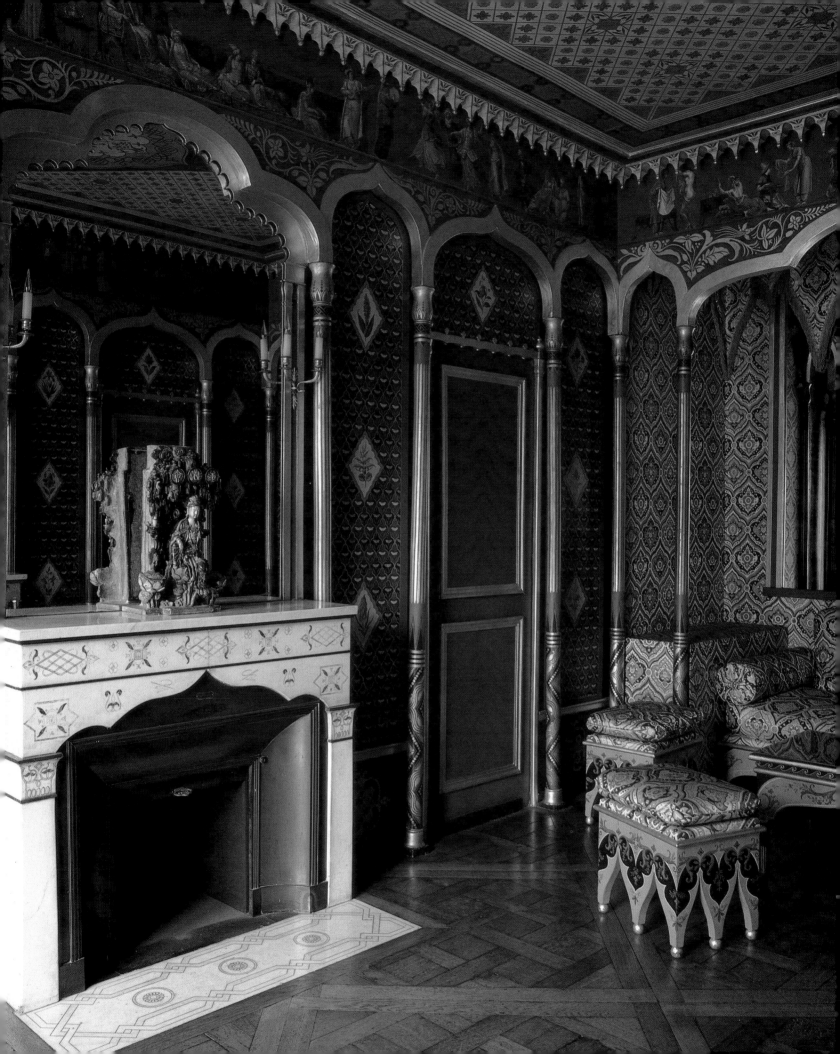

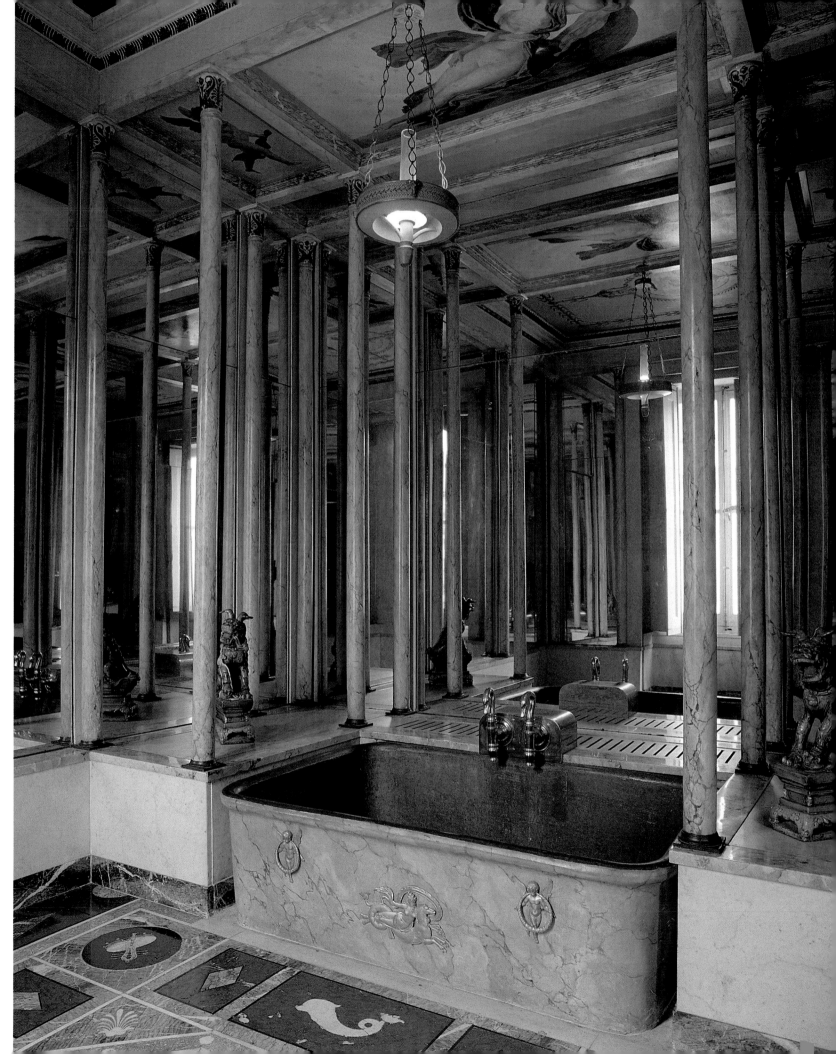

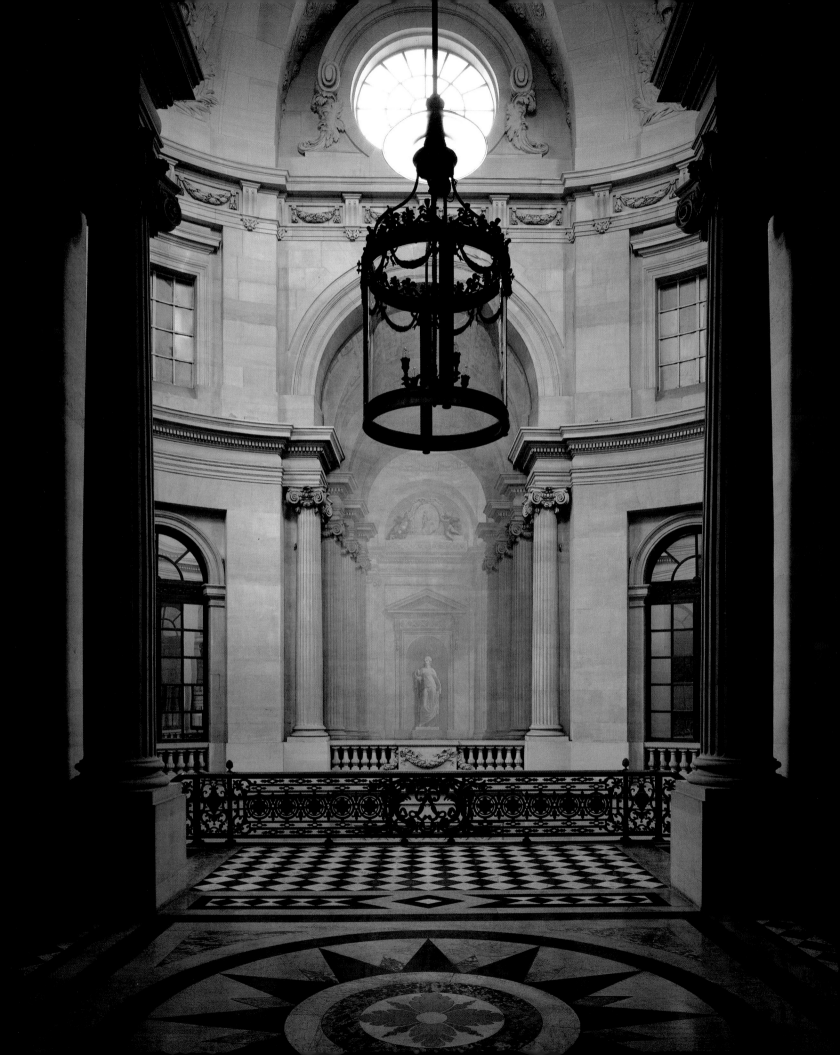

Government and Civic Buildings

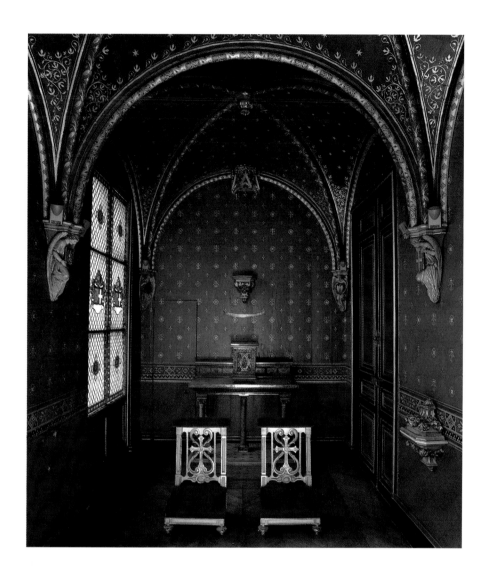

CONSEIL D'ETAT

SINCE 1875 the Conseil d'Etat has occupied a wing of the Palais Royal, originally the Palais Cardinal, begun for Cardinal Richelieu in 1634. The building has had a variety of occupants, among them Louis-Philippe, duc d'Orléans, who in the mid eighteenth century commissioned the magnificent painted staircase hall (*left*), built around the middle of the eighteenth century by Contant d'Ivry. Illusionistic murals and an ingenious use of space give an impression of grandeur in an area which is in fact quite restricted. The Neo-Gothic chapel (*above*) dates from the occupation of Prince Napoleon, a nephew of the Emperor, and his wife, Marie-Clotilde de Savoie, daughter of Victor Emmanuel II of Italy. The couples' arms appear in the stained glass window: eagles for the Prince, white crosses for the Princess. The chapel retains its original stencilled wallpaper and a pair of crimson velvet kneelers. A figure of the Virgin originally occupied the corbel over the altar, but in the Second World War it was removed for safe-keeping to a château in the Loire and has never been returned. Completed around 1859 by the architect Prosper Chabrol, the chapel serves today as an occasional store-room.

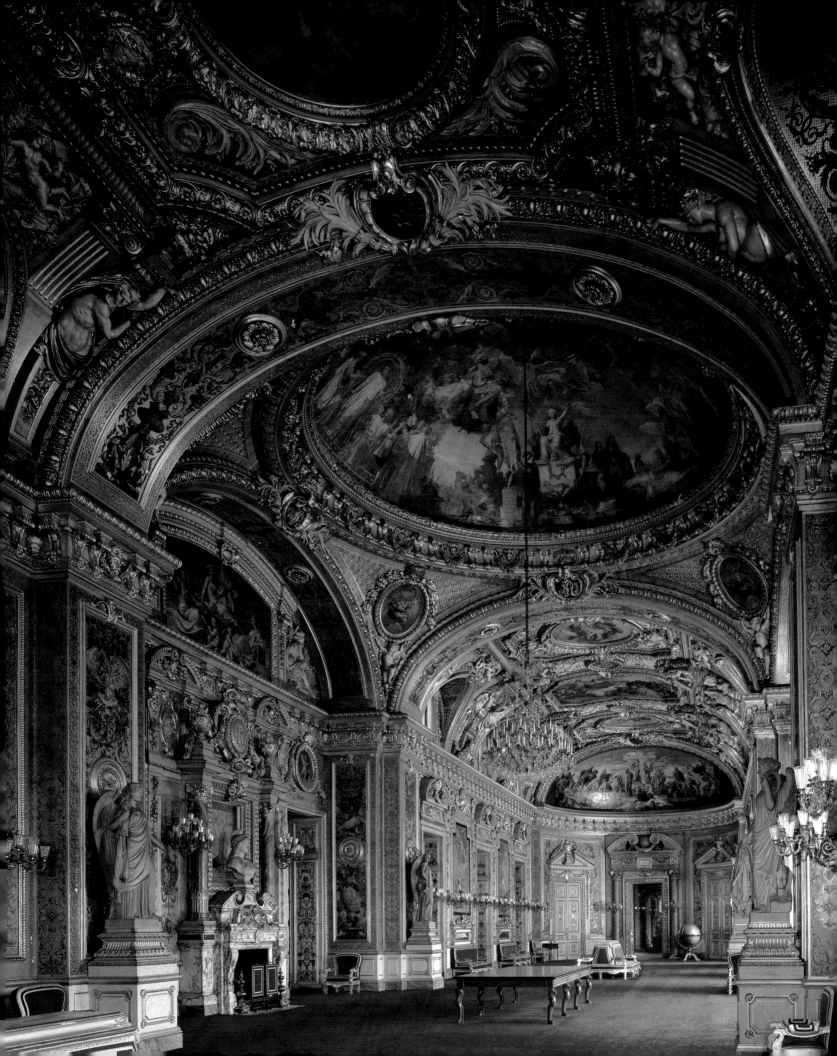

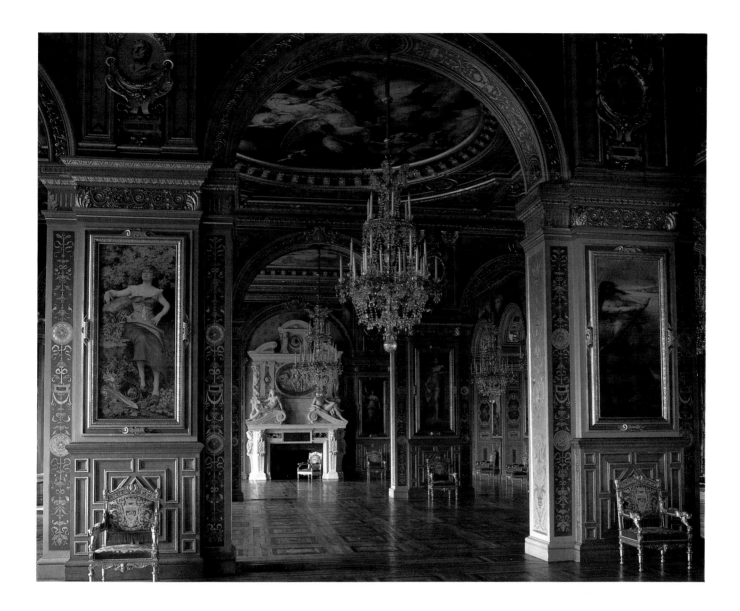

LE SÉNAT

𝒯ʜᴇ Sénat is housed in the old Palais du Luxembourg, built to the designs of Salomon de Brosse in 1615–30. The building was commissioned by a homesick Florentine, Marie de Medicis, the widow of Henry IV, and its mannerist architecture was directly inspired by the Palazzo Pitti in Florence. Later it was occupied by a string of French Royals, including the comte de Provence, later Louis XVIII, and in the Revolution it served as a prison. It was not until the Directoire that the building was converted for use as a parliamentary chamber. Little survives of the original interior besides a few architectural fragments from Marie de Medicis' private apartments. The interior above dates from the Second Empire, and was designed by the architect Alphonse de Gisors, assisted by the painters Lehmann, Aloux and Brune. The opulence and grandeur are typical of the reign of Napoleon III but also look back to the seventeenth century, a fitting compliment to the original occupant.

HÔTEL DE VILLE

𝐵ᴜɪʟᴛ in 1873–83 by the architectural partnership of Théodore Ballu and Edouard Deperthes, the Hôtel de Ville is a town hall to end all town halls. The exterior is a romantic evocation of the previous town hall which stood on this site from 1533 until 1871 when it was burned to the ground by Communard arsonists. The interior is more eclectic, offering up a seemingly endless succession of grandiose reception rooms and council chambers decorated to the glory of the Third Republic by an army of painters and sculptors drawn from the artistic establishment of the day. The Salon des Arcades (*above*) is a typical example. The room is partitioned to form three interconnecting interiors, each devoted to a particular theme: Literature, Science, and the Arts.

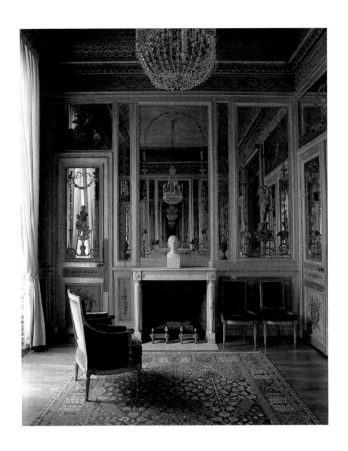 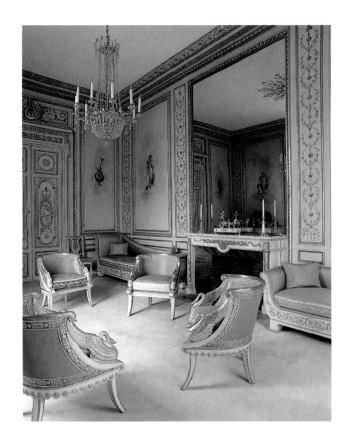

ELYSÉE PALACE

*S*INCE 1874 the Elysée Palace has been the official residence of the French President. The house was erected during the period of the Régence and was originally known as the Hôtel d'Evreux after the man who built it, Henri de La Tour d'Auvergne, comte d'Evreux. Later occupants included Madame de Pompadour, the Emperor Napoleon, Tsar Alexander of Russia, and Napoleon III. The house is a showcase of classic French design, with interiors ranging in date from the early eighteenth century to the present day. The Silver Salon (*above, right*) and the Bathroom of the Empress Eugénie (*above, left*) are a little out of the ordinary. The first dates from the occupation of Caroline Murat, sister of Napoleon, who lived here with her husband Joachim from 1805 to 1808 before ascending the throne of Naples. The room is remarkable for the extensive use of silver gilding, which is applied to the doors, panelling, ornaments, and furniture, the latter attributed to Jacob-Desmalter. The material is white gold rather than silver, which rapidly oxidises and turns black. Classical lyres appear in the carved decoration of the panelling and chairs, and in the painted decoration of the wall nearest the door, which suggests that the salon may originally have served as a music room. It was here in 1815 that Napoleon abdicated following his defeat at Waterloo. It was here also, in 1851, that the coup d'état was planned which ended the Second Republic and made the President,

Louis-Napoléon Bonaparte, Emperor of the French; which brings us to the bathroom of the Empress Eugénie, designed by the architect Eugène Lacroix in the late 1850s. The room is a rare example of the use of painted looking glass, with mirrored walls overlaid with classical figures and ornaments by the artist Jean-Louis Godon. The original bathtub (just out of view on the right) has been converted into a sofa, and the interior serves today as a private sitting room.

MINISTÈRE DE LA MARINE

*P*ERSPECTIVES are a characteristic feature of French design, from architecture and town planning to gardens and interior decoration. A seemingly infinite perspective leads the eye through the gilded *enfilade* of state reception rooms at Ministère de la Marine, the French Admiralty (*right*), which originally served as a repository for the French royal collection of furniture, bronzes and porcelain. The building was erected in 1768–74 but was extensively remodelled during the Second Empire.

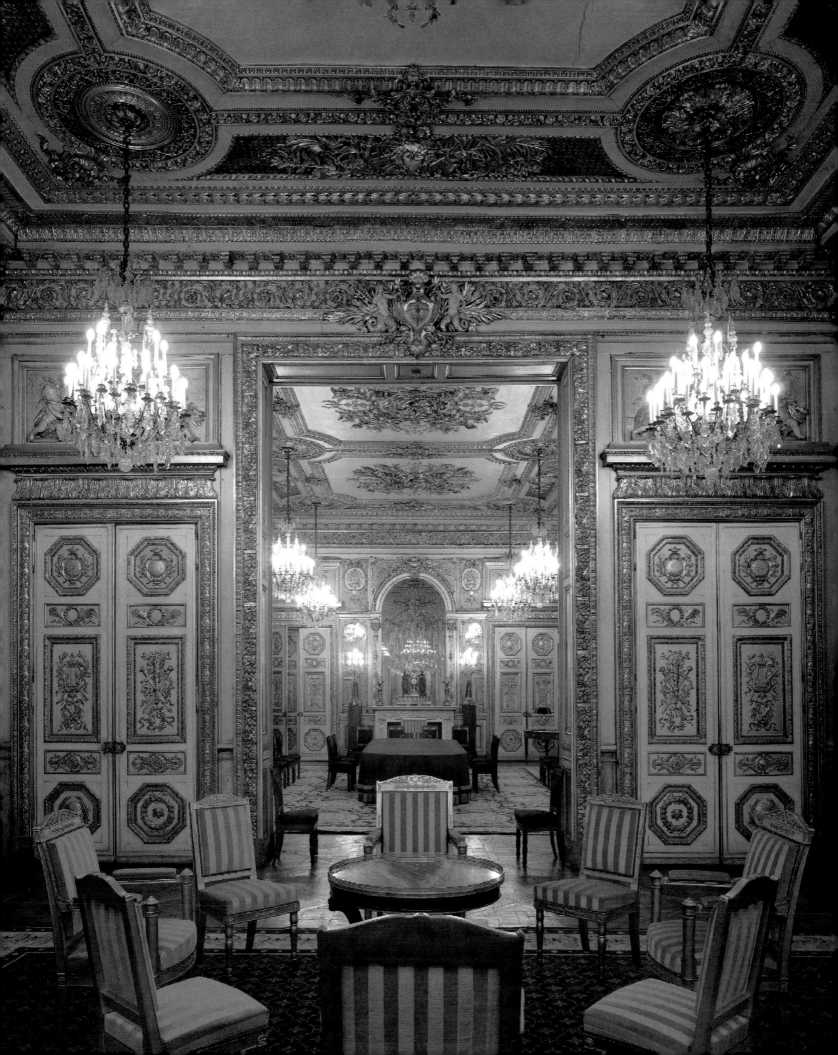

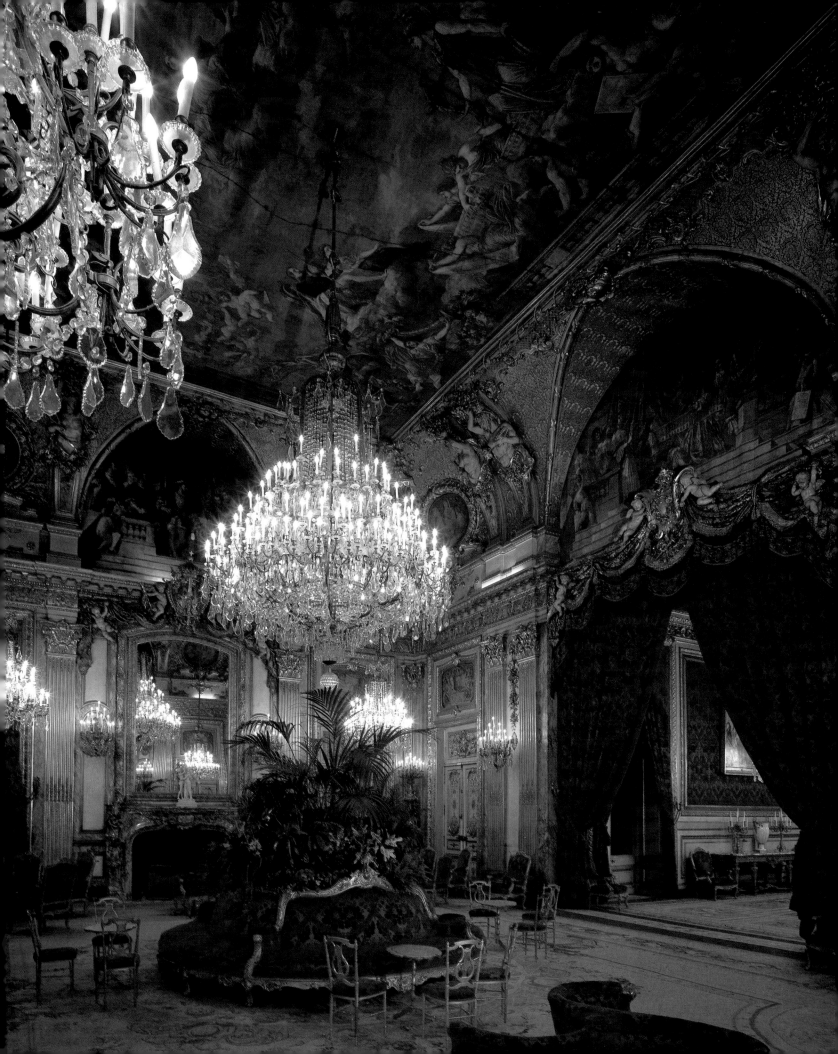

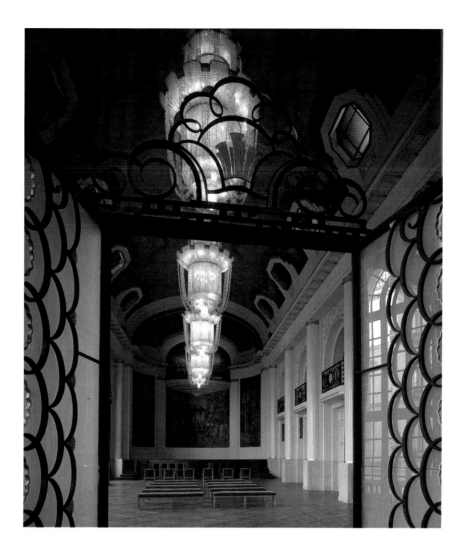

MINISTÈRE DES FINANCES

*T*HE Ministry of Finance occupies a wing of the
Nouveau Louvre, built by order of Napoleon III in
1852–57 by the architects Visconti and Lefuel. The Grand
Salon (*left*) is typical of the interior, an interior so grand it
often has visitors laughing in disbelief. The salon speaks
of the power of money and political ambition, but also of
the care with which the ministry has been maintained by
its present occupants, who with understandable
reluctance will shortly be handing over the keys to the
expanding museum of the Louvre. The murals and
ceiling painting represent the history of the construction
of the Louvre, with various French monarchs inspecting
the designs of the building's architects. The chandelier in
the centre was the largest ever made before Garnier
capped it at the Paris Opera. In the centre of the room is a
circular Louis XV-style sofa, known for reasons that are
obvious as an 'indiscret'.

TOWN HALL OF THE 5TH ARRONDISSEMENT

*P*ARIS is divided into twenty arrondissements or
precincts, each of which has its own town hall. The town
hall of the 5th Arrondissement is situated in the Place du
Panthéon, facing the former church. The building was
begun in 1844, but the Salle des Fêtes (*above*) is part of an
extension added in the late 1920s. The interior was
decorated around 1935 by the painter Gustave Louis
Jaulmes, who also worked at the town hall of the 15th
Arrondissement. The mural to the rear of the stage is an
allegory of Literature, Science, and the Law an
appropriate choice since the townhall is situated in the
heart of the university quarter. The monumental doors in
the foreground are a reminder that the 1930s were a high-
point in the history of French ironwork.

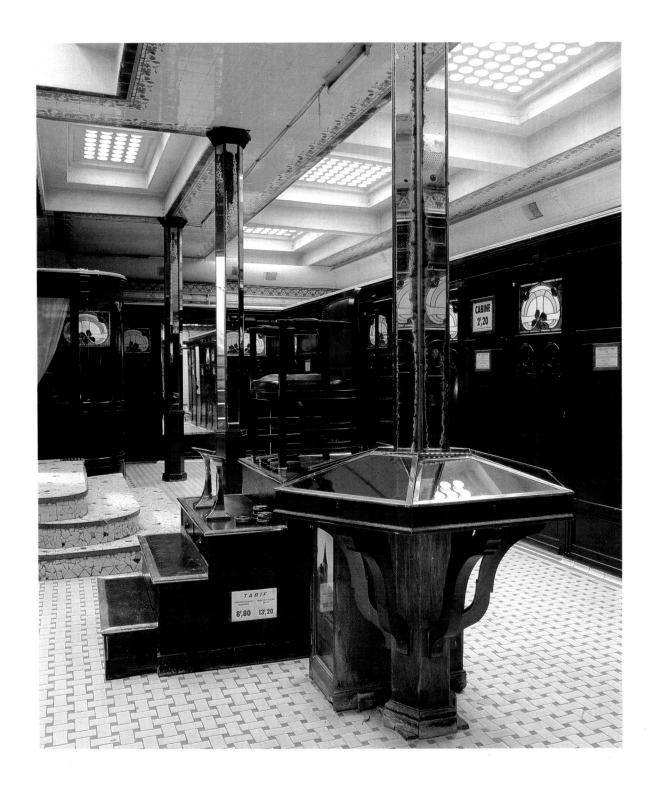

PUBLIC LAVATORIES, PLACE DE LA MADELEINE

*T*HIS elegant Art Nouveau lavatory is situated just a stone's throw from that humourless temple, the Church of the Madeleine. The lavatory is approached by a winding mosaic staircase leading down from the square and was built in 1905 by Porcher & Company. Originally there were two such establishments, this one for the ladies and another for the gentlemen. The 'Gents' has recently been converted into a control room for the national telephone company and so the 'Ladies' now serves both sexes. The interior retains its original wooden stalls with inset stained glass panels, a glazed ceramic frieze and ceiling, and a majestic shoe-shine stand salvaged in the nick of time from the neighbouring 'Gents'.

ACKNOWLEDGEMENTS

First I must thank the home team. Jérôme Darblay deserves top billing for his outstanding photographs. Charlotte de Jessé was the perfect assistant, keen, efficient, able to sweet-talk her way past any closed door. James Campus has again produced a first-class design, coping brilliantly with last minute changes and captions well beyond the expected length.

I could not have stood the course without the constant encouragement of my agent, Xandra Hardie, who treats her authors like flowers and never shows she is cross. I am likewise grateful to my publishers, Phaidon Press, and more particularly Roger Sears, Neil Drury, and Sally Dunsmore. From my publishers in France, Flammarion, I received every courtesy and kindness, and I am especially grateful to Ghislaine Bavoillot, Claire Desserrey, Béatrice Le Guay, Brigitte Benderitter, Pierre-Antoine Dupuy, and Nelly Largo.

Special thanks are due to Jean-Pierre Babelon and Bernard de Montgolfier, who offered specific answers to vague questions about the Middle Ages and the Renaissance; to Barry Bergdoll, an oracle in matters of French architectural history; to Vincent Bouvet, who offered so many useful suggestions and whose interest was an inspiration; and to François Baudot, whose knowledge of twentieth-century French interior decoration is remarkable, as is his willingness to share it.

The book would never have got off the ground without the kind co-operation of Mme Brugeaud at the Ministry of Culture, and would have run into serious difficulties without the generous intervention of Patrice de Voguë.

Olivier Saillant was always on hand to offer technical assistance, and Christophe Delamure made a significant contribution, helping to gather information for the gazetteer. From friends I received no end of moral support, as well as recommendations and the pleasure of their company on reconnaissance excursions. Here I must mention Bridget Strevens Romer and Toto, Barbara Bray, Laure Darblay and Scoop, Alice Brinton, Catherine Healey, Louis Cutner, Alison Harris, David Downie, Alan Perry and Jorge Zelaya; a special thank you also to the freak anticyclone which in the depths of winter gave us the blue skies and brilliant sunshine which photographers dream of in summer.

Last but not least, I wish to thank all the many people who allowed me access to their homes and places of work, and without whose hospitality this book could never have been produced:
Joseph Alexandre, Jean-Marie Amartin, comte Amédée d'Andigné, Henri-François Andriveau, Pierre Anglade, Joelle Arbousse-Bastide, Catherine Bachellerie, Thierry Balesdent, Paul Bardin, Réjane Bargielle, François Barraud, Sophie Boudin, Jérôme Bédier, Jean-Paul Belmondo, François Berce, Véronique Bérecz, Henri Berguerand, Sophie Berluet, Gérard Bigourden, Marc Bodin, Marie Thérèse Bonnaz, Lily Book, François Boucher, Colette Bouchez, Mme Bouchez, Augustin de la Bouillerie, François Boulard, Chedly Boussaïd, Jeanne Boussemart, Réjane Boutet, Marionne Boyone, Jean-François Brégy, Anne-Marie de Brem, Odette Bresson, Véronique Brown, Yvonne Brunhammer, Chantal Buigues, Christine Bulau, Joël Cabardos, André Cador, Patrice Cahart, André Camboulas, Corinne Camby, Robert Capia, Mme Cardinet, Jean-Pierre Caricchio, Suzanne Youd Caron, Xavier Castaing, Monique Castelain, Xavier de Cathelineau, Thérèse Chardar, Flore Chardenoux, Paul Charlemagne, Christine Chasselade, Elizabeth Chasseray, Jean-Pierre Chauvet, Philippe Chazal, Gérard Chevalier, Pierre Chieze, Marie-Louise de Clermont-Tonnerre, Philippe Codant, Claude Comiti, Véronique Coqué, Laurent Cornaz, Général Charles de Cossé-Brissac, Michel Dané, Sylvie Danon, Jean-Marie Darnis, Michèle Delormo, Christiane Demeulenaera, Dominique Deschamps, Robert Devé, Marie-Renée van Droo, Mireille Dubois, Michel Dubosc, Jacqueline Dubray, Nathalaie Duhamel, François Duluc, Gilbert Dumas, Francis Dupin, Sonia Edard, Marie Edelman, Monique Emery, Jacques Egurreguy, Henri Escobio, Claude Fabry, Arlette Facchinetti, Jocelyne Faget, Joseph Farran, Myriam Fauduet, M. Feigner, H. E. Sir Ewen Fergusson, Alfred Fierro, Michel Foisel, Luigi Fontana-Giusti, Jean Fossoyeux, Georges Fréchet, Edouard Frédéric-Dupont, Eric de Fretin, Jacques Garcia, Jean-Claude Garreta, Pierre Gasnault, Philippe Génot, Edith George, Christine Ginestet, Carole Girard, Nicole Girard, Sylvie Gohel, Szczepan Goralski, Sophie Grossien, Mme Gryner, Daniel Guérin, André Guilbert, Gérard Guillaume, André Guinle, Yvonne Hadfield, Parker F. Hallberg, Marie Hamon, Jean-Luc Hascoet, René Hascoet, Anne Marie Helleisen, François Hélie, Elizabeth de Henzel, Christian Hérault, Daniel Hourdry, Robert Hugon, Alexandre Iliescu, Françoise Jacquier, Jean-François Jarrige, Jean Jengère, Karl Jetter, Katia Joski, Fabienne Joubert, Marie-Louise de Jouvencel, Abdel Kader, Geneviève Lacambre, Mèdecin Générale Guy Lagrave, Hervé de Laitre, Vincent Laloux, Monique Lambert, Bernard Lang, Anick Lanoë, Pierre Lariguet, Bernard Larrousse, Jean Laurent, Guy Laurette, Jean Luc Lavau, Patrice Leconte, Dominique Legros, Anne-Claude Lelieur, André Lemaire, Jean-François Lemaire, René Lemaire, Wulf Liebau, Jean-François Llana, Jean-Marie Lormont, André Lossignol, Guennadi Loutaï, Umberto Lucchesi-Palli, Alain Le Véel, Pierre Henri Machioni, M. Malaise, comte Jean-Louis de Maigret, Jean-Claude Mandin, Hélène de Mare, Général Marry, Haydée Martine, Jacques Mathirat, Henri Maurel, Alain Maurois, André and Georges Menut, André Mercier, André Meyric, Françoise Monié, Robert Montagut, Monique Montivier, Guy de Montrichard, Libby Morgan, Jacqueline Morin, Véronique Moulin, Arlette Mounier, Adjudent Chef Mouscardes, Véronique Nansenet, Sixtine de Naurois, Rebecca Navick, Serge Nereyou, Dominique Nicolas, Pierre Nore, Tina Pacheco, Jean-Daniel Pariset, Fanny Pascal, Sylvie Patine, Marguerite Pélissié, Annie Perrault, Hélène Perrin, Michel-Jacques Perrochon, Jean Petin, Judith Petit, Olivier Philip, Florence Piguet, Sonja Pillet, Michel Plainex, Thierry Potier, Rayond Pouget, M. Prévost, Zana Rachedi, Christian Rapin, Catherine Rein, Marie-Christine Renaud, Denise Reybel, Jean-Pierre Richard, Michel Richard, Colette Robiquet, Isabelle de Rocca, Luc Roger, Brigitte Roset, Martine Rossignol, Anne Roubaudi, Jacques Roullet, Mme Roussel, the late Jean-Michel Rouzière, Henri Royer, Béatrice Ruggieri, André de Sambucy, Christian Schmidt, Christiane Schmidt, Daniel Schmidt, Michèle Schneider, Kim Schou, Josy Schneider, Dominique Sebban, Alain Senderens, Michel-Regis Ralon, comtesse de Talhouet, Philiippe Taquet, François Thomas, Daniel Touboul, Evelyne Tréhin, Walter von Tschirschky, Nicole Vaillant, Dominique Valine-Ramadier, Michel Vandermeersch, Marie-Thérèse Varlamoff, Bernard Védrines, H. E. Jomkheer Maximilien Veglelin van Claerbergen, Liliane Velfch, Marc Vellay, Soisick Videau, Commandant Viger, Jacques Vilain, Chantal Vitte, Dominique Wargnier, Sylvie Watelet, Michel Weiss, Jean Willesme, Michel Yvon, Marian Zaleski, Dany Zana, Jean-Claude Zugolaro.

Gazetteer

Most of the buildings listed below are open to the public on a regular basis. Those which are not can sometimes be visited by prior appointment. For details contact: CNMHS (Caisse National des Monuments Historiques et des Sites), Hôtel de Sully, 62 rue Saint Antoine, 75004. Tel: 48.87.24.14.

The CNMHS arranges guided tours of historic buildings generally closed to visitors as well as public museums and monuments. A programme of events is published every two months and is available, free of charge, at the CNMHS headquarters and most museums.

Tours are for members only. Anyone wishing to join the organization should apply in writing.

..

Shops

A La Mère de Famille

Address: 35 rue du Faubourg Montmartre, 75009
Telephone: 47.70.83.69
Metro: Le Peletier
Open: 8 am - 1.30 pm and 3 - 7 pm Tues-Fri, 8 am - 1.30 pm Sat.
page 24

Aux Cinq Poissons

Address: 24 rue du Faubourg Montmartre, 75009
Telephone: 48.24.57.40
Metro: rue Montmartre

Open: 8 am - 1 pm, Tues-Sat, Sun 8 am - 1 pm.
page 24

Boulangerie Azrak

Address: 56 rue Vaneau, 75007
Telephone: 45.48.98.16
Metro: Vaneau
Open: daily (except Wed) 8 am - 1.30 pm and 3.30 pm - 8 pm.
page 22

Baccarat

Address: 30 bis, rue de Paradis, 75010
Telephone: 47.70.64.30
Metro: Château d'Eau
Open: Main showrooms and museum open Mon-Fri 9 am - 5.30 pm, Sat 10 am - 12 pm and 2 pm - 5 pm; period showrooms not generally open to visitors other than major clients.
page 21

Debauve et Gallais

Address: 30 rue des Saints-Pères, 75007
Telephone: 45.48.54.67
Metro: rue du Bac / Saint Germain des Près
Open: 10 am - 12.45 pm and 2 - 6.45 pm, Tues-Sun, early closing Sat: 5.45 pm.
page 21

Deyrolle

Address: 46 rue du Bac, 75007
Telephone: 42.22.30.07
Metro: Rue du Bac
Open: 9 am - 12.30 pm and 2 pm - 6.30 pm Mon-Sat.

Situated in old Hôtel Samuel Bernard, built 1741-44 to designs of Germain Boffrand; remains of once magnificent rococo designs, notably in first room on first floor.
page 18

Galerie Vivienne

Address: 4 rue des Petits-Champs / 6 rue Vivienne / 5 rue de la Banque, 75002

Metro: Bourse / Palais Royal
Open: Entrance on rue de la Banque open at all times; those on rue Vivienne and rue des Petits Champs open daily 6 am - 9.30 pm.
page 17

Teinturerie Huguet

Address: 47 Avenue Marceau, 75016
Telephone: 47.20.23.02
Metro: Alma Marceau / George V
Open 9 am - 6.30 pm Mon-Fri
page 23

C. T. Loo & Cie

Address: 48 rue de Courcelles, 75008
Telephone: 45.62.53.15 / 42.25.17.23
Metro: Courcelles
Open: 10 am - 12.30 pm and 2.30 pm - 6.30 pm Mon-Sat.

Oriental and Indian style interiors of 1926-28 designed by partnership of Chinese-born art dealer C. T. Loo and French architect Fernand Bloch; highlights include coffered exhibition hall on ground floor with 'moon' doorway and ceiling ornamented with casts of animal carvings dating from Han period; Chinese-style lift-shaft and balustrade to main staircase;

octagonal sanctuary in basement with reliefs inspired by fifth- and sixth-century Chinese Buddhist rock temples; first floor occupied by interconnecting galleries panelled in seventeenth- and eighteenth-century lacquer; Indian room on top floor ornamented with nineteenth-century carvings.
page 16

Robert Montagut

Address: 15 rue de Lille, 75007
Telephone: 42.60.29.25
Metro: Rue de Bac / Saint Germain des Près
Open: 10.30 am - 12.30 pm and 2.30 pm - 7 p m Mon-Sat; interior visible through glazed street front at all times.

Pharmaceutical antique shop; interior fitted out with panelling and other elements from early seventeenth-century apothecary's in Avignon, purchased and re-assembled by present owner 1987; walnut woodwork carved with feathers and oak leaves overlaid in eighteenth century with blue-green lacquer now faded to pale yellow; remarkable collection of antique faience pots contained in niches forming tiers of miniature arcades;' exposed beams, stone floor, and candle-lit chandelier.
page 25

Stern

Address: 47 Passage des Panoramas, 75002

Telephone: 45.08.86.45
Metro: Rue Montmartre
Open: 9.30 am - 12.30 pm and
1.30 pm - 5.30 pm Mon-Fri.
page 19

Restaurants & Cafés

ANGELINA

Address: 226 rue de Rivoli, 75001
Telephone: 42.60.82.00
Metro: Tuileries
Open: daily 9.30 am - 7 pm.
page 27

CADOR

Address: 2 rue de l'Amiral
Coligny, 75001
Telephone: 45.08.19.18
Metro: Louvre / Pont Neuf
Open: 9 am - 7 pm Tues-Sun
page 32

CHARTIER

Address: 7 rue du Faubourg
Montmartre, 75009
Telephone: 47.70.86.29 /
42.46.86.85
Metro: Montmartre
Open: daily 11 am - 3 pm and 6
pm - 9.30 pm.
page 33

LE COCHON À L'OREILLE

Address: 15 rue Montmartre,
75001
Telephone: 42.36.07.56
Metro: Les Halles
Open: 4 am - 3 pm Tues-Sun,
6 am - 3 pm Mon.
page 29

JULIEN

Address: 16 rue du Faubourg
Saint-Denis, 75010
Telephone: 47.70.12.06
Metro: Bonne Nouvelle /
Strasbourg Saint-Denis
Open: daily 12 am - 3.30 pm and
7 pm - 2 am.
page 34

LE PIGALLE

Address: 22 Boulevard de Clichy,
75018
Telephone: 46.06.72.90
Metro: Pigalle
Open: daily 7.30 am - 5 am.
page 37

LA POTÉE DES HALLES

Address: 3 rue Etienne Marcel,
75001
Telephone: 42.36.18.68
Metro: Etienne Marcel

Open: 12 am - 2.30 pm and 7 pm -
10.30 pm Mon-Fri; 7pm - 10.30
pm Sat.
page 28

LE TRAIN BLEU

Address: Gare de Lyon, 20 Bld
Diderot, 75012
Telephone: 43.43.09.06 /
43.43.38.39
Metro: Gare de Lyon.
Open: restaurant open daily 12 am
- 2.15 pm and 7 pm - 9.45 pm; bar
open daily 9 am - 10 pm.
pages 30/31

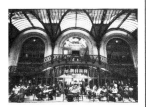

LE VAGENENDE

Address: 142 Boulevard Saint
Germain, 75006
Telephone: 43.54.57.99 /
43.26.68.18
Metro: Odéon / Mabillon
Open: daily 12 am - 3 pm and 7
pm - 1 am.
 Spectacular Art Nouveau
restaurant of *c*.1902, built for
Chartier brothers and originally
known as 'Bouillon Chartier' (see
Chartier above); interior well
preserved; original features
include Corinthian colonnettes
with Lincrusta paper to shafts;
ornate 'nouille' (noodle) style
woodwork framing resplendent
mirrors and miniature landscapes
painted on glazed ceramic by G.
Pivain; remains of patterned tile
floor; listed 1983.
page 35

LE VAUDEVILLE

Address: 29 rue Vivienne, 75002
Telephone: 42.33.39.31
Metro: Bourse
Open: daily 11 am - 3.30 pm and
7 pm - 2 am.
page 36

LE GRAND VÉFOUR

Address: 17 rue de Beaujolais
Telephone: 42.96.66.27

Metro: Palais Royal.
Open: 12.30 pm-2 pm and
7.30 pm-9.30 pm Mon-Fri,
7.30 pm-9.30 pm Sat.
page 26

Hotels

HÔTEL CRILLON

Address: 10 Place de La Concorde,
75008
Telephone: 42.65.24.24
Metro: Concorde
Open: 'Les Ambassadeurs'
Restaurant open daily 7 am -
10.30 am, 12 am - 2.30 pm, and 7
pm - 10.30 pm; Salon des Aigles
available for hire.
 Originally built as private
house 1775-77; exterior designed
by Jacques-Ange Gabriel, interior
by Pierre-Adrien Pâris; first
occupied by duc d'Aumont;
purchased 1788 by comte de
Crillon; confiscated during
Revolution and afterwards
converted into hotel; returned to
Crillon's heirs 1820 following
Bourbon Restoration; refurbished
c.1869 and 1894-6; interior largely
dismantled 1907, when sold for
development as hotel to Société
des Grands Magasins et Hôtels du
Louvre; inaugurated as Hôtel
Crillon 1909 after extensive
alterations by architect
Destailleurs; some surviving
eighteenth-pcentury decoration,
notably in Salon des Aigles, as
well as splendid restaurant of
c.1908.
page 38

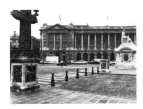

GRAND HÔTEL

Address: 2-6 rue Scribe, 75009
Telephone: 42.68.12.13
Metro: Opéra
Open: Salle des Fêtes generally
closed to visitors but available for
hire.
 Built 1861-62 for Péreire & Co
by team of architects headed by
Armand. Much subsequent
remodelling and redecoration,
but magnificent Salle des Fêtes
still intact.
page 39

Theatres & Cinemas

*Theatres and cinemas are not
generally open to visitors other than
ticket-holders; l'Officiel des
Spectacles and other weekly
entertainment guides provide details
of performances.*

THÉÂTRE DU CONSERVATOIRE

Address: 2 rue du Conservatoire,
75009
Telephone: 42.46.12.91
Metro: Cadet / Rue Montmartre
 Built 1811 to designs of
architect Delannoy as home for
national conservatoires of music
and drama; interior extensively
redecorated 1866; vacated by
conservatoires 1909 and
converted into public concert
hall; reoccupied by conservatoire
of drama 1947; recently restored.
page 45

THÉÂTRE DAUNOU

Address: 9 rue Daunou, 75002
Telephone: 42.61.52.12
Metro: Opéra
 Built 1921 to designs of
architect A. Bluysen; interior
decorated by firm of Jansen under
supervision of Armand Rateau;
damaged in arson attempt 1971
but subsequently restored; good
surviving decoration in
auditorium and foyers.
page 41

THÉÂTRE GRÉVIN

Address: Musée Grévin, 10
Boulevard Montmartre, 75009
Telephone: 47.70.85.00
Metro: Rue Montmartre
 Built 1900 to designs of
Antoine Bourdelle with
decorative paintings by Chéret;
originally known as 'Théâtre
Joli'; rechristened 1905.
page 46

THÉÂTRE DE L'OPÉRA COMIQUE

Address: 5 rue Favart, 75002
Telephone: 42.96.12.20
Metro: Richelieu Drouot
 Built 1893-98 to designs of
Stanislas Louis Bernier; opulent
interior decorated by foremost
artists and craftsmen of day;
restored 1967; of special interest:
entrance hall, ceremonial
staircases, avant-foyer, grand
foyer, and auditorium.
page 42

THÉÂTRE DU PALAIS-ROYAL

Address: 38 rue de Montpensier, 75001
Telephone: 42.97.59.76
Metro: Palais Royal
Occupies north-west corner of Palais Royal; erected 1781-84 to designs of Victor Louis; latest in long line of theatres on this site; present building designed by Paul Sédille *c.*1880 and restored by Henri Bernouville 1905; first-floor foyer and auditorium virtually unchanged.
page 44

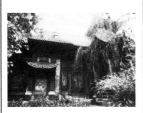

LA PAGODE

Address: 57 rue de Babylone, 75007
Telephone: 47.05.12.15
Metro: St. François Xavier
Genuine Japanese pagoda shipped to France by architect Alexandre Marcel and reassembled on present site 1896; original structure (nineteenth century) embellished with Oriental-style panels by painter Benet; originally used as pleasure-house but converted for use as cinema 1931; restored 1973.
page 43

LE RANELAGH

Address: 5 rue des Vignes, 75016
Telephone: 42.88.64.44
Metro: La Muette
Neo-Renaissance music hall built 1890 on site of private theatre house erected in eighteenth century in grounds of Château de Boulainvilliers; originally known as Théâtre Mors after founder Louis Mors; closed at commencement of First World War and sold by Mors' heirs 1931 to firm of property developers; miraculously saved from demolition and subsequently converted into cinema / theatre; well-preserved basement foyer with Henri II-style chimney piece and carved bench leading through to baronial auditorium.
page 47

LE REX

Address: 5 Boulevard Poissonière, 75002

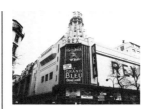

Telephone: 42.33.40.49
Metro: Bonne Nouvelle / rue Montmartre
Grandiose 'atmospheric' cinema built 1932 to designs of John Eberson and Auguste Bluysen; requisitioned by Germans during Occupation and used as 'Soldatenkino' for screening of Nazi propaganda films; listed 1982.
pages 48/49

THÉÂTRE DE L'OPÉRA

Address: Place de l'Opéra, 75009
Tel: 47.42.57.50
Metro: Opéra
Built 1862-75 under direction of architect Charles Garnier; spectacular interiors decorated by host of eminent artists and craftsmen; ceiling of auditorium painted by Marc Chagall 1964.
page 40

..

Private Houses

HÔTEL DE BOURRIENNE

Address: 58 rue d'Hauteville, 75010
Telephone: 47.70.51.14
Metro: Bonne Nouvelle / Château d'Eau
Open: 2pm - 4 pm Sat and Sun, otherwise by appointment; interiors available for hire.
Built *c.*1787; architect unknown; interior redecorated *c.*1793 by François-Joseph Bélanger, architect of Bagatelle (see Museums) and Lycée Saint-James (see Schools and Colleges); further alterations *c.*1801 under direction of Lecomte and again *c.*1900 when attic storey added to accommodate Art Nouveau studio apartment; past occupants include Fortunée Hamelin, famous First Empire belle and intimate of Empress Josephine; Louis-Antoine Fauvelet de Charbonnière de Bourrienne, schoolfriend and one-time private secretary to Napoleon; and Charles Tuleu (great uncle of present owner), director of printing works founded by Balzac.
pages 50/51

HOTEL DE FIEUBET

Address: 10 rue des Lions Saint Paul, 75004
Open: Staircase usually accessible from courtyard opening on street.
page 58

HÔTEL GOUFFIER DE THOIX

Address: 56 rue de Varenne, 75007.
Closed to visitors
Built *c.*1719-27 by property developer Baudouin for marquise de Thoix; subsequent occupants include eighteenth-century statesman Maupeou and twentieth-century poet Aragon; house divided today between private apartments and government offices; interior substantially modernized with exception of remarkable suite of period rooms on ground floor of *corps de logis* (central block).
page 52

HÔTEL JULES-HARDOUIN MANSART

Address: 28 rue des Tournelles, 75004
Closed to visitors.
Built *c.*1674-85 by architect Jules-Hardouin Mansart; occupied by same until death 1708; interior decorated with ceiling paintings attributed to Le Brun, Mignard, Lafosse and Allegrain; occupied by Mansart's heirs until 1767 when sold to duchesse de Mouchy, lady-in-waiting to French Queen, Marie Leczinska, and afterwards to Marie Antoinette when Dauphine; sold 1777 and still in private ownership.
pages 54/55

LA MAISON 'OPÉRA'

Address: 5 rue du Dr Lancereaux, 75008
Telephone: 45.62.77.04 / 45.61.91.82
Metro: Miromesnil
Open: Mon-Fri by appointment; interiors available for hire.
Begun 1867 for marquis de Luzarches d'Azay; architect unknown but traditionally attributed to Charles Garnier; sold while still incomplete to baron de Rouvre 1871; acquired 1890 by marquise de Moustier and 1906 by Dr Eugène Dupeyroux; still in family ownership; wonderfully evocative suite of unspoilt late nineteenth-century interiors ranging in style from Neo-Renaissance to Neo-Louis XVI.
page 56

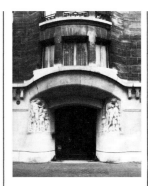

67 BOULEVARD RASPAIL

Address: 67 Boulevard Raspail, 75006
Open: Entrance hall visible at all times through glazed front door. For access to other parts of building apply in writing to *gérant* (administrator).
page 59

HÔTEL DE SALM-DYCK

Address: 97 rue du Bac, 75007
Closed to visitors.
Built *c.*1722 for state functionary Pierre-Henri Le Maistre; architect unknown; privately owned until 1793 when confiscated by Revolutionary Government; acquired 1809 by Prince Joseph de Salm-Dyck and wife Constance de Theïs; extensively redecorated 1809-11 under direction of architect Antoine Vaudoyer; sold 1824 and subsequently divided up into separate apartments, one of which retains original decorative painting dating from First Empire.
page 57

MAISON DE VERRE

Address: 33 rue Saint Guillaume, 75007
Generally closed to visitors.
page 60

..

Clubs & Institutions

ASSOCIATION POUR LA SAUVEGARDE DE PARIS
(Hôtel de Beauvais)

Address: 68 rue François Miron, 75004
Metro: Saint Paul
Open: Currently being restored.
Built 1655-58 to designs of Antoine Le Paultre; remodelled *c.*1704, possibly by Robert de Cotte; vandalized during Revolution, when building

confiscated by state and sold; later acquired by City of Paris; little surviving decoration except for remarkable stone staircase hall; currently under restoration.

page 68

CHAMBRE DE COMMERCE ET D'INDUSTRIE DE PARIS

Address: Hôtel Potocki,
27 Avenue de Friedland, 75008
Telephone: 42.89.70.00
Metro: Charles de Gaulle/Etoile
Open: Guided tours by CNMSH Sat; telephone for details.

Palatial town house begun *c.*1857 to designs of architect Renaud for Polish nobleman Count Grégoire Potocki; house enlarged and redecorated in Louis XIV style 1881 under direction of architect Jules Reboul for Potocki's son Felix-Nicolas; bequeathed by same to brother Alfred 1921 and sold 1923 to Chambre de Commerce et d'Industrie; enlarged 1925-27 by architects Viard and Dastugue to provide, among other interiors, Salle des Fêtes, decorated by Ruhlmann; staircase hall, reception rooms, and certain offices (notably Director's office, originally Princess Pignatelli's bedchamber) well preserved.

page 69

FONDATION NATIONAL DES ARTS GRAPHIQUES ET PLASTIQUES
(Hôtel de la baronne Salomon de Rothschild)

Address: 11 rue Berryer, 75008
Telephone: 45.63.23.56
Metro: Ternes / George V
Occasional exhibitions, but Cabinet des Curiosités not generally open to visitors.

Built 1872-78 for widow of baron Salomon de Rothschild; begun to designs of Léon Ohnet and completed after his death by student Justin Ponsard; interiors decorated by painter Léopold de Montignon; house bequeathed by baronne de Rothschild to French state as artistic centre to be administered by Ministry of Education; most of contents bequeathed to various national museums; occupied since 1976 by Fondation Nationale des Arts Graphiques et Plastiques; interior largely remodelled and modernized with exception of remarkable Cabinet des Curiosités, virtually untouched since 1870s.

page 63

INSTITUT PASTEUR

Address: 25 rue du Docteur Roux, 75015
Telephone: 45.68.82.82
Metro: Pasteur
Open: 2 pm - 5.30 pm Mon-Fri; guided tours by appointment.

Louis XIII-style research centre-cum-private house built 1887-88 for bacteriologist Louis Pasteur; Pasteur's private apartments undisturbed since widow's death 1910; when donated by heirs, opening to public 1936; also of interest Grande Bibliothèque and funerary chapel.

pages 66/67

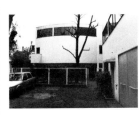

FONDATION LE CORBUSIER
(Villa La Roche).

Address: 10 Square du Dr Blanche, 75016
Telephone: 42.88.41.53
Metro: Jasmin
Open: 10 am - 12.30 pm and 1.30 pm - 6 pm Mon-Fri; early closing Fri: 5 pm.

Modernist villa designed and built by Le Corbusier 1923-25 for modern art collector Raoul La Roche; twinned with adjoining Villa Jeanneret-Raaf 1923-25, also occupied by Fondation Le Corbusier but not generally open to public; few contents but architecture and fitted furniture undisturbed; especially striking are entrance hall, with ingenious play of galleries, balconies, and staircases, and split-level picture gallery.

page 61

FONDATION PAUL-LOUIS WEILLER
(Hôtel des Ambassadeurs de Hollande)

Address: 47 rue Vieille du Temple, 75004
Telephone: 42.78.14.40
Metro: Hôtel de Ville / Saint Paul
Not generally open to visitors.

Built 1657-60 to designs of Pierre Cottard; extensively remodelled 1759 under direction of master mason Le Tellier, assisted by architect Guibert; vandalized and allowed to fall

into ruin after Revolution; listed (grade I) and restored 1926; restoration work resumed 1951 and continued to this day; surviving seventeenth-century decoration in Galerie de Psyché and Chambre à l'Italienne; Salon de Flore decorated with seventeenth century woodwork salvaged from other parts of house and painted ceiling by Vien, master of David; similar mix of seventeenth- and eighteenth-century decoration in adjoining Grand Cabinet.

page 62

TRAVELLERS CLUB
(Hôtel de Païva)

Address: 25 Avenue des Champs Elysées, 75008
Telephone: 43.59.75.00
Metro: Franklin Roosevelt
Open: Guided tours Sun 9.30 am - 11 am.

Franco-Italian neo-Renaissance palace built 1855-66, to designs of architect Pierre Manguin for marquise de Païva; sold by heirs and converted for use as a restaurant; occupied since 1902 by Travellers Club; original contents dispersed at auction in late nineteenth century (certain items acquired by Musée des Arts Decoratifs), but architectural decoration perfectly intact; suite of opulent Second Empire interiors decorated by foremost artists and craftsmen of day.

pages 64/65

...

Schools & Colleges

ECOLE NATIONALE SUPÉRIEURE DES BEAUX ARTS

Address: 17 Quai Malaquais, 75006
Telephone: 42.60.34.57
Metro: Saint Germain des Près
Open: Regular guided tours by CNMHS and school officials. Telephone for details.

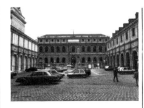

Originally School of Academy of Painting and Sculpture, founded 1648; established on present site 1816; wide range of buildings with many fine interiors, including: *Chapelle des Louanges*, early seventeenth-century Augustine chapel with copy by Sigalon of Michelangelo's 'Last Judgement'; *Hôtel de Chimay*, town house begun *c.*1630 to designs of François Mansart with surviving First Empire decoration carried out 1808 for Stéphanie de Beauharnais; *Palais des Etudes*, principal classroom block, begun 1820 to designs of Debret and substantially completed 1839 by Duban, with interior decoration showing influence of *cinquecento*, notably vaulted galleries on first floor with ceiling paintings and murals of 1835-40 copied from Vatican loggie by Raphael and followers, and *Amphithéâtre*, featuring mural by Delaroche of 1841-42 representing 'Le Génie des Arts distribuant des couronnes.'

page 73

ECOLE NORMALE DE MUSIQUE ALFRED CORTOT

Address: 114 bis Boulevard Malesherbes, 75017
Telephone: 47.63.85.72
Metro: Malesherbes
Not generally open to visitors, but staircase hall accessible from street.

Neo-Renaissance *hôtel particulier* built *c.*1881 to designs of architect L. Cochet; occupied since 1924 by music school; three storeys of well-preserved interiors in variety of styles, most spectacular being marbled staircase hall and Louis Revival salons.

pages 75/76/77

LYCÉE CHARLEMAGNE

Address: 101 rue Saint Antoine, 75004
Telephone: 42.72.19.21
Metro: Saint Paul
Not generally open to visitors.

Originally headquarters of Society of Jesus, begun *c.*1640 and

attributed to architect and priest Frère Turmel; remodelled 1679-93; occupied by Order of Saint Catherine following expulsion of Jesuits from France 1762; confiscated by state during Revolution and converted 1795 into school, christened Lycée Charlemagne 1804; interior extensively modernized, but some surviving decoration from seventeenth century, notably ceiling over main staircase by Gherardini representing Apotheosis of Saint Louis (heavily restored); eighteenth-century decoration in Library and suite of late nineteenth-century classrooms, most atmospheric being Salle Joffre.

page 72

LYCÉE HENRI IV

Address: 23 rue Clovis, 75005
Telephone: 46.34.02.20
Metro: Cardinal Lemoine
Open: Guided tours Sun pm

State secondary school occupying former Abbaye de Sainte Geneviève; founded 1795 and known originally as Ecole Centrale du Panthéon; name changed with rise and fall of successive political regimes to Lycée Napoléon (1804), Collège Henri IV (1815), Lycée Corneille (1848), Lycée Napoléon again (1849), Lycée Corneille again (1870), and finally to Lycée Henri IV (1873); distinguished former pupils include five sons of King Louis-Philippe, Romantic poet Alfred de Musset, Gothic Revival architect Viollet Le Duc, and town-planner extraordinary baron Haussmann; surviving features include vestiges of thirteenth-century kitchens and refectory, magnificent eighteenth-century stone staircase, and most impressive of all, baroque cupola painted by Restout c.1730 to represent 'Triumph of Saint Augustine'.

page 74

LYCÉE SAINT-JAMES

Address: Folie Saint-James, 34 Avenue de Madrid, Neuilly / Seine
Telephone: 47.47.79.04
Metro: Pont de Neuilly
Open: Guided tour of house Sat and Sun pm; park open 2 pm - 5 pm Sat and 8 am - 5 pm Sun.

State secondary school housed in neo-classical villa built 1775-80 to designs of François-Joseph Bélanger; several well-preserved interiors, notably trompe-l'oeil entrance hall and staircase, ground-floor classroom

(originally library), Principal's study and adjoining office, and marbled and pebbled interiors of 'Grand Rocher' (grotto) in park.

pages 70/71

...

Libraries & Archives

ARCHIVES NATIONALES

Address: Hôtel de Soubise, 60 rue des Francs Bourgeois, 75004
Telephone: 42.77.11.30
Metro: Rambuteau
Open: First-floor apartments open daily (except Tuesday) 2 pm - 5 pm. Ground-floor apartments by appointment.

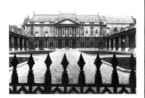

Built 1705-9 to designs of Pierre-Alexis Delamair for François de Rohan, Prince de Soubise; entirely redecorated 1732-39 by Germain Boffrand, assisted by painters Boucher, Van Loo, Trémolières, Restout, and Natoire, and sculptors Lemoine and brothers Adam; confiscated by state and used during Revolution as among, other things, gun-powder store, sales room, and military barracks; acquired by state 1808 and made over to Archives Nationales, (established 1790); extensively remodelled in nineteenth century but exquisite Rococo decoration by Boffrand survives in former apartments of Prince and Princesse de Soubise on ground and first floors.

page 84

BIBLIOTHÈQUE DE L'ARSENAL

Address: 1 rue de Sully, 75004
Telephone: 42.77.44.21
Metro: Sully Morland
Open: Guided tours by CNMSH; telephone for details.

Former gun-powder factory and cannon foundry converted in early nineteenth century into library; original building erected to designs of Philibert Delorme c.1563; successively enlarged and remodelled c.1599-1602 by

Marceau Jaquet, c.1632-37 (architect unknown), 1715-36 by Germain Boffrand, c.1745 by Dauphin, and 1856-76 by Theodore Labrouste; surviving decoration from virtually every phase of construction.

page 85

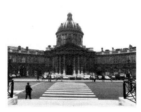

BIBLIOTHÈQUE MAZARINE

Address: Palais de l'Institut, 23 Quai Conti, 75006
Telephone: 43.54.89.48 / 43.26.39.16
Metro: Saint Michel
Open: Open to readers 10 am - 6 pm Mon-Fri; guided tours Mon-Fri by written application to keeper.

Situated in wing of Palais de l'Institut, built 1663-84 to designs of François d'Orbay and Louis Le Vau as school, Collège des Quatre Nations, founded by Cardinal Mazarin 1661; library houses Mazarin's own collection of books and manuscripts, transferred here 1668; main reading room assembled from fragments of Mazarin's library, built c.1649 by François Mansart and originally attached to Hôtel de Tubeuf, occupied today by Bibliothèque Nationale; ceiling and gallery altered c.1739 but otherwise little changed since mid seventeenth century; staircase hall equally impressive, built to designs of Léon Biet 1824.

pages 81/82/83

BIBLIOTHÈQUE NATIONALE

Address: 58 rue de Richelieu, 75001
Telephone: 47.03.81.26
Metro: Palais Royal / Bourse
Open: Guided tours by CNMSH; telephone for details.

Originally Bibliothèque du Roi (Royal Library), founded by Charles V in fourteenth century, if not earlier, in reign of Saint Louis (1236-70), and established on present site 1721; wide range of buildings and interiors dating from seventeenth to twentieth centuries; of special interest: Galerie Mazarine and Galerie

Mansart, twin galleries built 1644-45 by François Mansart as extension to Cardinal Mazarin's Paris house (Hôtel de Tubeuf) and designed to house Cardinal's priceless collection of paintings, tapestries, sculpture and furniture; surviving murals and ceiling paintings by Grimaldi and Romanelli, including illusionistic landscapes to window embrasures and walls; Salle de Lecture (Main Reading Room), built c.1863 to designs of Henri Labrouste.

page 78

BIBLIOTHÈQUE SAINTE GENEVIÈVE

Address: Place du Panthéon, 75005
Telephone: 43.29.61.00
Metro: Luxembourg
Open: Open to readers 10 am - 10 pm Mon-Sat; not generally open to visitors.

Built 1844-50 to designs of Henri Labrouste on site of celebrated Collège de Montaigu, founded 1314; houses important collection of books salvaged from neighbouring Abbaye de Sainte Geneviève, converted into school during Revolution (see Lycée Henri IV); magnificent entrance hall (open to passer-by) and reading room.

page 81

MINUTIER CENTRAL

Address: Hôtel de Rohan, 87 rue Vieille du Temple, 75004
Telephone: 40.27.61.78
Metro: Rambuteau
Open: For occasional exhibitions, but otherwise closed to visitors

Built 1705-8 to designs of Pierre-Alexis Delamair, architect of neighbouring Hôtel de Soubise (see Archives Nationales above); interior redecorated 1749-52 under direction of architect Saint-Martin; originally occupied by Armand-Gaston-Maximilien de Rohan-Soubise, after 1712 Cardinal de Rohan; handed down through family to Cardinal Louis-René-Edouard de Rohan (1779), dupe of diamond necklace affair; house confiscated by state during French Revolution and stripped of contents; thought to have been used as gun-powder store and Revolutionary club run by Tallien; returned to Rohan heirs after Revolution and sold 1807 to property developer Chandor; acquired from same by state 1808 and used as National Printing Works until 1925 (see Banks & Offices: Banque de France / Galerie Dorée);

extensively remodelled in nineteenth century; made over to Minutier Central (notarial division of National Archives) 1927; restored 1927-37 under direction of architect Robert Danis and again 1967; of principal interest: Salle de Compagnie (1750-51), retaining panelling, plasterwork, overdoors, and chimney piece; Cabinet des Singes (1749-50), decorated by painter Christophe Huet (see page ??); and Cabinet des Fables, with eighteenth-century green lacquer panelling enriched with carved and gilt medallions representing scenes from Fables of La Fontaine (interior originally situated in Hôtel de Soubise, dismantled 1859, and reassembled on present site 1936-7).

page 79

..

Banks & Offices

BANQUE DE FRANCE
Hôtel Gaillard

Address: 1 Place du Général Catroux, 75017
Telephone: 42.27.78.14
Metro: Malesherbes
Open: Entrance Hall and Banking Hall open during banking hours; other interiors not generally open to visitors.

Built *c.*1878-84 under direction of architect Jules Février for Grenoblois banker and connoisseur baron Emile Gaillard; sold 1904 to Fédération Nationale des Employés du Commerce; occupied by Banque de France since 1919, when restored and enlarged by architect Defrasse and decorating company Jansen; architectural decoration largely intact.

page 86

BANQUE DE FRANCE
Hôtel de Toulouse

Address: 39 rue Croix des Petits Champs, 75001
Telephone: 42.32.39.08
Metro: Bourse / Palais Royal
Open: Galerie Dorée open one day in September; occasional visits also for groups; telephone for details.

Built 1635-43 by Françoise Mansart for marquis de La Vrillière; acquired 1713 by comte de Toulouse, natural son of Louis XIV, and extensively remodelled 1718-19 under direction of Robert de Cotte; bequeathed by Toulouse to son, duc de

Penthièvre, 1737; confiscated by Revolutionary Government 1793 and used as national printing works until 1808, when occupied by Banque de France.

page 89

SFICA
(Société Français des Ingénieurs Conseils en Aménagement))

Address: Hôtel Botterel-Quintin or de La Corée, 44 rue des Petites Ecuries, 75010
Telephone: 42.46.92.08
Metro: Bonne Nouvelle / Chateau d'Eau
Not generally open to visitors.

Neo-classical *hôtel particulier* built 1780-82 for Charles Audin de La Corée by Perard de Montreuil or possibly Dubois-Tiers; purchased 1785 by comte de Botterel-Quintin; occupied 1807 by Marie-Louise-Jeanne Klein, later duchesse d'Aumont, and since 1972 by SFICA; of special interest: boardroom (originally dining room; see p.90); Director's study (originally salon); and first-floor cabinet / office.

page 90

SICOMI DE PARIS
(Société Immobiliére du Commerce et de l'Industrie)

Address: Hôtel Bony, 32 rue de Trévise, 75009
Telephone: 47.70.00.30
Metro: Cadet.
Interior not generally open to visitors, but painted decoration of ground-floor salon visible from remarkable sunken courtyard.

Former *hôtel particulier* built *c.*1826-28 to designs of Jules de Joly, pupil of Percier; originally occupied by property developer René Bony, succeeded in turn by marquise Sauvaise de Barthélémy (1833-34), Jean Raphaël Bleuart (1834-53), Spanish banker José-Xavier de Uribarren (1854-62), and Louis-Marc Chabrier and heirs (1862-75); acquired 1875 by Banque Claude Lafontaine and 1924 by Banque Syndicale de Paris; subsequently divided up into rented units and allowed to fall into decay; listed in mid 1970s; occupied since 1987 by SICOMI; interior substantially remodelled but good surviving decoration in entrance hall and salon.

page 88

SOCIÉTÉ IMMOBILIÈRE DE LA CHARCUTERIE FRANÇAISE

Address: 10 rue Bachaumont, 75002
Telephone: 43.03.04.33

Metro: Sentier
Not generally open to visitors.
page 87

..

Museums

MUSÉE DES ARTS AFRICAINS ET OCÉANIENS

Address: 293 Avenue Daumesnil, 75012
Telephone: 43.43.14.54
Metro: Porte Dorée
Open: daily (except Tues); 10 am - 12 am and 1.30 pm - 5.30 pm Mon-Fri Sat and 12.30 pm - 6 pm Sun.

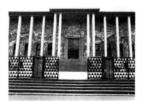

Originally built as exhibition hall for Exposition Coloniale 1931; inaugurated as museum of French colonial history 1936; re-opened under present name 1960; building designed by architectural partnership of Albert Laprade and Léon Jaussély; facades decorated with colossal allegorical reliefs by sculptor Alfred Janniot; well-preserved interior incorporating: Salon Paul Reynaud; Salon du Maréchal Lyautey, and Salle des Fétes, with murals by Ducos de La Haille.

pages 96/97

MUSÉE DES ARTS DÉCORATIFS

Address: 107 rue de Rivoli, 75001
Telephone: 42.60.32.14
Metro: Tuileries / Palais Royal
Open: 12.30 pm - 6 pm Wed-Sat, 11 am - 6 pm Sun; for guided tours telephone extension 926.

Museum devoted to history of French decorative arts from Middle Ages to twentieth century; several period rooms assembled from architectural fragments and furnishings, most successful being private apartment of Jeanne Lanvin.

page 1

CHÂTEAU DE BAGATELLE

Address: Route de Sèvres, Bois de Boulogne, 75016
Telephone: 40.67.97.00
Metro: Pont de Neuilly, then bus No. 43 to Place de Bagatelle

Open: Guided tours of house Sat and Sun 2 pm and 4 pm (1 Apr-31 Oct only). Park open daily 9 am - 6 pm.

Neo-classical villa set in landscape park; house designed by François-Joseph Bélanger, architect on neighbouring Lycée Saint James (see Schools and Colleges); shell erected 1777; interior completed *c.*1782, decoration involving sculptors Lhuillier, Roland, and Auger, and painters Dusseaux, Dugourc, and Hubert Robert; attic storey added and first floor redecorated with Louis XV-style plasterwork in second half of nineteenth century; house originally owned by comte d'Artois, later Charles X; confiscated during Revolution and earmarked for use as agricultural and artistic institute; sold 1797 and converted into restaurant; acquired 1806 by Napoleon; reappropriated by comte d'Artois following Bourbon Restoration; handed down through family until 1835 when sold to francophile art collector Lord Yarmouth, afterwards Marquis of Hertford; bequeathed by same 1870 to adopted son Richard Wallace, founder of Wallace Collection, London; sold by heirs to French state 1905; ground-floor apartments recently restored and opened to public; first-floor apartments awaiting restoration.

front of jacket

MUSÉE CARNAVALET

Address: 23 and 29 rue de Sévigné, 75003
Telephone: 42.72.21.13
Metro: Saint Paul / Chemin Vert
Open: 10 am - 5.40 pm Tues-Sun.

Museum of history of Paris, occupying Hôtel Carnavalet and Hôtel Le Peletier de Saint Fargeau; Hôtel Carnavalet begun 1548 and enlarged under direction of François Mansart *c.*1660; restored and again enlarged 1871-90 and 1907-14; named after Françoise de Kernevernoy, otherwise known as Carnavalet, who purchased house 1578; other former occupants include marquise de Sévigné, resident here 1677-96; used as school 1814-66, when acquired by city authorities and converted to present use; Hôtel Le Peletier de Saint Fargeau, sober late seventeenth-century town house built to designs of military engineer and architect Pierre Bullet; later occupied by martyr of French Revolution, Louis Michel Le Peletier de Saint Fargeau; used as school 1803-63,

when occupied by offices of Paris postal service; acquired by city authorities 1895 and converted for use as library; made over to Musée Carnavalet 1968 and recently opened to public; fascinating collection of exhibits illustrating history of Paris from earliest times; several reconstructions of period interiors salvaged from Parisian buildings either demolished or remodelled, notably: painted study from Hôtel Colbert de Villacerf (c.1660); illusionistic murals from staircase of Hôtel de Luynes (1750); panelling and other fragments from Ledoux's Café Militaire (1762); Salon of Hôtel d'Uzès, also by Ledoux (1767); painted interior by Boucher, Fragonard, and J. B. Huet from house of engraver Demarteau (c.1765); Art Nouveau interiors from Café de Paris (1899) and Fouquet's, jewellery shop by Mucha (1900); ballroom from Hôtel Wandel.
page 92

HÔTEL DE CLUNY

Address: 6 Place Paul Painlevé, 75005
Telephone: 43.25.62.00
Metro: Cluny La Sorbonne / Saint Michel / Odéon
Open: daily 9.45 am - 12.30 pm and 2 pm - 5.15 pm (except Tues); guided tours.
Former abbey built 1485-98; setting for wedding of James V of Scotland and daughter of François Ier; exterior well preserved but little surviving decoration except in staircase; large collection of medieval artworks and architectural fragments; building adjoined by remains of third century A.D. Gallo-Roman baths
page 93

MUSÉE GRÉVIN

Address: 10 Boulevard Montmartre, 75009
Telephone: 47.70.85.00
Metro: rue Montmartre
Open: 1 pm - 6 pm and during school holidays 10 am - 6 pm daily.
Waxworks museum founded 1880 by newspaper owner Arthur Meyer; named after Alfred Grévin, appointed artistic director 1881; museum building erected 1881-82 to designs of architect Esnault-Pelterie; several surviving interiors, each more outlandish than next, notably: *Salle des Colonnes*, lavish Louis XIV-style colonnaded gallery terminating in Italianate rococo

rotunda, enriched with mosaics and allegorical ceiling paintings; *Staircase Hall*, mirrored interior presided over by bust of Grévin; *Palais des Mirages*.
pages 98/99

MUSÉE GUSTAVE MOREAU

Address: 14 rue de la Rochefoucauld, 75009
Telephone: 48.74.38.50
Metro: Trinité
Open: daily 10 am - 5 pm (except Tues); lectures Wed and Sat.
Late nineteenth-century studio house designed by Albert Lafon for symbolist painter Gustave Moreau; bequeathed by Moreau to French state; structure incorporates earlier building with private apartment occupied by Moreau's family after 1852; spacious studios filled with Moreau's work; remarkable spiral staircase with iron supports and balustrade.
page 100

HÔTEL DE LAUZUN

Address: 17 Quai d'Anjou, 75004
Telephone: 43.54.27.14
Metro: Pont Marie / Sully Morland
Open: Apr-Oct, Sat and Sun after 10 am (telephone for closing times); Nov-Mar visits can be arranged through CNMSH; guided tours by appointment.
Remarkable mid seventeenth-century town house with suite of interiors retaining much of their original decoration; built 1656-57 and several times restored, notably c.1849 and c.1905; originally occupied by war contractor Gruyn des Bordes; named after duc de Lauzun, who purchased house 1682; later occupants include poets Charles Baudelaire and Théophile Gautier, tenants here in 1840s; acquired by city authorities 1928 and converted for use as museum.
pages 94/95

TOUR DE JEAN SANS PEUR

Address: 20 rue Etienne Marcel, 75002
Metro: Etienne Marcel
Open: Currently closed for restoration. Due to reopen summer 1990
Fortified tower built 1408 as refuge for Jean, duc de Bourgogne, known as Jean sans Peur, assassin of Louis, duc d'Orléans, head of rival house of Armagnac; sole remains of once extensive medieval palace, Hôtel de Bourgogne, begun 1270; base of tower rests on rampart built in

reign of Philippe Auguste 1190; spiral staircase of 140 steps rising to remarkable carved ceiling ornamented with radiating oak branches, rare example of medieval sculpture as applied to domestic interior.
page 91

··

Embassies

BRITISH EMBASSY
(Ambassador's Residence)

Address: Hôtel de Charost, 39 rue du Faubourg Saint Honoré, 75008
Telephone: 42.66.91.42
Metro: Miromesnil
Not generally open to visitors.
Built 1722-25 to designs of military engineer and cartographer Antoine Mazin; many times remodelled and redecorated, notably by P. F. L. Fontaine (1803-5), L. T. J. Visconti (1825), Decimus Burton (1840s), Jacques Ignace Hittorff (1851), Vye Parminter and Georges Hoentschel (1904), Georges Geoffroy, Christian Bérard, and Charles de Beistegui (1945); many distinguished occupants, including Armand de Béthune, 2nd duc de Charost, and descendants (1725-85), Lord Whitworth, British Ambasador to France during Peace of Amiens (1802-3), Pauline Borghese (1803-14), Duke of Wellington (1814), and long line of British diplomats.
pages 102/103

EMBASSY OF THE FEDERAL
REPUBLIC OF GERMANY
(Ambassador's Residence)

Address: Hôtel de Beauharnais, 78 rue de Lille, 75007
Telephone: 45.51.25.60
Metro: Assemblé Nationale
Open: First and Third Monday of each month by prior appointment; groups admitted at other times by appointment.
Built 1713-15 by architect Germain Boffrand and originally occupied by marquis de Torcy; converted into apartment building c.1796; acquired by Eugène de Beauharnais and remodelled in First Empire style under direction of architect Nicolas Bataille 1804-6; let to Prussian Legation 1816; purchased by Kaiser Friedrich Wilhelm 1818; established 1821 as permanent headquarters of Prussian Legation, later Prussian

Embassy and ultimately Embassy of Federal Republic of Germany; restored under direction of architect Jacques-Ignace Hittorff 1830-60; confiscated by French state 1945 and occupied by ministerial offices; Embassy reinstated 1962; restored 1965-67 by representatives of Berlin historic buildings authorities and architects Marc Nebinger and Roland Grohmann.
pages 107/108/109

ITALIAN EMBASSY
(Ambassador's Residence)

Address: Hôtel de Boisgelin, 47 rue de Varenne, 75007
Telephone: 45.44.38.90
Metro: Varenne
Not generally open to visitors.
Built 1732-33 for Gérard Hensch de Janvry to designs of Jean-Sylvain Cartaud; occupied 1783-92 by Archbishop of Aix, Jean de Dieu-Raymond de Boisgelin (hence name); alterations 1783 and c.1807; interior extensively remodelled and redecorated under direction of Henri Parent c. 1860-75 for then owner duc de Doudeauville Bisaccin; suite of Italian-style interiors added by Félix Bruneau and Adolfo Leovi c.1937, when acquired by Italian Embassy.
pages 104/105

POLISH EMBASSY
(Ambassador's Residence)

Address: Hôtel de Monaco, 57 rue Saint Dominique, 75007
Telephone: 45.51.60.80
Metro: Varenne / Solférino
Not generally open to visitors.
Built c.1838 for Dutch banker and art collector William Williams Hope; attributed to architect Achille-Jacques Fédel; exterior modelled on that of previous building on site, Brogniard's Hôtel de Monaco; interior inspired by state rooms at Versailles; house stripped of contents after Hope's death (1855) and sold to Baron Achille Seillière; occupied by Princesse de Sagan and heirs 1873-1909, when acquired by art dealer Jacques Seligmann; Polish Embassy installed 1937, when restored by architects Crevel and Desssauer.
page 106

SOVIET EMBASSY
(Ambassador's Residence)

Address: Hôtel d'Estrées, 79 rue de Grenelle, 75007
Telephone: 45.04,05.50
Metro: Rue du Bac

Not generally open to visitors.
Built 1711-13 to designs of Robert de Cotte; extensively remodelled and redecorated in second half of nineteenth century; occupied since 1864 by Russian Embassy; previous owners and occupants include duchesse d'Estrées (1713-1753); duc de Biron (1753-54); duchesse de Modène (1754-61); duc de Beuvron and heirs (after 1762); Revolutionary Government; duc de Feltre (after 1807); comte de Montesquiou (1810); and marquise de Tourzel and heirs (1823-64).

page 101

························

Government & Civic Buildings

Several government buildings operate a system known as 'Portes Ouvertes', opening to the public on one day a year, usually in September. For details contact either Ministère de la Culture, Service du Patrimoine, on 40.15.82.42, or Direction Générale des Affaires Culturelles d'Ile de France on 42.25.03.20.

PALAIS DE L'ELYSÉE
(Official Residence of French President)

Address: 55 rue du Faubourg Saint Honoré, 75008
Telephone: 42.92.81.00
Metro: Miromesnil / Champs-Elysées Clemenceau
Closed to visitors.
Palatial *hôtel particulier* built 1718-22 to designs of Claude-Armand Mollet, assisted by fellow architect Jules-Michel-Alexandre Hardouin and sculptors Michel Lange, Louis Herpin, and Jean-Martin Pelletier; subsequent alterations by Lassurance *c.*1754-55; Boullée (assisted by sculptor Cauvet) *c.*1773; Pâris *c.*1787; Vignon, Lecomte, and Thibault, (with participation of cabinet-maker Jacob-Desmalter) *c.*1805; Percier and Fontaine *c.*1808-14; Meunier *c.*1848-52; Lacroix 1857-61 and 1863-7; Debressenne 1879 and 1889-96. Past occupants include comte d'Evreux and heirs (1721-53); marquise de Pompadour (1753-64); Garde Meuble de la Couronne (Royal Furniture Store) (1768); financier Nicolas Beaujon (1773-86); duchesse de Bourbon (1787-93); Revolutionary Government

(1793); Joachim and Caroline Murat (1805-8); Napoleon Bonaparte (1809, 1812-14, and 100 days); Josephine Bonaparte (1810-12); Tsar Alexander of Russia (1814); Duke of Wellington (1815); duc de Berry (1816-20); Napoleon III (1848-70); Thiers (1871); official Residence of French President since 1874. Surviving decoration from virtually every period, including 'Op Art' dining room added by President Pompidou 1972.

page 114

MINISTÈRE DES FINANCES
(Ministry of Finance)

Address: 93, rue de Rivoli, 75001
Telephone: 42.60.33.00
Metro: Palais Royal / Louvre
Open: Guided tours by CNMSH Sat, Sun, and public holidays 5 pm.
Built 1852-57; begun to designs of Visconti; continued and greatly enriched after Visconti's death (1853) by Lefuel; sumptuous suite of state reception rooms retaining original furnishings; especially impressive are Grand Salon and Grande Salle à Manger; soon to be vacated (reluctantly) by Ministry of Finance and occupied (eagerly) by Louvre museum.

page 116

MINISTÈRE DE LA MARINE
(The Admiralty)

Address: 2 Place de la Concorde, 75008
Telephone: 42.60.33.30
Metro: Concorde.
Building erected 1768-74 to designs of Jacques-Ange Gabriel with supervision of interior decoration entrusted to Potain; alterations 1794; interior extensively remodelled and redecorated during Second Empire. Originally occupied by Garde Meuble de la Couronne (Royal Furniture Repository); taken over by Ministère de la Marine 1789-98.

page 115

SÉNAT
(Senate)

Address: Palais du Luxembourg, 15 rue de Vaugirard, 75006
Telephone: 42.34.20.00
Metro: Luxembourg
Visits suspended since 1986; possibility that visits will resume July 1989.
Built 1615-30 by Salomon de Brosse for Marie de Medicis on site of sixteenth-century *hôtel particulier* occupied by duc de Luxembourg (hence name); west wing decorated by Rubens with scenes from life of Marie de Medicis (paintings removed 1780 and exhibited today in Louvre); occupied after death of Marie de Medicis (1631) by various members of French royal family, including Gaston d'Orléans, Grande Mademoiselle, duchesse de Berry, and comte de Provence, later Louis XVIII; converted into prison during Revolution; government chamber since Directoire; extensively remodelled during Consulate (1802-4) under direction of Chalgrin; Bedchamber and Cabinet of Marie de Medicis dismantled during Bourbon Restoration (1815-30) and reassembled as single interior (Salle du Livre d'Or de la Pairie) on ground floor using fragments from Anne of Austria's apartments at Louvre; building enlarged and remodelled 1836-41 by Alphonse de Gisors; Library and cupola decorated by Eugène Delacroix 1840-46; first floor of north front remodelled 1852-54 to provide breathtaking enfilade culminating in Imperial Throne Room for Napoleon III; enfilade designed by Gisors with decorative painting by Henri Lehmann, Jean Aloux, and Adolphe Brune.

page 112

HÔTEL DE VILLE
(Town Hall)

Address: Place de l'Hôtel de Ville, 75004
Telephone: 42.76.40.40
Metro: Hôtel de Ville
Open: Guided tours each Monday

at 10.30 am; telephone in advance on 42.76.54.04.

page 113

MAIRIE DU Vᵉ ARRONDISSEMENT
(Town Hall of 5th Arrondissement)

Address: 21 Place du Panthéon, 75005
Telephone: 43.29.21.75
Metro: Luxembourg
Not generally open to visitors.
Built 1844-47 as town hall of 12th Arrondissement; occupied since 1860 by town hall of 5th; begun to designs of François-Jean-Baptiste Guenepin; completed by Jacques-Ignace Hittorff, seconded by Victor Calliat; facade copied from that of neighbouring School of Law designed by Jacques-Ange Gabriel *c.*1770; building remodelled and enlarged *c.*1927-35 under direction of Patouillard-Demoriane to provide, among other interiors, Salle des Fêtes with murals and ceiling paintings by Gustave Louis Jaulmes and staircase with mural by Henri Martin representing 'Life in the Luxembourg gardens'.

page 117

CONSEIL D'ÉTAT
(Palais Royal)

Address: Place du Palais Royal, 75001
Metro: Palais Royal
Not generally open to visitors.
Occupies wing of Palais Royal, originally Palais Cardinal begun 1634 for Cardinal Richelieu and many times remodelled and enlarged, principally in 1781-84, when extended for duc du Chartres to form complex of shops, theatres, apartments, and restaurants around central garden; sumptuous suite of interiors with surviving decoration from eighteenth and nineteenth centuries, notably *Salle des Conflits, Escalier d'Honneur, Chapelle du Prince Napoléon*.

pages 110/111

TOILETTES PUBLIQUES DE LA MADELEINE
(Public Lavatory)

Address: Place de la Madeleine, 75008
Telephone: Société E.S. 46.60.10.93
Metro: Madeleine
Open: 9.30 am - 11.30 am and 12.30 pm - 7 pm; W.C. 2,20 F; shoe shine 8,80. F (13,20 F for boots).

page 119

Index

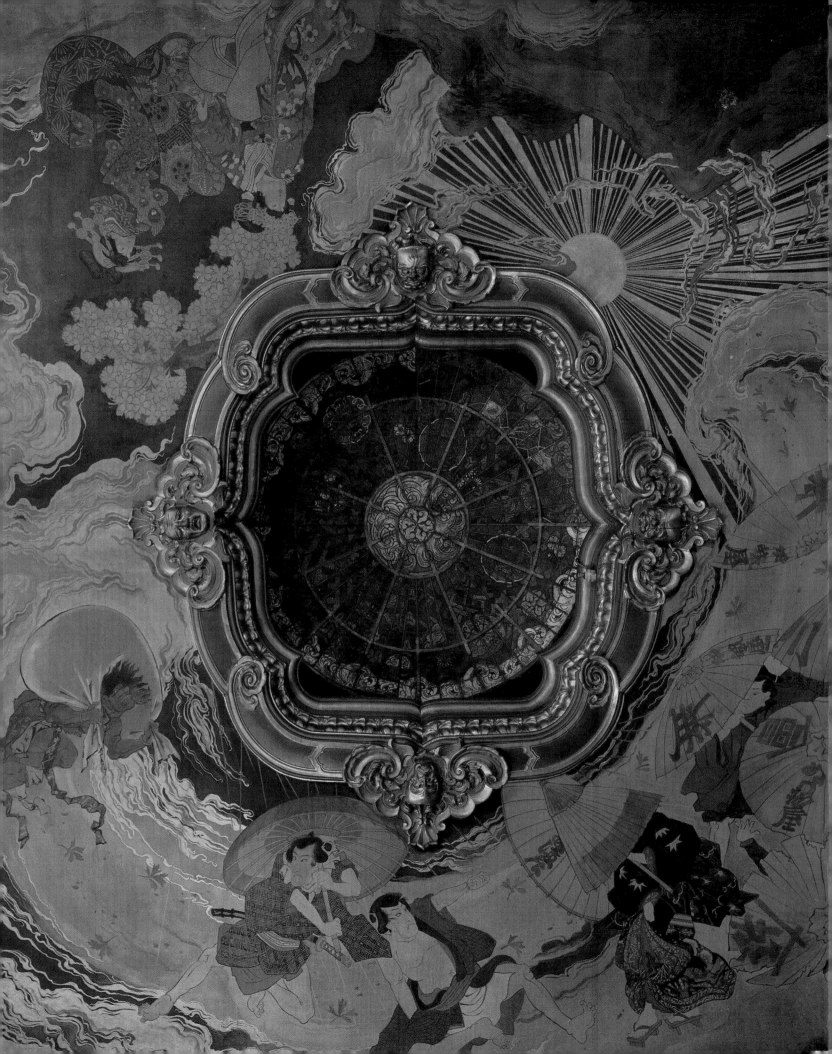